Praise for Michael Finkel's

The Art Thief

A WASHINGTON POST NOTABLE BOOK

A PUBLISHERS WEEKLY BEST NONFICTION BOOK

A LITERARY HUB BEST BOOK

"Propelled by suspense and surprises.... This ultra-lucrative, odds-defying crime streak is wonderfully narrated by Finkel, in a tale whose trajectory is less rise and fall than crazy and crazier... Part of what makes Finkel's book so much fun is that, without exception, [Breitwieser's] strategies are insane." —*The New Yorker*

"A mesmerizing true-crime psychological thriller. . . . *The Art Thief* develops the tension of a French *policier*, where the crook (for whom you alternately feel sympathy and disgust) has Maigret or Poirot hot on his trail. The final outcome is a shock. Mr. Finkel tells an enthralling story. From start to finish, this book is hard to put down."

-The Wall Street Journal

"Enthralling. In animated and colorful prose, Finkel summons the emotional intensity of a murder mystery. But old masters, not bodies, are missing. . . . *The Art Thief* is about heists, yes, but it also speaks to much more."

—The Washington Post

"Exhilarating. . . . Finkel's narrative thrills and electrifies, until it all barrels toward inevitable capture, two shocking betrayals, and an astonishing conclusion." —*Esquire*

"As much a crime caper as a psychological thriller. . . . Finkel deftly keeps us swaying between great sympathy for his central character and profound suspicion." — Air Mail

"The author's account of the skulduggery is thrilling. . . . [Breitwieser] emerges from this astonishing tale as a tragic figure." —The Economist

"Finkel controls the pace effortlessly, broadening and narrowing focus from the day-to-day of the thieves to the intricate plotting of their thefts and a history of art crime, as well as who steals and why. That combined with mounting dread for the artworks' fate makes for a heart-pounding read."

-Minneapolis Star Tribune

"The level of detail Finkel is able to provide . . . is uncomfortably gripping, as if the reader is watching these events unfold and working as an accomplice to the French robber's crimes. . . Although the definition of a page-turner, this book will also likely force the reader to consider why details of this kind are so exhilarating to us in the first place."

-St. Louis Post-Dispatch

"Thrilling. . . . Finkel deftly unspools the story of Breitwieser's improbable years-long adventure." — GQ

Michael Finkel

The Art Thief

Michael Finkel is the bestselling author of *The Stranger in the Woods: The Extraordinary Story of the Last True Hermit* and *True Story: Murder, Memoir, Mea Culpa*. He lives with his family in northern Utah.

michaelfinkel.com

Also by Michael Finkel

The Stranger in the Woods True Story Alpine Circus

The Art Thief

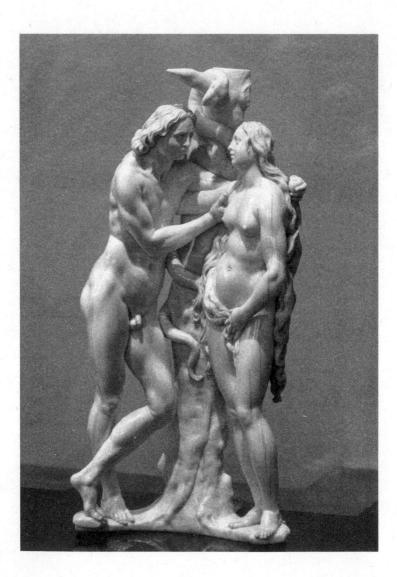

The Art Thief

A TRUE STORY OF LOVE, CRIME, AND A DANGEROUS OBSESSION

Michael Finkel

VINTAGE BOOKS A Division of Penguin Random House LLC New York

FIRST VINTAGE BOOKS EDITION 2024

Copyright © 2023 by Michael Finkel

All rights reserved. Published in the United States by Vintage Books, a division of Penguin Random House LLC, New York. Originally published in hardcover in the United States by Alfred A. Knopf, a division of Penguin Random House LLC, New York, in 2023.

Vintage and colophon are registered trademarks of Penguin Random House LLC.

A portion of this work was adapted from "The Secrets of the World's Greatest Art Thief," originally published in *GQ* (February 28, 2019).

Frontispiece of *Adam and Eve* by Georg Petel, 1627, ivory. Stolen from the Rubens House in Antwerp, Belgium. (RH.K.015, Collection of the City of Antwerp, Rubens House)

The Library of Congress has cataloged the Knopf edition as follows: Name: Finkel, Michael, author. Title: The art thief: a true story of love, crime,

and a dangerous obsession / Michael Finkel.

Description: First edition. | New York: Alfred A. Knopf, 2023.

Identifiers: LCCN 2022049664 (print)

Classification: LCC N8795.5.B74 F26 2023 (print) | DDC 364.16/2870944—dc23 LC record available at https:///lccn.loc.gov/2022049664

Vintage Books Trade Paperback ISBN: 978-1-9848-9845-6 eBook ISBN: 978-0-525-65733-0

Author photograph © Doug Loneman Book design by Maria Carella Maps by Kristine Ellingsen

vintagebooks.com

Printed in the United States of America 10 9 8 7 6 5 4 3 2 I For my father, Paul Alan Finkel

Aesthetics are higher than ethics.

-OSCAR WILDE

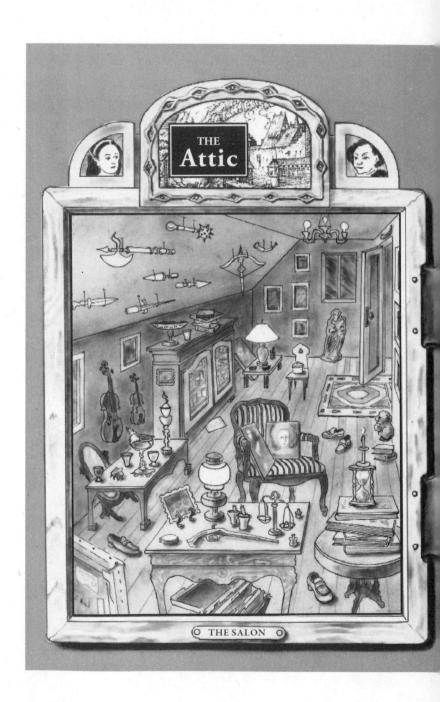

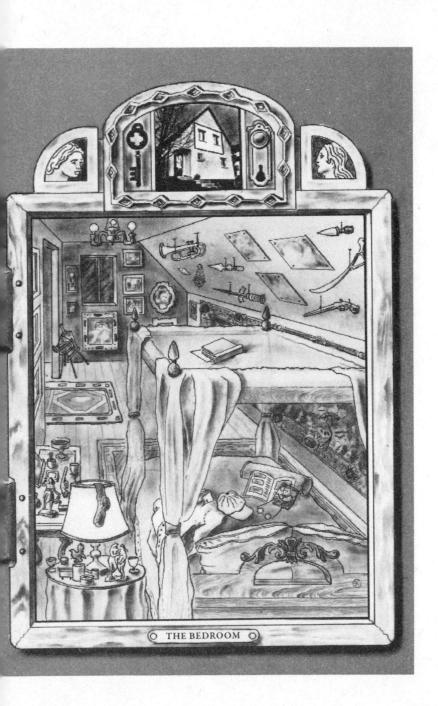

The Art Thief

Approaching the museum, ready to hunt, Stéphane Breitwieser clasps hands with his girlfriend, Anne-Catherine Kleinklaus, and together they stroll to the front desk and say hello, a cute couple. Then they purchase two tickets with cash and walk in.

It's lunchtime, stealing time, on a busy Sunday in Antwerp, Belgium, in February 1997. The couple blends with the tourists at the Rubens House, pointing and nodding at sculptures and oils. Anne-Catherine is tastefully dressed in Chanel and Dior bought in secondhand shops, a big Yves Saint Laurent bag on her shoulder. Breitwieser wears a buttondown shirt tucked into stylish pants, topped by an overcoat that's sized a little too roomy, a Swiss Army knife stashed in a pocket.

The Rubens House is an elegant museum in the former residence of Peter Paul Rubens, the great Flemish painter of the seventeenth century. The couple drifts through the parlor and kitchen and dining room as Breitwieser memorizes the side doors and keeps track of the guards. Several escape routes take shape in his mind. The item they're hunting is sheltered at the rear of the museum, in a ground-floor gallery with a brass chandelier and soaring windows, some now shuttered to protect the works from the midday sun. Here, mounted atop an ornate wooden dresser, is a plexiglass display box fastened to a sturdy base. Sealed inside the box is an ivory sculpture of Adam and Eve.

Breitwieser had encountered the piece on a solo scouting trip a few weeks earlier and had fallen under its spell the four-hundred-year-old carving still radiates the inner glow, unique to ivory, that feels to him transcendent. After that trip, he could not stop thinking of the sculpture, dreaming of it, so he has returned to the Rubens House with Anne-Catherine.

All forms of security have a weakness. The flaw with the plexiglass box, he had seen on his scouting visit, is that the upper part can be separated from the base by removing two screws. Tricky screws, sure, difficult to reach at the rear of the box, but just two. The flaw with the security guards is they're human. They get hungry. Most of the day, Breitwieser had observed, there is a guard in each gallery, watching from a chair. Except at lunchtime, when the chairs wait empty as the security staff rotates shorthanded to eat, while those who remain on duty shift from sitting to patrol, dipping in and out of rooms at a predictable pace.

Tourists are the irritating variables. Even at noon there are too many of them, lingering. The more popular rooms in the museum display paintings by Rubens himself, but these pieces are too large to safely steal or too somberly religious for Breitwieser's taste. The gallery with *Adam and Eve* features items Rubens collected during his lifetime, including marble busts of Roman philosophers, a terracotta sculpture of Hercules, and a scattering of Dutch and Italian oil paintings. The ivory itself, by the German carver Georg Petel, was likely received by Rubens as a gift.

As the tourists circle, Breitwieser positions himself in front of an oil painting and assumes an art-gazing stance. Hands on hips, or arms crossed, or chin cupped. His repertoire includes more than a dozen poses, all meant to connote serene contemplation, even while his heart is revving with excitement and fear. Anne-Catherine hovers near the gallery's doorway, sometimes standing, sometimes sitting on a bench, always with an air of casual indifference, making sure she has a clear view of the hallway beyond. There are no security cameras in the area. There's only a scattered handful in the whole museum, and he has noted that each has a proper wire; occasionally, in smaller museums, they're fake.

A moment soon comes when the couple is alone in the room. The transformation is explosive, a flame to the fuel, as Breitwieser sheds his studious pose and leaps over the security cordon to the wooden dresser. He digs the Swiss Army knife from his pocket, pries open a screwdriver tool, and sets to work on the plexiglass box.

Four turns of the screw, maybe five. The carving to him is a masterpiece, just ten inches tall yet dazzlingly detailed, the first humans gazing at each other as they move to embrace, the serpent coiled around the tree of knowledge behind them, the forbidden fruit picked but not bitten: humanity at the precipice of sin. He hears a soft cough—that's Anne-Catherine and vaults away from the dresser, light-footed and fluid, and reassumes art-watching mode as a guard appears. The Swiss Army knife is back in his pocket, though the screwdriver is still extended.

The guard walks into the room and stops, then scans the gallery methodically. Breitwieser contains his breathing. The officer turns around and is barely beneath the doorway before the theft resumes. This is how Breitwieser progresses, in fits and starts, grasshoppering about the gallery, a couple of turns of the screw, then a cough, a couple more, then another.

To unfasten the first screw amid the steady drip of tourists and guards requires ten minutes of concentrated effort, even with the margin for error shaved thin. Breitwieser does not wear gloves, trading fingerprints for dexterity and touch. The second screw is no easier, finally yielding as further visitors arrive, forcing him to bound off again, the pair of screws in his pocket.

Anne-Catherine makes eye contact with him from across the room, and he taps his hand to his heart, signaling that he's ready for the finishing step and will not need to use her big purse. She heads off to the museum's exit. The security guard has already appeared three times, and although both he and Anne-Catherine have stationed themselves in different spots at each check-in, Breitwieser is stressed. He'd once worked as a museum guard, soon after graduating from high school, and he understands that while almost no one will detect a detail as tiny as a missing or protruding screw, all decent guards focus on people. To remain in the same room for two consecutive security visits, and then commit a theft, is inadvisable. Three visits is borderline reckless. A fourth, which by his watch is little more than a minute away, must not happen. He needs to act or abandon now.

The problem is the group of visitors present. He slides his eyes over. They're huddled near a painting, all wearing headphones attached to audio guides. Breitwieser deems them sufficiently distracted. This is the critical instant—one glance from one visitor and his life could effectively end—and he does not delay. It isn't action, he suspects, that usually lands a thief in prison. It's hesitation.

Breitwieser steps to the dresser, lifts the plexiglass box from the base, and sets it carefully aside. He grasps the ivory sculpture, sweeps his coattails out of the way, and pushes the work partially into the waistband of his pants at the small of his back, then readjusts the roomy overcoat so the carving is covered. There's a bit of a lump, but you'd have to be extraordinarily observant to notice.

He leaves the plexiglass box to the side—he does not want to waste precious seconds replacing it—and strides off, moving with calculation but no obvious haste. He understands that such a conspicuous theft will swiftly be spotted, triggering an emergency response. The police will arrive. The museum could be locked down, all visitors searched.

Still, he does not run. Running is for pickpockets and purse thieves. He eases outside the gallery and slinks through a nearby door he'd scouted, one reserved for employees yet neither locked nor alarmed, and emerges in the museum's central courtyard. He glides over the pale stones and along a vine-covered wall, the sculpture knocking at his back, until he reaches another door and pops through, returning inside the museum close to the main entrance. He continues past the front desk and onto the city streets of Antwerp. Police officers are likely descending, and he consciously keeps his pace easy, shuffling in his shiny loafers until he spots Anne-Catherine and they proceed together to the quiet road where he'd parked the car.

He pops the trunk of the little Opel Tigra, midnight blue, and sets the ivory down. Both of them holding in a bubbling euphoria, he takes the wheel and Anne-Catherine settles into the passenger seat. He wants to gun the engine and screech away, but he knows to drive slowly, pausing at traffic lights on the route out of town. Only when they reach the highway and he hits the accelerator does their vigilance fly away, and then they're just a pair of twenty-five-year-old kids, joyously speeding, home free. 2

The house is humble, a pale cube of stuccoed concrete pitted with small windows and covered by a steep, red-tiled roof. A couple of pine trees shade a grassy patch out back. It sits on a street of similar homes among the suburban sprawl of Mulhouse, an automobile and chemical manufacturing city in the industrial belt of eastern France, one of the least attractive areas in a nation brimming with beauty.

Most of the living space is on the ground floor, but a narrow stairway leads up to two rooms, a living area and a bedroom, tucked beneath the rafters, low ceilinged and cramped. The door to these rooms is always kept locked, the window shutters permanently closed. Wedged into the bedroom is a majestic, four-poster canopied bed, draped with gold velour curtains tied back with maroon ribbons, covered with red satin sheets piled with cushions. Here, amid this odd opulence, is where the young couple sleeps.

When Breitwieser opens his eyes, one of the first things he sees is *Adam and Eve*. He'd placed the ivory piece on his bedside table specifically for this view. Sometimes he brushes his fingertips over the carving, where the artist's own hands had once labored—across the ripples in Eve's hair, along the serpent's scales, up the nubby tree trunk. It's among the most gorgeous works he has ever encountered; it might be worth more than every house on his block put together, times two.

Also on his bed table is a second ivory carving, a figurine of Diana, the Roman goddess of hunting and fertility, her right arm raised, clutching her golden arrows. And near that a third, a statuette of Catherine of Alexandria, an early Christian saint. And then another, of a curly-haired Cupid resting his foot on a skull, love overpowering death. Could anything offer a more stirring start to each day than the ethereal glow of an ivory collection?

Yes, it turns out. Near the ivories is a polished golden tobacco box, frilled in bright blue enamel, commissioned by Napoleon himself. To hold it in your palm is to travel through time. Next to that is a flower vase, prismatic and curvy, made by Émile Gallé, the French master glassblower of the late 1800s. Then an older item, a great silver goblet engraved with garlands and coils—held aloft by royalty, Breitwieser imagines, sloshing wine at feasts across centuries. Then more little round tobacco tins, so pleasingly shaped, and a section of bronze pieces near a porcelain figurine next to a nautilusshell chalice. Just the contents of his nightstand could stock a museum exhibit of its own.

There is also a night table on Anne-Catherine's side of the bed. And a large armoire with showcase shelves enclosed by glass doors. And a desk, and a dresser. Every flat surface in the bedroom is filled. Silver platters, silver bowls, silver vases, silver cups. Gilded tea sets and pewter miniatures. A crossbow, a saber, a poleax, a mace. Pieces in marble and crystal and mother-of-pearl. A gold pocket watch, a gold urn, a gold perfume flask, a gold brooch.

The second room of the couple's hideaway has more. A wooden altarpiece, a copper plate, an iron alms box, a stainedglass window. Apothecary jars and antique game boards. Another group of ivory carvings. A violin, a bugle, a flute, a trumpet.

Further pieces are stacked on armchairs, propped against walls, balanced on windowsills, beached on piles of laundry, slid under the bed, and corralled in the closet. Wristwatches, tapestries, beer tankards, flintlock pistols, hand-bound books, and more ivory. A medieval knight's helmet, a wooden statue of the Virgin Mary, a bejeweled table clock, an illustrated prayer book from the Middle Ages.

All of this is ancillary to the true splendor. The grandest, most valuable items, by far, hang on the walls: oil paintings, primarily from the sixteenth and seventeenth centuries, by masters of the late Renaissance and early Baroque styles, detailed and colorful with movement and life. Portraits, landscapes, seascapes, still lifes, allegories, peasant scenes, pastorals. Exhibited floor to ceiling, left to right, room to room; arranged thematically or geographically or whimsically.

The works include dozens of period greats—Cranach, Brueghel, Boucher, Watteau, Goyen, Dürer—so many that the rooms seem to swirl with color, amplified by the radiance of ivory, added to the sparkle of silver, multiplied by the glitter of gold. Everything, in total, has been estimated by art journalists to be worth as much as two billion dollars, all stashed in an attic lair in a nondescript house near a hardscrabble town. The young couple has conjured a reality that surpasses most fantasies. They live inside a treasure chest. 3

Stéphane Breitwieser is not really an art thief. Or so he believes, even though he is perhaps the most successful and prolific art thief who has ever lived. He doesn't deny having stolen the pieces in his hidden rooms, most with the aid of Anne-Catherine Kleinklaus. He knows exactly what he has done; he can recount some of his crimes down to the precise number of steps it took him to sneak a work out the museum exit.

His issue is with other art thieves. They disgust him virtually all of them, even the most accomplished ones. Like the two men dressed in police uniforms who arrived at Boston's Isabella Stewart Gardner Museum on the night of Saint Patrick's Day 1990. They were buzzed inside by the pair of overnight guards, who were swiftly subdued, eyes and mouths bound with duct tape, then handcuffed to pipes in the basement.

A violent, late-night heist is an insult to Breitwieser's notion that stealing artwork should be a daytime affair of refined stealth in which no one so much as senses fear. But this is not why he despises the Gardner crime. It's what happened next. The thieves marched upstairs and pulled down the most magnificent work in the museum, a Rembrandt from 1633, *The Storm on the Sea of Galilee*. Then one of the men stuck a knife in the canvas.

Breitwieser can hardly bring himself to imagine it—the blade ripping along the edge of the work, paint flakes spraying, canvas threads popping, cutting the full nineteen-foot perimeter until the piece, released from its stretcher and frame, curled up in death throes, paint cracking and chipping some more. And then the thieves moved on to another Rembrandt and did it again.

This is not the way Breitwieser works. No matter how depraved a criminal's morals, deliberately slicing or breaking a painting should still be immoral. A picture frame, Breitwieser understands, can make a painting unwieldy to steal, so what he does after he detaches a piece from the wall is turn it over and coax the clips or nails on the back to drop the frame, which he leaves behind in the museum. If there's no time for such diligence, he abandons the crime, and if there is, he's mindful that the painting, now vulnerable as a newborn, must be shielded from scratches and warpage and creases and dirt.

The Gardner thieves, by Breitwieser's standards, are savages—they gratuitously vandalized works by Rembrandt. *Rembrandt*. Virtuoso of human emotion and godly light. The thieves remain missing, along with the thirteen pieces they took, worth half a billion dollars, but even if the paintings are eventually found, they will never be whole. As with most art thieves, the Gardner burglars didn't actually care about art. All they did was make the world uglier.

Breitwieser's sole motivation for stealing, he insists, is to surround himself with beauty, to gorge on it. Very few art thieves have ever cited aesthetics as an incentive, but Breitwieser has emphasized this repeatedly, across dozens of hours of media interviews, during which he has not tried to hide his guilt, describing his crimes and emotions with present-tense immediacy and seemingly pinpoint precision. Sometimes he's gone further to provide accuracy. Pressed on the details of the *Adam and Eve* theft, Breitwieser donned a quick disguise a baseball cap pulled low and a fake pair of eyeglasses—and returned to the scene of the crime, to aid in recalling every decision point, screw removal, and art-watching pose. He's done similar things for a few other heists. Hundreds of police reports help confirm the general facts of his accounts.

He takes only works that stir him emotionally, and seldom the most valuable piece in a place. He feels no remorse when he steals because museums, in his deviant view, are really just prisons for art. They're often crowded and noisy, with limited visiting hours and uncomfortable seats, offering no calm place to reflect or recline. Guided tour groups armed with selfiestick shanks seem to rumble through rooms like chain gangs.

Everything you want to do in the presence of a compelling piece is forbidden in a museum, says Breitwieser. What you first want to do, he advises, is *relax*, pillowed in a sofa or armchair. Sip a drink, if you desire. Eat a snack. Reach out and caress the work whenever you wish. Then you'll see art in a new way. Take the ivory *Adam and Eve*. There's a profusion of symbolism embedded in the piece, augmenting a notable consistency of proportion and a fine balance of pose. Or so a museum tour guide will say, each word further walling off your chances of feeling any raw emotions at all.

Now steal the carving, follow Breitwieser's advice, and look again: Adam's left arm is draped around Eve's shoulders while his other hand touches her body. The first couple, freshly formed by God, appears flawless—muscled, lean, healthy, great hair. Their lips are full, Eve's neck coyly tilted. They are naked. Adam's penis is right there; he seems to be circumcised. It's okay to stare. Eve's right hand lies on Adam's back, urging him closer, and her left rests between her legs, fingers curled inward.

So many great works of art are sexually arousing that what you'll also want to do, Breitwieser says, is install a bed nearby, perhaps a four-poster, for when your partner is there and the timing is right. When Breitwieser is not in bed, he dotes like a butler on the works in his rooms, monitoring temperature and humidity, light and dust. His pieces are kept in better condition, he says, than they were in museums. Lumping him in with the savages is cruel and unfair. Instead of an art thief, Breitwieser prefers to be thought of as an art collector with an unorthodox acquisition style. Or, if you will, he'd like to be called an art liberator.

And Anne-Catherine? Her feelings are more difficult to gauge. She is not willing to talk with reporters. A few people who have spent time with her, however, have spoken extensively, including lawyers, personal acquaintances, and detectives. Sections of psychology reports for both her and Breitwieser have been made public, along with transcribed interrogations and testimony. Preserved as well are some of the couple's home videos and sections of personal letters. There are also museum security images, media reports, and statements from police officers, prosecutors, and several people in the art world.

Every item has been studied to offer an accurate depiction of the art thefts, though the most intimate details of the couple's romance and criminality come only from Breitwieser. It might be enlightening to hear Anne-Catherine's full version of her experiences, but her response to many questions would put her in the position of either incriminating herself, with potentially punitive repercussions, or overtly lying. Faced with these options, her silence seems wise.

What is evident, despite Anne-Catherine's limited public remarks, is that she would not describe herself as an art liberator. Nor would she propose any other morally distorted justifications for the crimes. She's the more pragmatic and rational of the two. Her feet are on the ground; his head's in the clouds. Breitwieser provides the lift to carry them away on flights of fancy, while Anne-Catherine offers the ballast to bring them safely back home. Anne-Catherine, say people she's confided in, views their stolen pieces with wary ambivalence gorgeous, and just as surely tainted. Breitwieser's conscience is clear. To him, beauty is the world's only true currency, always enriching whatever its source. The person with the most beauty is therefore the richest. He has sometimes considered himself one of the wealthiest people alive.

Anne-Catherine would also not describe herself as wealthy, with good reason. The couple is perpetually broke.

Breitwieser vows that he isn't seeking financial gain, and never steals with the intent of selling anything, not one piece. This too sets him apart from nearly any other art thief. Breitwieser has so little money that even on getaway drives he avoids paying highway tolls. Occasionally he'll take a temporary job stocking shelves, unloading trucks, waiting tables at a pizza place, then a café, then a bistro—but mostly he collects government welfare and gifts from his family. Anne-Catherine works full time as a nurse's assistant in a hospital, though isn't well paid.

This is why the couple's secret gallery is in such a strange site. Breitwieser can't afford rent, so he lives with his mother and pays nothing. His mother's rooms are on the ground floor and she respects his privacy, he insists, and does not venture upstairs. The items he and Anne-Catherine haul home, he tells his mother, are flea-market finds or knockoffs, to enliven a boring attic.

Breitwieser is an unemployed freeloader holed up in his mother's house. This he acknowledges. The arrangement permits him to live cheaply, allowing him to keep all his illicit artwork without the need to even consider converting any loot into cash. Stealing art for money, he says, is disgraceful. Money can be made with far less risk. But liberating for love, he's known a long time, feels ecstatic. 4

His first loves were pottery shards and tile fragments and arrowheads. He'd embark on "expeditions," as he called them, for that is what they were to an elementary-school kid, exploring the ruins of medieval fortresses with his grandfather, who might have sparked a two-billion-dollar string of heists with the tip of his cane.

The grandfather, from the maternal side, had a beachcomber's eye, and when he poked his cane in the soil, Breitwieser knew to dig with his hands. Unearthed remnants, such as glazed tiles and crossbow pieces, felt to Breitwieser like private messages that had waited centuries specifically for him to receive. He sensed, even then, that it might have been forbidden to keep them, but his grandfather said that he could, so he stashed them in a blue plastic box in the basement of his family's home. Sneaking to the cellar and opening the blue box could make him tremble and cry. "Objects that held my heart," is how Breitwieser described his cherished finds.

He was born, in 1971, into a family with deep roots in

Alsace, a part of France that is often considered stolen property itself. His parents christened him with a regal-sounding name: Stéphane Guillaume Frédéric Breitwieser. He is the only child of Roland Breitwieser, an executive manager of a department store chain, and Mireille Stengel, a hospital nurse specializing in child care.

Breitwieser grew up, with a trio of dachshunds, in a stately home in the village of Wittenheim, on the French side of the three-way borderlands that include Switzerland and Germany. He speaks native French, fluent German, workable English, and some Alsatian, the regional Germanic dialect. France and Germany have wrested the area from each other five times in the past 150 years, and many locals, envious of the higher salaries and lower prices over the border, feel that it is France's turn to give it back.

Their house was finely furnished—Empire dressers from the 1800s, Louis XV armchairs from the 1700s—and ornamented with antique weaponry. Breitwieser recalls playing with the old armaments, sneaking them off their display stands when his parents weren't looking and dueling against imaginary enemies. The walls shimmered with paintings, several by the acclaimed Alsatian expressionist Robert Breitwieser, who has a street named after him in his hometown of Mulhouse. The painter was not a close family member, he was the brother of Stéphane Breitwieser's great-grandfather, but he accepted visits from the whole Breitwieser clan. Shortly before the painter's death, in 1975, he completed a portrait of Stéphane Breitwieser as a toddler.

For years, Breitwieser told acquaintances that he was Robert Breitwieser's grandson. The lie was justified, Breitwieser felt, because the famous painter on his father's side of the family had devoted the effort to enshrine him on canvas, while he'd never developed a deep relationship with either of his paternal grandparents.

Breitwieser's attachment to his maternal grandparents, Aline Philippe and Joseph Stengel—the grandfather with the cane and the beachcomber's eye—was unshakably strong. The best days of his youth, Breitwieser says, were spent with them: weekend lunches at their converted farmhouse in the country, Christmas feasts that unspooled until dawn, and of course expeditions with his grandfather in the hills above the Rhine valley, where Julius Caesar's troops began building forts in the first century BC.

As Breitwieser's tastes shifted and he flitted to new obsessions, most requiring financial assistance, his maternal grandparents invariably obliged. Breitwieser was their only grandchild, and they spoiled him rotten, he says, usually sending him home from a visit with a little white envelope. He fell in love with coins and stamps and old postcards, and happily spent the contents of the envelopes at flea markets and antiques fairs. He loved Stone Age tools, bronze miniatures, and vintage flower vases. He loved Greek and Roman and Egyptian antiquities.

Breitwieser was a moody and anxiety-prone adolescent, uncomfortable socially, awkward and stiff. He subscribed to archaeological journals and fine-art magazines and read textbooks on medieval pottery, classical architecture, and Hellenic history. He volunteered to work on a local archaeology dig. "I took refuge in the past," he says, an old soul at a very young age. Kids his own age baffled him. Their fixations—video games, sports, parties—were repulsive to him. As an adult, he feels the same about cell phones, email, and social media. Why make it *easier* to be bothered by others? Breitwieser's parents expected him to excel in school, then become a lawyer, but for him the inside of a classroom was the worst place to learn. He has always been scrawny, and was bullied at school. "I am like the opposite of everyone," he says. Depressive episodes closed around him like curtains and could hang there for weeks. He has spoken off and on with therapists since his teenage years, but suspects that his problem is incurably existential: he was born in the wrong century.

His father was authoritarian and demanding, Breitwieser says, dismayed by the softness he sensed in his son. One summer during high school, his father found him a job on the Peugeot auto-assembly line-long hours of physical labor to toughen him up. He lasted a week. "My father probably thought I was worth less than nothing," he says. His mother ran hot and cold, volcanically temperamental or glacially inaccessible, though rarely with him. As if to counter the household tension between father and son, she tended to be permissive and pliable with her child, perhaps to a fault. While in high school, he brought home one report card with a poor grade in math, and when his mother saw it, she warned him that his father would be furious. With a black pen, Breitwieser forged a new mark, and his mother kept silent in tacit approval. She let him get away with anything, he says, or quickly forgave him.

When Breitwieser seemed intractably sullen, his parents, who had noted that visiting a museum always helped restore his equilibrium, would drop him off at any of a dozen small museums nearby and allow him to wander for an afternoon alone. He would find a private spot, out of the sight line of guards, and slide his hands across sculptures and paintings, sensing the tiny irregularities and imperfections. "Witness marks," as art experts call them, do not exist on machinestamped wares, and attest to the uniqueness of human creations, no two brushstrokes or chisel strikes ever the same. By the time his parents arrived to pick him up, he was invariably happier.

At the Archaeological Museum of Strasbourg during one of these drop-offs, his finger snagged on a loose bit of metal attached to a Roman coffin. A coin-sized piece of lead broke off in his palm. He stuffed it reflexively into his pocket. It might have been his first museum theft, but he thought of it, rationalizing from the start, more as a personal gift from the antiquity gods, like the pieces he had found while on expeditions with his grandfather. Back home, he added this two-thousand-year-old relic to the blue plastic box, still in his basement, that held items from the expeditions, as well as purchases funded by the little white envelopes—a box of his favorite things in the world.

In his teenage years, he fell in love with musical instruments and medical devices and pewter pitchers. He loved drinking steins, decorative boxes, and oil lamps. He loved the furniture, weapons, and paintings in his home, and his father's collections of watches and ivory figurines. He loved porcelain dolls, antiquarian books, and fireplace tools.

His parents bickered quietly, at first. Then loudly and bitterly. Then with fits of rage and dishes shattered. The year Breitwieser graduated from high school, 1991, the neighbors were so fearful of the clamor that they called the police, more than once. When his father moved out that same year, he took with him all the furniture, weapons, paintings, watches, and ivory. His father, who had inherited these works, didn't leave behind a single piece, Breitwieser says, not even his famous relative's portrait of him as a toddler. Breitwieser, though at the cusp of adulthood at age nineteen, says he felt an acute sense of abandonment. He remained with his mother and completely cut off contact with his father.

The large home no longer affordable, Breitwieser and his mother moved into an apartment. "My mother bought furniture from Ikea and this crushed me," he says. Unbound from his father's strictures and humiliated by the social tumble his family had once owned a boat and a Mercedes automobile, and now he and his mother relied on government aid—Breitwieser seemed to exempt himself from the rules of society. He shoplifted clothing, books, collectibles; whatever he wanted. Even after he was spotted in a store and police were summoned, forcing him to apologize and pay compensation, the only lesson learned, Breitwieser says, was that he had to avoid being caught, ever again.

His maternal grandparents bought him a car, but further freedom made him a bigger delinquent. A dispute with a police officer about a parking ticket escalated until Breitwieser became overly belligerent and was arrested, and not long after, a similar police encounter culminated in a physical struggle, during which Breitwieser injured an officer's finger. These outbursts resulted in a court-appointed, two-week stay at a behavioral therapy clinic. Breitwieser also suffered aching spells of sadness, and sometimes had to push away notions of suicide. He was prescribed the antidepressant Zoloft. "The medicine didn't work," he says, so he stopped taking it. But he did manage to find a job, just before his twentieth birthday, as a security guard at the Mulhouse History Museum. He saw works of art and museum visitors through a guard's eyes, and realized as well that he hated the daily grind of employment. He quit after a month, taking with him an education in museum security and also, from a display case on the upper floor, which he rearranged to appear as if nothing were missing, an immaculate belt buckle hammered out during France's Merovingian dynasty, around AD 500.

The blue plastic box had moved with him from the basement of his grand childhood home to an Ikea bookshelf in a cramped apartment. The belt buckle joined his other sacred objects, all of which to him were the definition of perfect: they would never enrage him, bully him, or abandon him. He could not say the same for any one human. How easy and painless life would be, he thought, to pass his whole time filling blue boxes, alone in his room but entirely complete. People were superfluous.

Then he fell in love with a girl.

5

Anne-Catherine lounges on the four-poster bed in Ferrarired sheets, wearing a silky black nightshirt and an insouciant grin. "This is my kingdom," she proclaims, opening her arms theatrically, acknowledging the riches. She blows an air-kiss to her boyfriend, who is videoing the scene.

They are in their attic lair, just the two of them as always, around the time of the *Adam and Eve* theft. By this point they have been together five years. Anne-Catherine is pixieish and petite, five feet three, cheeks dimpled and chin clefted, with short blond hair that's stylishly tousled. One impish curl hangs over her brow. He calls her Nena and she calls him Steph, but that's only for each other. When referred to publicly, especially as a team, he likes the blend of one last name and one first—Breitwieser and Anne-Catherine—not for any logical reason, he adds, but for the way it pleases his ear.

"A hundred francs to visit," says Anne-Catherine, gazing at the video camera mischievously. Is this the price, about twenty U.S. dollars, for entering the secret kingdom, or for something more provocative? She extends a palm as if waiting for cash.

"Too expensive," Breitwieser teases from behind the camera. He pans away, past Anne-Catherine's nightstand, arranged with treasure, to the wall by the bed, where seventeenth-century Flemish landscapes parade one beside the other.

"Come back," she coos. "I'll give you a real kiss." She leans toward the lens. There's a frisson of sensuality in the confined space of the room, and the recording ends here as he puts down the camera, presumably to meet her lips.

For Breitwieser, as with a piece of art, so too it was with Anne-Catherine, from the very beginning. When Breitwieser sees a beautiful artwork, he says that a tremor builds in his fingers, followed by buzzy, tactile vibrations that spread over his skin. It's as if an electric circuit has been completed between him and the art, fine-tuning his senses and jolting his thoughts. The feeling culminates in what Breitwieser calls a *coup de coeur*—literally, a blow to the heart. That's when he knows he'll go to great lengths to possess something.

In his senior year of high school, his only steady companions were a few fellow archaeology buffs. At a birthday party for one of these acquaintances, in the autumn of 1991, he was introduced to Anne-Catherine. The two of them were born less than three months apart, both from deeply Alsatian families. He found her stunningly gorgeous, and for the first time in his life he experienced a *coup de coeur* for an actual person. He'd never had a serious girlfriend before. "I loved her right away," he says.

She loved him too. All the people who know Anne-

Catherine, and are willing to speak about her, describe the couple's relationship as unhealthy, irrational, and reckless. But they concede this essential point. "She fell in love with him, totally and sincerely," says one confidant, Eric Braun, who has served as her attorney and has spent a great deal of time with her. "She isn't someone who does things halfheartedly." When it comes to romance, Braun says, Anne-Catherine is all in or all out; there's no waffling. "It's a straightforward yes or no," stresses Braun, and Breitwieser was an absolute yes.

When they met, Breitwieser was still living with both parents in his sprawling childhood home—"a high-end bourgeois mansion," as Anne-Catherine later described it to police inspectors. She came from more modest means. Anne-Catherine's father, Joseph Kleinklaus, was a line cook, and her mother, Ginette Muringer, a day-care worker. She is the oldest of three siblings. The Breitwieser family still owned a motorboat at the time, with sleeping cabins below deck, and had embarked on multiday voyages across Lake Geneva, the crescent-shaped lake amid the sawblade mountains dividing Switzerland and France. In winter, the Breitwieser family had skied in the Alps. In summer, they'd hiked in the Alsatian countryside and dined at traditional inns. Breitwieser had taken tennis lessons and earned his scuba-diving certificate. None of these activities had played any part in Anne-Catherine's youth.

Coupling with Breitwieser seemed to awaken in her a great sense of adventure. Her life before him, says Braun, had been "perhaps a little drab." Anne-Catherine and her family were hindered by financial stresses. Her family didn't own a car for a while, and as a young adult she did not learn how to drive. "She was lacking some passion," Braun says, "and Breitwieser provided her that, and beyond—he gave her a feeling of being fully alive."

At the same time, she opened his eyes to even more of the beauty around them. Breitwieser had always been captivated by diverse objects and styles, but Anne-Catherine was his true aesthetic muse, Breitwieser insists, the one who guided his preferences to maturity. "She had impeccable taste," he says, for artistry both highbrow and low, clothes to antiques to fine art. They frequently visited museums together, primarily quirky, small-town places, where works befitting royalty might mingle with items more suited for garage sales. Breitwieser and Anne-Catherine didn't care which was which. They judged each piece by its emotional tenor and usually toured the rooms in reverent silence. Just being present with her made the world brighter. "We could read each other's reactions," he says, "so there was no need to speak."

When so much in his life collapsed, she was there to support him. A few months after they began dating, his parents split and he moved with his mother from the mansion to the Ikea apartment. Anne-Catherine seemed to feel that their relationship was strengthened by his troubles, as if they'd gone through a trial and passed, and she began spending most nights with him in the apartment, sharing a narrow mattress on a blue plywood frame. This was before they lived in the house with the attic. Movie posters were pinned to the walls; *Rain Man*, with Dustin Hoffman, was one he remembers. They were well paired temperamentally, he says. His emotions swung wildly, while she tended to remain centered and calm. "The world could crumple around her," says Breitwieser, "and she would stay placid." Career-wise, they struggled. Anne-Catherine had been studying to become a registered nurse, and he had enrolled at the University of Strasbourg in undergraduate law. Breitwieser dropped out after a semester, and Anne-Catherine did not pass the nurse's test, settling for a job as an aide, responsible for tasks like changing bedpans and collecting the trash.

One late spring weekend in 1994, they visited the Alsatian farming village of Thann, a cluster of homes, bowed with age, surrounding a Gothic church with a soaring stone steeple. The local museum is in a renovated sixteenth-century granary. When the couple reached the second floor, Breitwieser felt his eyes drawn to a display case, and a sensation thundered through him, shaking his heart—*coup de coeur*.

It was a flintlock pistol from the early eighteenth century, hand carved in walnut, with silver inlay ornamenting the barrel and grip. His first thought was that he should already possess something like this. His father owned a few flintlocks. They were Breitwieser's favorite pieces in the family collection, and his father knew it. He hadn't seen one of them since the day his father had packed up and left. Breitwieser had previously tried to replace a few of his father's possessions by attempting to purchase similar items at nearby auctions, but he'd been repeatedly outbid by deep-pocketed dealers. The dealers then offered the works in their shops, often at ten times the price. "Which is obscene," says Breitwieser.

He stared at the pistol a long time. Then he didn't want to look at it anymore. He wanted to take it home. This pistol, he whispered to Anne-Catherine, was older and nicer than anything in his father's collection. "It would be the ultimate 'fuck you' to my dad." Anne-Catherine's relationship with her own parents was warm, but she sympathized with the fury Breitwieser bore toward his father. She had met his father herself, and they hadn't gotten along, according to Breitwieser; his father, he says, had come off as snobbish about Anne-Catherine's humble origins.

The access panel on the display case with the pistol, Breitwieser pointed out to Anne-Catherine, did not have a lock. Three years had passed since his brief, post-high-school stint as a museum security guard, but he'd retained an eye for such details. There were no other visitors around, no alarms, no cameras, no guards. The museum's sole employee, a student on summer break, was downstairs on the ground floor. Breitwieser was wearing a backpack that day, a small schoolbag, but he thought it was roomy enough to work.

Anne-Catherine's response, says Breitwieser, marked the moment from which there would be no turning back. They were both twenty-two years old. When he'd met Anne-Catherine, Breitwieser had been acting like a petty criminal, shoplifting goods and wrestling police officers. Anne-Catherine had never experienced any run-ins with the law, but that didn't mean she found his behavior off-putting.

"His scoundrel side may have actually attracted her," muses her confidant, the attorney Braun. And here, in front of the flintlock pistol, was a chance for further adventure. Anne-Catherine could impress her rebel boyfriend, feel closer to him, and perhaps be loved by him all the more. She could indulge in a youthful fantasy, say some of those who know her, of becoming a little like Bonnie and Clyde.

"Go ahead," said Anne-Catherine. "Take it."

6

He slid open the display-case access panel, slipped his hand inside, and grabbed the pistol. He shoved it in his backpack. "I was terrified," Breitwieser says. He and Anne-Catherine, not thinking what their behavior might reveal, dashed from the museum and sped off. They drove past rolling vineyards and wheat fields, expecting to hear sirens. "I also felt panicked and sick," he says, but they made it back to his apartment without incident.

Breitwieser dampened a soft cloth with lemon juice and buffed the pistol. He'd learned from an art magazine that citric acid brings forth a shine. The brilliance of the piece lit up the room, and for a while even the Ikea furniture appeared a little less ludicrous.

In the museum they'd made no effort to disguise themselves. It was an impulsive act, he says, a hit and run. They'd left so many clues of their crime that officers would surely arrive at their door, he thought. Once, queasy with fear, they discussed getting rid of the pistol but persuaded themselves to wait. Every day for weeks they scoured the local press and saw nothing on the theft. Maybe officers would not arrive at their door. Fear softened to tension, then eased to relief. Still no police. Soon a measure of pride crept in, and after that some pleasure.

The pistol was too exquisite to be concealed in the blue plastic box. Breitwieser slept next to the gun, and occasionally felt the desire to kiss it, he admits. By the time he reached the level of *fou de joie*, crazy joy, the anger he'd harbored for his father was exceeded by the happy triumph of possession. As for Anne-Catherine, partner in love and crime, they were soulmates, he felt, destined to be together for life.

The whole whirligig, swiping the pistol to swinging from terror to joy, was worth experiencing again. With a few behavioral tweaks, Breitwieser knew they could mitigate much of the risk. To hell with auctions; Breitwieser would amass art his own way. On a cold February day in 1995, nine months after the pistol theft, he and Anne-Catherine drove into the Alsatian mountains, to an imposing, fortified castle with redsandstone towers and a moat. The castle was built, in the twelfth century, at a contentious crossing of trade routes wheat, wine, salt, silver—and had been turned into a museum of medieval life. He'd visited the museum many times as a kid, a place where he'd been dropped off by his parents. He had a vision of what he wanted to steal.

"You are very brave," said the cashier at the ticket counter. She explained that the unheated castle was frigid in winter. Breitwieser didn't mention that it was precisely because the place was cold and unlikely to have many visitors that they'd come this time of year. In a museum as vast and rambling as this castle, Breitwieser had figured, the lack of tourists, if he acted discreetly, would be advantageous for stealing. He was wearing the same backpack he'd used in the pistol theft, and Anne-Catherine shouldered a large purse.

In the hall of weapons, he spotted a crossbow out of his childhood dreams. On expeditions with his grandfather they had found scraps of crossbows, but he'd always fantasized of discovering a whole one intact. Attached by a wire from the ceiling was a crossbow made of walnut and bone, embellished with an engraving of an eagle and leather tassels. He'd forgotten in his memories, though, a pertinent detail: the crossbow was too high to reach.

One of Breitwieser's criminal talents is his ability to conjure, on the fly, simple solutions to unanticipated problems at pressure-filled moments, a prison term on the line. Seeing no guards, taking advantage of the lack of tourists, Breitwieser carried a chair across the weapons hall and placed it beneath the crossbow. Anne-Catherine kept watch for a stray visitor or guard. He stood on the chair and unhitched the wire. A crossbow, he realized while cradling one in his hands, is *big*. The limbs of the bow stretched an arm's length apart, undetachable. This weapon was not going to fit in any backpack or purse.

Another quick solution was needed. The castle had repelled outside marauders for a thousand years, but wasn't quite prepared, Breitwieser noted, for an invader to come from within. The few windows in the rooms, tall and thin, appeared just wide enough. They could be forced open, he found, with a little effort. He peered out a window in the weapons hall: a two-story drop onto rocks; no good. He could see, craning his neck, that it wasn't the same all around. He moved the crossbow to another room and wrenched open a window there. Again a long fall, but with bushes below. Crossbows, intended for battlefield use, are sturdy. He maneuvered the weapon out the window and let go.

They dallied a little, so as not to rouse suspicions from the guards but not so long that someone would note the dangling wire in the weapons hall. Breitwieser and Anne-Catherine then exited the castle. She warmed up in the car while he followed the outer ramparts through a boggy forest. A nimble hiker, he quickly recovered the weapon undamaged.

Once they returned home, they were initially gripped by fear, as with the pistol theft. This time, the local newspaper, *L'Alsace*, did write about the crime. The crossbow, he discerned from reading the paper, was not noticed missing until days after their visit, and the police reported no suspects. The article buoyed him, so he and Anne-Catherine clipped it and glued it into a scrapbook. They were proud of what they'd done, he says, and for their second theft the journey from distress to joy passed swiftly.

His parents' divorce was finalized soon after. Breitwieser's mother used the settlement to purchase a house in the suburbs, and she agreed that her son and his girlfriend could stay in the attic. She'd even cook dinner for them frequently. His mother could be fierce, but by profession she was a pediatric nurse. Caring came naturally. And she never pressed him too firmly, says Breitwieser, about what he was doing with all his free time. "Except at meals, my mother and I tried to live separate lives."

As a housewarming gift, his grandparents gave him the

extravagant four-poster bed, which he and Anne-Catherine outfitted in velvet and silk. No more Ikea, Breitwieser vowed, and no more movie posters either. They displayed the flintlock pistol and crossbow near the bed, the start of a decor that he hoped would ultimately offer a sensation of old-world glory, like a room in the Louvre. The project clearly had a long way to go, for what they saw most, looking around their new place, was an abundance of hungry blank walls. 7

Still in a celebratory mood a few weeks after the crossbow theft, Breitwieser and Anne-Catherine set off to go skiing. The trip, in early March 1995, is funded by Breitwieser's grandparents, who continue to supply him with money. Ski gear in the car, the couple stops along the way at Gruyères Castle in Switzerland, a thirteenth-century fortress, now a museum, overlooking the jagged ridgelines of the central Alps. They pay for tickets in cash and enter in their usual way.

Have they come here explicitly to steal? No, Breitwieser will say, about this and every theft. They've arrived only to look. But this is just a psychological trick, he admits, so they feel less pressure walking in and nerves won't give them away. The correct answer is yes.

A long-standing Breitwieser habit is to pick up museum brochures wherever he sees them. He gathers them by the armload at tourist bureaus and hotel lobbies. When he visits libraries or browses newsstands, he thumbs every art magazine he can find. He subscribes to the French weekly art journal *La Gazette Drouot*.

Sometimes, in one of these pamphlets or publications, an image of a piece leaps out at him. Fingers twitchy, he reads the accompanying article or caption and makes a mental note of where the artwork is located. With museums he has visited before, even as a kid, he remembers vividly the works that have most affected him. These pieces too are on his mental list. As often as they can, Breitwieser and Anne-Catherine travel to see one of the works. When Anne-Catherine is able to take a full week off from the hospital, Breitwieser charts a route and they embark on a road trip, stringing several mental-list pieces together.

That's the extent of their planning. All he needs is a visual cue and a destination. The rest unfolds more or less improvisationally, the pace of their crimes determined by tourists and guards, his hands always ready to strike. More than half the times they visit a museum, the conditions are overly dangerous for thieving—too many guards, surveillance cameras, visitors—or he sees no work of art inspiring enough to take, and they leave empty-handed. When they do steal, Breitwieser is never sure of their exact escape route, through the museum or on the drive home. He follows his instincts. Often on road trips they'll chance upon a museum unknown to them and drop in. If he sees a work that's suitably rousing, he'll attempt a spontaneous theft. His only dedicated tool is a Swiss Army knife made by Victorinox, a wide one packed tightly with gadgets.

Curling around the stone stairs of a turret in Gruyères Castle, Breitwieser sees the artwork that inspired their skitrip stopover. It's a small oil portrait of an elderly woman wearing fine jewelry, her head covered by a shawl, her visage both noble and melancholy. The wall label identifies the painter as the eighteenth-century German realist Christian Wilhelm Ernst Dietrich. The piece has been painted on a wood panel. Breitwieser doesn't know anything about the artist. He isn't even aware yet that works from this era were usually painted on wood, because canvas was rare and expensive. But he stands before the piece bewitched. He says that he can feel the texture of the ruffled collar, tight on the old woman's neck, and unbearable intimacy when he looks into her eyes.

Breitwieser has studied Stendhal syndrome, mostly from art-theory books he's borrowed from a library. He has always been a voracious reader on topics that fascinate him. Anne-Catherine, busy all day at the hospital, does not have time for this sort of detailed study. Nor, say those who know her, does she have much interest. She leaves the brochures and the research to him.

The French writer Stendhal, in his 1817 travelogue, *Rome, Naples, and Florence*, described an incident that took place in Florence's Santa Croce basilica. Inside a small chapel tucked within the vast church, Stendhal tipped his head back to absorb the vaulted ceiling's spectacular frescoes. He was overcome, he wrote, with "celestial sensations" and "impassioned sensuality" and "the profoundest experience of ecstasy." Fearing that his heart might burst, Stendhal fled the chapel, stumbling and faint, and sprawled on a bench outside and soon recovered.

In the 1970s, Graziella Magherini, the chief of psychiatry at Florence's central hospital, began documenting instances of visitors who had become overwhelmed by art. Symptoms included dizziness, heart palpitations, and memory loss. One person said she felt as if her eyeballs had grown fingertips. Michelangelo's iconic sculpture of David was one of the more common triggers. The effects lasted from a few minutes to a couple of hours. Magherini advised bed rest and sometimes administered sedatives. The patients were all cured after staying away from art for a while.

Magherini compiled more than one hundred cases, divided evenly among men and women, most between the ages of twenty-five and forty. Those who experienced the sensation were prone to repeat occurrences in front of other artworks. Magherini published a book on the disorder and gave it a name: Stendhal syndrome. The condition has since been widely reported; Jerusalem and Paris seem to be hot spots. But outside Florence the information is only anecdotal, and the condition remains an unofficial one, not listed in the *Diagnostic and Statistical Manual of Mental Disorders*.

Breitwieser says that when he learned of Stendhal syndrome, he felt a shock of recognition. Here, documented by a doctor, seemed to be a description of his *coup de coeur*. He was grateful to discover that he wasn't alone, slightly less alienated from the human race.

Breitwieser does not react to every artwork, not nearly, but when he is transported, the response is instinctual and rapid and often hypnotically strong. "Art is my drug," he declares. Breitwieser says he is puritanical about actual drugs: no tobacco or caffeine, no alcohol except a sip of wine when politeness requires, and never marijuana or anything harder. But a pure dose of art can set his head spinning. When asked about Breitwieser's claims of Stendhal syndrome and art as a drug, many people in the art world, as well as most police inspectors, say he's lying. Stendhal syndrome, some argue, is merely a fancy name for jet lag or heat exhaustion. What Breitwieser is really addicted to, his detractors say, is stealing. He's a glorified shoplifter; he's a kleptomaniac.

Breitwieser furiously denies this. He does not enjoy his thefts, he insists. He cherishes only the results. His compulsion is collecting, not stealing. Weighing in on what kind of thief he might be is the Swiss psychotherapist Michel Schmidt, who visited with Breitwieser several times in 2002 and issued a thirty-four-page assessment. Breitwieser is clearly a menace to society, Schmidt says, and self-deluded by thinking that his crimes are in any way justifiable. But nothing in the therapist's report supports the idea that Breitwieser is a pathological liar or a compulsive thief.

A kleptomaniac, Schmidt cautions, does not care about the specific objects stolen, just the act of stealing itself. Also, a theft by a kleptomaniac is typically followed by a letdown steeped in shame and regret. Breitwieser is the opposite. He is selective about his loot and exults in his criminal success. "I exclude a diagnosis of kleptomania," Schmidt states. The psychotherapist believes that Breitwieser truly steals for the love of art.

Breitwieser's blind spot is for perceiving how others see him. The only reason he's considered a common thief rather than appreciated as a special case, Breitwieser says, is that the police and psychologists, along with most everyone in the art world, are aesthetically impotent. They're incapable of comprehending the potency of a Stendhal reaction, and this frustrates him. He knows how he feels, but how can he prove it? In the turret of Gruyères Castle, gazing at the Dietrich portrait, he describes himself as "stunned and amazed." He stares at it for ten minutes, unable to move. After that he knows what to do. Security cameras have not been installed in the turret; Breitwieser is often pleasantly surprised that regional museums are sparsely protected. No guards or visitors are near. He pulls his gaze from the portrait and glances at Anne-Catherine. She certainly likes the style of art preferred by Breitwieser, but not in an intense, Stendhal syndrome sort of way. She seems to have a greater attachment to her boyfriend. Anne-Catherine responds to his look with one of her own, signaling consent.

He tugs down the picture and extracts the four thin nails on the back that attach the painting to the frame. For this task, he uses the edge of his car key—a secondary, unofficial tool, supplementing his Swiss Army knife. He stashes the frame higher up in the turret, and pockets the wall label. There's nothing he can do to hide the clean spot, the size of a pizza box, now imprinting the wall.

Breitwieser and Anne-Catherine walk out of the castle together, his jacket covering the work—their third theft as a couple, and their first painting. They endure the long trek through the medieval village of Gruyères, to the car park. They cushion the piece in a suitcase and drive off, only to pull over later and admire the portrait more. Then they head to the ski slopes. 8

Stealing from three museums, inside a year, is already a considerable feat. Most thieves are enticed by museums just once. Even if they aren't caught, a successful heist is usually challenging enough.

The man who took the *Mona Lisa* first labored as a handyman at the Louvre for eight months. Wearing his work uniform, Vincenzo Peruggia entered the museum with the rest of the staff, at 7:00 a.m. on a Monday in August 1911, a day the museum was closed to the public for cleaning and most guards were off duty. One of Peruggia's tasks had been to reinforce security on valuable works, which is how he knew the precise moves needed to detach the *Mona Lisa* from its four bolted hooks. Then Peruggia ducked into a spiral service stairwell, removed the frame, draped a sheet over the poplar panel— Leonardo painted on wood—and carried the only work he would ever steal onto the Paris streets.

At the Boston Museum of Fine Arts, in 1975, seventeen people—lookouts, drivers, gunmen, muscle, thieveschoreographed an elaborate raid to capture a Rembrandt. The heist was coordinated by the New England criminal mastermind Myles Connor Jr., who was a member of Mensa, a guitarist who once toured with the Beach Boys, and a thug who shot and wounded a policeman during another of his thefts.

In 1985, two burglars in Mexico City scouted the National Museum of Anthropology for fifty days over the course of six months, studying every intricacy of the building's layout and security. On Christmas morning, before dawn, they crawled into the museum through an air-conditioning duct, filled a canvas bag with Mayan and Aztec artifacts, and snuck out the same way they'd come in. They never triggered an alarm or encountered a guard.

The Swedish National Museum job of 2000, performed by an international team with criminals from Sweden, Iraq, and Gambia, began with a pair of coordinated car explosions that panicked central Stockholm and blocked access to the museum. The robbers, already on the museum grounds, held the staff and visitors at gunpoint and removed two Renoirs and a Rembrandt. By the time police pushed through the wreckage, the thieves had escaped on a speedboat, out of the city and across Stockholm bay. They abandoned the boat, transferred the loot to a car, and drove away.

The real problem with most museum thefts, though, goes beyond prep work or logistics. The issue is that after you thwart security systems, unlatch displays, circumvent guards, and sneak the art out, your headaches have only begun. A unique and traceable item, whose image will likely appear on the news, cannot safely be seen by anyone. It's a burden. Displaying a stolen work is risky, and trying to sell one elevates the risk far more.

Peruggia, the *Mona Lisa* thief, hid the painting in his Paris apartment, wrapped in red silk at the bottom of a trunk, buried beneath carpentry tools. He was interrogated by French inspectors, along with all Louvre workers, and Peruggia's calm demeanor and willingness to cooperate, police later said, eliminated him as a suspect. Peruggia waited two and a half years. Then he decided to sell one of the world's most well-known paintings to an Italian dealer who advertised that he bought "art objects of every sort." Peruggia was arrested immediately. The *Mona Lisa* returned to the Louvre unharmed.

The seventeen-person crew, the air-duct escape, and the car bombs might have been impressively cinematic, but nearly every item stolen in those capers was recovered. Most of the thieves went to prison. For the majority of the bandits, it was the only museum crime of their lives. The one major exception is Myles Connor Jr., the Mensa member who organized the seventeen people on the Boston museum team.

Connor, whose father was a police sergeant and his mother a painter, robbed at least a dozen museums in New England in the 1960s and '70s. Connor also spent more than a decade in federal prisons, but he is still among the historical greats. He qualifies for art crime's Mount Rushmore. In the three hundred years that public museums have existed, very few individuals or gangs have pulled off a dozen or more heists.

In April 1995, a month after raiding Gruyères Castle, Breitwieser and Anne-Catherine return to Switzerland. The nation's artistic and natural grandeur is Breitwieser's vision of paradise, beauty inside the museums and out. Touring the heavily guarded Fine Arts Museum in the riverside town of Solothurn, Breitwieser strikes, lightning swift—"just enough time for a flick of my hand"—and grabs a religious painting from the sixteenth century. The icon, part of an altarpiece, portrays the early Christian theologian Saint Jerome, known for his sermons on how to live morally. To plunder art is unholy, Saint Jerome wrote, and doubly so for religious works.

The Saint Jerome theft is quickly noticed, though not quick enough. The couple has already departed the museum. Breitwieser believes that their high-toned criminal style, brandishing Hugo Boss suits and Chanel skirts instead of Uzis and bombs, greatly reduces the chance of being identified by witnesses. Crime works best, he says, not with overpowering force but when nobody knows it's being committed. In a museum he often thinks of himself as a hunter, camouflaged behind stylish clothes. If no one in a bustling museum can describe the thieves, or each points a finger at another, then nearly everyone is a suspect. Newspaper accounts of the Saint Jerome theft say that the authorities are unable to agree on how many perpetrators took part, or what any one of them looks like.

Breitwieser and Anne-Catherine attempt to gather every news report of their crimes. These dispatches are their chief source of information for how close the authorities may be to identifying them. So far, through four museum thefts—a pistol and crossbow in France, a painting and the Saint Jerome icon in Switzerland—no inspector, as far as Breitwieser can tell from the newspapers, has linked the crimes or expressed alarm that serial thieves may be active. The articles are added to the couple's scrapbook, which they store on top of the canopy over their four-poster bed. Breitwieser often brings the book down to reread the pieces and gloat. He imagines that any police officer inspecting their crimes would consider them aristocratic and honorable thieves.

To afford their attire and travel, the couple is frugal. Many of their clothes are purchased used at Emmaüs shops, French versions of Salvation Army stores. For most items, he pays the equivalent of ten U.S. dollars or less. In addition to funds from his grandparents—who often provide more than a thousand dollars a month—he receives money, along with free room and board, from his mother. He mainly collects unemployment, and Anne-Catherine brings home about fifteen hundred dollars a month. It's enough to get by.

All of their thefts as a team have occurred on weekends, to accommodate Anne-Catherine's job. Her risk tolerance is lower than his. Several times in a museum, Breitwieser has been ready to steal and she has said no. She's more cautious about guards, tourists, and security cameras; though she doesn't show it on her face, he says, she's often quite nervous inside museums, and she has a definite size limit, no matter how lax the security or how strong his will. Paintings must fit flat against his back, a maximum of about a foot and a half on each side, unframed. Sculptures need to be smaller than a brick to avoid too much bulging in a jacket, backpack, or purse.

Anne-Catherine's best thieving skills seem to be the opposite of his expertise. Where Breitwieser has an uncanny ability to spot security flaws, Anne-Catherine intuits the strengths. She's aware, more than him, of people who appear to observe them suspiciously. He tends to be laser focused; she takes in the whole scene. This yin and yang is central to their stealing prowess. Breitwieser typically terminates a theft when she wishes, with only a little argument. "I trust her instincts," he has said, multiple times, in media interviews. Yet if a piece remains lodged in his thoughts, he will sometimes return to a museum alone while she is at work. He tells her about it, or she sees the new piece in their attic. Anne-Catherine tolerates these missions, Breitwieser says, though not enthusiastically.

On a solo outing, he nabs a large wooden lion with a lamb pinned beneath its paws, an allegory of sacrifice atoning for sin. The carving is marvelous to behold, but under his jacket it's a cinder block. He cradles it in front of him like a belly and waddles away. Breitwieser feels that he can make himself almost invisible in museums. He's shorter than average, scarcely five feet nine, lithe and springy as a willow branch, with pale skin, dark brown hair, and a baby-cheeked face. He blends into a room, conforms to its contours. He can steal while people, even guards, are near.

"An extraordinary thing about Stéphane Breitwieser," says Michel Schmidt, the Swiss psychotherapist, "is that he is so ordinary he can go unnoticed." Only his eyes are striking, big and piercing and sapphire blue, accented by thick brows. For all his clever secrecy, Breitwieser's eyes are revealingly readable, windows to his soul and front doors too—wide with unrestrained wonder in the presence of beauty, quick to leak tears of joy, or of sorrow; he cries quite a lot.

Anne-Catherine would never consider stealing without

Breitwieser present. Her eyes are usually difficult to read. She seldom touches a piece before it leaves the museum. He'll use her purse maybe one theft in ten. She is not exactly a thief, but she's *not* not a thief either. She's more like a magician's assistant, hovering in the background during a trick, making sure the overly curious are gently diverted. She also reins in, when necessary, her boyfriend's exuberance, and occasionally aids him.

One time, while parking the car near a museum in France, Breitwieser announces to Anne-Catherine that he's going to take a day's break from stealing, and leaves his Swiss Army knife in the vehicle. But he's soon infatuated with a poignant charcoal drawing of a Christian apostle. The drawing is exhibited flat on a table beneath a plexiglass sheet, with a screw at each corner. Anne-Catherine rummages through her bag and hands him a nail clipper. Using the handle of the clipper, Breitwieser manages to remove two of the screws. He pries up the plexiglass, but his fingers can't fit under. Anne-Catherine's can, so she slides the work free. Her boyfriend carries it out.

Breitwieser realizes that crimes committed with Anne-Catherine are safer than solo trips, and if he's in it for the long run, he should wait for the weekends. Which he does, mostly. In the spring and summer of 1995, only a year after their first museum theft together, Breitwieser and Anne-Catherine find an incredible rhythm. They steal at a pace as fast as any known art-crime spree has been committed, outside of wartime. They hop between Switzerland and France, trying to keep at least an hour's drive, and preferably two or three, between any places they hit. Even if they have to visit a couple of spots, museums are everywhere in Europe. And about three out of every four weekends, they successfully steal—a seventeenthcentury oil painting of a war scene, an engraved battle-ax, a decorative hatchet, another crossbow. A sixteenth-century portrait of a bearded man. A floral-patterned serving dish. A brass pharmacy scale with little brass weights.

This completes for him one dozen thefts. Breitwieser is not motivated by his historical art-crime ranking, but he is aware of it. He wants to own better art than his father's, and more of it. And gloriously adorn the walls of his attic, and see ever more treasure as he's entwined in bed with Anne-Catherine. He hopes as well to satisfy some hole inside him, though no matter how much he steals, the emptiness never feels filled. 9

On a Monday after a weekend theft, Anne-Catherine heads off to work and Breitwieser goes to the library. He drives to his local branch in Mulhouse, or the Museum Library in Strasbourg, or the art-history collection at the University of Basel in Switzerland. Usually over the course of a week, he visits all three.

At the library, he starts with the basics—artist, era, style, region—by reading dozens of entries in the *Benezit Dictionary of Artists*, France's extravagant gift to inquisitive art buffs, twenty thousand pages across fourteen fat volumes. He scrutinizes an artist's catalogue raisonné, an annotated listing of all known works. He traces a painting's provenance and learns about the previous owners. He reads in German, English, and French. He does this all day when he doesn't have a temporary job, or he's not out stealing.

Each stolen piece is assigned its own folder, which he stores in a filing box in the attic. The folders contain photocopied reference-book entries, index cards scribbled with notes in his schoolboy cursive, and his agile line drawings labeled with details and dimensions. His personal art library, funded by his grandparents and also kept in the attic, eventually surpasses five hundred books. He reads academic papers on silversmiths, ivory carvers, enamelists, and sword builders. He researches iconography, allegory, and symbolism. He's committed to learning everything possible about crossbows. He devours history books. He's read more than five thousand pages, he says, on Alsace alone.

After he steals the ivory *Adam and Eve*, he studies for days to get a feel for its maker. Georg Petel was an orphan, raised in Bavaria, with a precocious gift, able to form solid works that appeared silky and pliable. Petel's talent so impressed the German royal family that he was invited to serve as a court artist, an easy road to career success. But Petel declined, preferring instead to push the creative boundaries of his time and travel free-spiritedly. In Antwerp, he met Peter Paul Rubens. A generation older, Rubens offered mentorship and advice, and Petel, in gratitude, gifted him *Adam and Eve*. Petel, however, never had a chance to discover the full depths of his mastery. In 1635, he died of the plague at age thirty-four.

The more Breitwieser reads, the more he covets. He and Anne-Catherine maintain their intense thieving tempo, and sometimes exceed it. At Spiez Castle, on the shore of a Swiss lake, during an August weekend in 1995, they steal two pieces at once—a sixteenth-century knight's helmet fits snugly into his backpack, and a handblown hourglass nests in the helmet. Then they steal from two different museums on the same day, once before lunch and once after.

They are natural thieves, attuned to risk, uncommonly

calm. Some of their achievement, though, is due to an uncomfortable truth: many regional museums rely for security, to a shocking degree, on public trust. Protecting a museum can feel paradoxical, because its mission isn't to conceal valuables but to *share*, in a way that makes you feel as close to a piece as possible, unencumbered by any security apparatus. Permanently ending nearly all museum crime would be easy: lock the works in vaults, and hire armed guards. Of course this would also mean the end of museums. They'd now be called banks.

As Breitwieser seems to point out every time he's in one, museums struggle to offer intimate encounters with art. Adding more guards, more security cordons, more fortified display cases, more glass-fronted picture frames, and more electric eyes is not likely to improve the experience. If it seems that many of the museums Breitwieser plunders are dangerously unprotected, that's because they are.

Directors of small-budget museums don't like to talk about security, but these institutions, rather than allocating funds for the latest protection measures, such as tracking devices as thin as threads that can be sewn into canvases, instead almost always opt to acquire more art. New works, not better security, draw crowds.

In regional museums, there's sometimes an implicit social pact in force. The museum will permit close access to priceless objects that are marginally secured. And the public, in turn, will leave these objects undisturbed, respectful of the idea that works of communal heritage, often suffused with spiritual significance and a sense of place, should be open and accessible to all. Breitwieser, with the support of Anne-Catherine, is a cancer on this public good. He rewards himself and deprives everyone else.

Even if a museum does everything right, devoting funds and effort to proper security, this still might not stop Breitwieser. In September 1995, he and Anne-Catherine visit a museum on the campus of the University of Basel, near his favorite Swiss art library. The work he's after, featured in a brochure, is one of the museum's showpieces—an eccentric oil painting by the Dutch golden age master Willem van Mieris, depicting an apothecary and his assistants preparing a potion. The work is composed in an effusive style, realistic and yet absurd, as evidenced by the apothecary's assistants: a child, two angels, a parrot, and a monkey. As soon as Breitwieser sees the painting, he's joyfully smitten. He can't help but smile.

A security camera is pointed directly at the valuable work. Breitwieser and Anne-Catherine can regard the painting from outside the view of the lens, but the presence of a camera is normally enough to annul any theft. Breitwieser has observed, though, an empty chair that has changed the equation. He's informed Anne-Catherine about the chair, and wonders if this will be enough to persuade her to bend her rules. He has noticed, as well, that Anne-Catherine has also reacted positively to the apothecary painting. The air of stoicism she usually maintains during a theft feels lighter this time. The painting seems to have a bubbly effect on both of them, aesthetic champagne. She might enjoy, as much as him, seeing this piece from the warmth of their bed. Anne-Catherine permits him to continue with his plan.

Positioning his back squarely to the camera lens, staring

straight ahead and not shifting his neck a degree, Breitwieser cautiously approaches the painting. He walks into the camera's field of vision, purposely allowing himself to be filmed. He reaches gingerly behind the apothecary painting with one hand and releases the wire from the wall hook, while his other hand keeps the work pressed to the wall.

Maintaining his strict back-to-the-camera position, he stiffly shuffles a few steps to his left, sliding the work horizontally along the wall until he's out of range of the lens. Then he detaches the frame. The three conjoined wooden panels that the work is painted on are slightly bigger than he'd expected, unable to fully fit under his coat or in her purse. Anne-Catherine is carrying a large paper shopping bag from an earlier purchase, and Breitwieser, out of options, wedges the painting inside, poorly concealed. He takes the bag and they break for the exit, scarcely fifteen minutes after they'd arrived.

In many museums, the video-monitoring booth is located in the private area behind the entry desk. As you buy tickets, there's often a chance to glance inside. Entering the University of Basel museum, Breitwieser noted an array of small screens displaying live feeds, including one centered on the apothecary painting. He knew from his time as a museum guard that there may be only a few people on a security staff trained to use the camera system. Sometimes there's just one on duty. Even without backup, that one guard is permitted to eat and rest, outside the video-monitoring booth.

Breitwieser had seen this in museums before, but hadn't yet figured out how to benefit from the situation. As he and Anne-Catherine arrived at the University of Basel museum, a little past noon, the screens in the security office were playing to an unoccupied chair. This time he had an idea.

He was willing to be filmed, so long as no one was watching. He had to be confident, as well, that neither his face nor hers would be captured on any other cameras. They also needed to leave the museum before the lunch break ended and the video-room official, noting that the camera turned to the apothecary painting was now recording a blank wall, sounded the alarm. Breitwieser's idea worked. The theft is discovered only after the couple is gone. Anne-Catherine and Breitwieser had successfully avoided every camera, except one. And when that one video is replayed, all that officers can see is the back of a slightly below-average-sized male with cropped brown hair in a plain gray summer-weight overcoat. Mr. Ordinary, unidentifiable. 10

The morning of Breitwieser's twenty-fourth birthday, Sunday, October 1, 1995, his car is full. Anne-Catherine, his mother, and one of her dachshunds join him in his compact blue Opel for a trip across the German border. They stroll in the Black Forest, confettied with fall foliage, then drive past the spas of Baden-Baden to the monumental New Castle on top of a hill; it's called new, but this is Europe. The castle is six centuries old.

They walk across a drawbridge and onto the New Castle grounds. Sotheby's auction house is hosting presale viewing for an estate auction, an immense one, with items displayed across all 106 rooms of the castle. Breitwieser mail ordered the auction catalog in advance, and an image had hijacked his mind. He can gift himself a birthday present of such stature that it would elevate the attic to a new level of greatness. Except his mother is with him.

Breitwieser insists that he and his mother hardly interact. But this is only in comparison to his youth, when they formed a tight pair, mother and son united against a judgmental father. Even now, though, they live in the same house. There's no bathroom in the attic so he and Anne-Catherine descend frequently. The three of them dine together about every other night, and once a week they travel as three to his grandparents' place. His mother is on his birthday trip. That makes for a lot of hours during which the topic of stealing art, the central activity of his life, is never mentioned, according to Breitwieser. There must be awkwardness between them.

He swears there is not. Breitwieser says that he is able to smoothly cover up all of his criminality. His mother, Mireille Stengel, won't reveal how much, if anything, she suspected. Stengel, like Anne-Catherine, will not consent to an interview with a reporter, so the details of his mother's home life, except for snippets Breitwieser has captured on video, are mostly opaque. Several times, however, Stengel has spoken at length with law-enforcement authorities, and these transcripts are available.

His mother does not join them inside New Castle. No dogs are allowed. Stengel leads the dachshund to the gardens while he and Anne-Catherine hurry in. The couple passes rooms with mounted elk heads, and ebony furniture, and cuckoo clocks, to the third-floor gallery with lot 1118. There he finally encounters the real item whose image has occupied his head—a sixteenth-century portrait of a princess, *Sibylle of Cleves*, painted by Lucas Cranach the Younger. Cranach and his father, Lucas Cranach the Elder, are among the greatest German painters of the Renaissance.

Breitwieser is hypnotized, he says, by the work's intense detail. "I see individual threads in her dress, and blue blood in

her veins." Painted on wood, unframed and small, about the size of a hardcover book, the Cranach is in pristine condition, likely worth millions. Sotheby's, dealing in valuables since 1744, does not skimp on security. An army of guards occupies the castle, one or more per gallery. The Sunday crowd is huge. *Sibylle of Cleves* is displayed on a tabletop easel, vivid as a sun in the center of the room, secured beneath a plexiglass dome. There's challenging, and there's suicidal. "Don't be idiotic," Anne-Catherine murmurs.

He concedes that this has the feel of "a kamikaze mission." Knowing when not to take an item, however deflating, is mandatory for a thief expecting career longevity. Stealing a work this notable would also cause a commotion, inviting extra police scrutiny. The couple still senses, from reading newspaper articles, that they are several steps ahead of the authorities. A theft like this could spur the police to catch up. Not nabbing a Cranach is good. Maybe the gift of restraint is his real birthday reward. They leave the portrait behind.

Breitwieser plods through further rooms, but his mind remains anchored in place. There are all those precisely painted jewels, embroidered on Sibylle's dress, winking like stars. There's the tiny winged serpent slithering at the bottom of the piece, the Cranach family insignia. The plexiglass dome covering the Cranach rests on a table, unlocked. He just needs to lift it. Conceivably, if he lies in wait near the work, he'll be able to pounce, silent and unseen, in the span of an eyeblink, then descend two floors past a dozen guards to the exit. Each individual move feels doable, and he thinks he can link them together. A birthday seems a fair time to reckon with one's abilities. They can't respectfully leave his mother outside much longer, but Anne-Catherine acquiesces to returning, briefly, to *Sibylle of Cleves*. The day is growing late, the crowds have thinned. The vigilance of the guards is waning. The security officer assigned to the Cranach room stands at the doorway conversing with a colleague. Already, an opportunity is forming. In a small gallery with tourists and guards, it's easy to see where everyone is. Breitwieser tries to visualize where each *will be*, and when he perceives an opening, one offering a few seconds, he looks to Anne-Catherine. She has been tracking the guards, and she nods, all clear, and he strikes.

He raises the dome, takes the Cranach, and tucks it between the pages of his auction catalog. Then, settling the dome back in place, he knocks over the little easel that had supported the work—a critical error. The plastic stand smacking against the hardwood table is a thunderclap in his ears. All he can do at this point is finish the action he's started, so he positions the dome atop the overturned easel and turns to face the consequences.

It's a chatty room, as luck would have it. Nobody seems to have noticed a thing. He and Anne-Catherine depart immediately, down the stairs, toward the exit. The guards at the doors are wearing jackets and ties and earpieces connected to radios. They might have already been informed of the crime. Breitwieser does not alter his stride or change direction, and neither does Anne-Catherine. Risk taking to them is an allor-nothing proposition, liberty or jail. No one grabs them, and they slip outside.

His mother is waiting with the dog, impatient, and they hustle over the drawbridge to the car. Breitwieser opens the hatchback and sets down the auction catalog shielding the portrait. Everyone folds themselves into seats. His mother doesn't appear to think anything is amiss. A jingle loops in his head—"I'm twenty-four years old and I have a Cranach, twenty-four and a Cranach!"—as he drives to his grandparents' farmhouse for a birthday dinner. 11

What is his problem?

He's not a kleptomaniac. Even if Stendhal syndrome was a certified condition, his crimes wouldn't come into better focus; of all the cases found by the Italian doctor who named the syndrome, none stole art. It seems as though there must be a severe psychological disorder ailing Breitwieser, some criminal insanity. He and Anne-Catherine have been stealing three out of four weeks for six months and counting, which is crazy, and Breitwieser says that the pace feels natural and sustainable, which is crazier. Maybe he can be treated and cured.

He can't, says the psychotherapist Schmidt—there's no criminal psychosis to treat or to cure. Other therapists agree. Breitwieser did not meet voluntarily with Schmidt, as with the other psychologists whose reports have been released. The examinations were forced on him by the judicial system, and the therapists were aware of his crimes. "Psychologists treat me like I'm a curiosity they're hungry to study," says Breitwieser. "They're all just big assholes." In 2002, Schmidt subjected Breitwieser to traditional meetings and a battery of psychological tests, including the Minnesota Multiphasic Personality Inventory, Spielberger's State-Trait Anxiety Inventory, and Raven's Progressive Matrices. Schmidt says that Breitwieser is a narcissist; he's an art thief who believes he is a literal seer, one of the chosen few who can perceive the true beauty of things, and thus entitled to all he desires, legal or not. Breitwieser disregards civility and law, Schmidt adds, without concern for others or remorse. And because Breitwieser never steals from private residences and does not incite violence, he sees his crimes as victimless.

"Not for a moment," Schmidt says, "does he consider what would happen to society if we all thought like him."

The Strasbourg psychologist Henri Brunner evaluated Breitwieser in 2004 and wrote that "he is surly, critical, demanding, and irritating—in a word, immature." Fabrice Duval, a psychiatrist Breitwieser saw in 1999, noted that "he shows impulsivity without considering the consequences."

Coddled by a mother who caters to his whims, he "has not learned to cope with the frustrations of the real world," Schmidt observes. In other words, he's a brat. Nothing about his personality is likely to change, says Schmidt, until Breitwieser respects authority, creates social bonds, stops stealing, and willingly undertakes intensive therapy. Schmidt can't envision any of this happening.

Anne-Catherine spoke with the French psychologist César Redondo in 2002, also at the behest of the court. Redondo wrote that Anne-Catherine has a "satisfactory intellectual capacity"—a psychology phrase that sounds insulting even if it's not—and a "fragile personality," susceptible to control. Anne-Catherine, suspected Redondo, had been manipulated by Breitwieser into joining his art-stealing perversion, and "she simply didn't have the strength to say no." Anne-Catherine exhibits no severe psychological deficiencies and is not a criminal threat on her own, Redondo said, though he advised her to begin psychotherapy immediately.

Breitwieser, the therapists agreed, is not detached from reality. He knows right from wrong. His intellectual capacity is satisfactory. Neither his depressive episodes nor his mood swings, Schmidt says, rise to the level of clinical disability. He does not have a genuine social phobia, as evidenced by his ability to work as a waiter, even infrequently. Brunner, the Strasbourg psychologist, says that Breitwieser displays no psychological or neurological anomaly that could alter his judgment. Breitwieser has full command of his actions, and theft in itself, Brunner clarifies, is not a symptom of an illness. This gives the psychologists little purchase on which to raise an argument that Breitwieser has any criminal psychopathy at all.

Schmidt says that Breitwieser shows signs of narcissistic personality disorder and antisocial personality disorder. Both disorders are common in felons but offer no explanations for the roots of Breitwieser's criminality. Brunner takes a guess and says that Breitwieser, for some psychological reason, is unable to fend off temptation. Everyone thinks the same thing in a museum—*it would be great to have this on my wall*—but only Breitwieser is incapable of flicking the irrational idea away, a crumb for us is to him a boulder.

Breitwieser's original excuse for the thefts, avenging his father, no longer applies. His collection has exceeded his father's, exponentially. The attic hoard could easily stock a room at the Louvre. Anne-Catherine, seemingly captivated by the thrills, at least some of the time, and eager to please her boyfriend, willingly joins him on thefts at a world-beating pace, even if she never says that the attic is lacking in art and needs additional filling. Breitwieser, beyond reason it appears, continues to steal, as invigorated as ever if not more so.

Breitwieser insists he has reasons. During his library deep dives into art history, he often follows the threads of the crimes. The Horses of Saint Mark is not a work he could ever swipe, he says, but it is one reason he steals. The horses, a team of four near-life-sized copper stallions that convey a rousing sense of motion, were believed to have been made in Greece by the celebrated sculptor Lysippus in the fourth century BC, though experts are uncertain of the work's early history. The copper horses were pillaged by Nero's army some four hundred years later, and installed in Rome.

Constantine the Great grabbed them three centuries after Nero, and displayed the horses in the Hippodrome chariotracing stadium in Constantinople. There they posed, midstride, for nine hundred years. They were looted in the brutal Fourth Crusade of 1202 and placed on the facade of Saint Mark's Basilica in Venice, presiding for six centuries over the city's main square. Napoleon swiped them during his Italian campaign of 1797, paraded the sculptures through Paris on an open wagon, and had them mounted on an arch in front of the Louvre. Following the Battle of Waterloo, British troops confiscated the horses, but decided to return them to where they belonged. A case could be made for Greece, Turkey, or Rome. They went to Venice. The story of art, Breitwieser says, is a story of stealing. Egyptian papyri from the early written age decry the menace of tomb raiders. The Babylonian king Nebuchadnezzar II, in 586 BC, hauled off from Jerusalem the Ark of the Covenant. The Persians plundered the Babylonians, the Greeks raided the Persians, the Romans robbed the Greeks. The Vandals binged on the riches of Rome. Francisco Pizarro and Hernán Cortés, in the early sixteenth century, ravaged the Inca and Aztec. Queen Christina of Sweden seized a thousand paintings from Prague in 1648 and paid her generals in artwork.

Napoleon stole to endow the Louvre, and Stalin to stock the Hermitage. Hitler, an aspiring watercolorist who was twice rejected by Vienna's Academy of Fine Arts, planned a museum in his hometown of Linz, Austria, that would house every important work in the world. The foremost items in the British Museum, the first national gallery to open, in 1759 during the Age of Enlightenment, include the Benin Bronzes, seized from Nigeria; the Rosetta stone, smuggled out of Egypt; and the Elgin Marbles, chipped off the Parthenon in Greece.

Art dealers and auction houses are the worst, says Breitwieser, every one of them lower than dirt. The historian Pliny the Elder, in the first century AD, described the dishonest tactics of art vendors in imperial Rome, and in September 2000, Christie's and Sotheby's auction houses were levied \$512 million in fines for cheating buyers and sellers in a price-fixing scheme. Shady people have been peddling bright colors for two thousand years.

Each pilfered work represents another reason he steals, Breitwieser says, and everyone in the art world is a thief in some way. If he doesn't get what he wants, he expects others will. Some grab works by wiring cash to a dealer; he acquires pieces with a Swiss Army knife. At the very least, he's a formidable rogue in the art world's eternal den of iniquity. And perhaps when all is said and done, this is his dream, he will be written into the story of art as a hero. 12

After the Cranach theft at the Sotheby's auction and the birthday dinner at his grandparents' place, Breitwieser and Anne-Catherine and his mother return home. It's late at night; his mother retires to her room while the couple climbs upstairs, carrying an auction catalog. They unlock the door and bolt it again behind them. Then they huddle on the bed and remove *Sibylle of Cleves* from the catalog and balance the painting intimately on their palms, no frame, no glass, no crowd, no guards.

They regard the back of the portrait too, embossed with wax seals, each stamped with the coat of arms of a family that had owned it, charting the 450-year journey from Cranach's hands to theirs. Holding the piece, the one and only copy that will ever exist, he's infused with happiness, he says, released from the stress of the crime and able at last to fully savor a gift they intend to keep hidden from everyone else.

No one is allowed in their attic rooms, not ever, not once, including relatives and repair people. If something breaks, it remains that way or they fix it themselves. "A secret life," he says, "is an ideal life." He's a skilled handyman, a trait he picked up from his mother, who owns an extensive tool kit and is so adept at patching dents in walls that Breitwieser calls her "the queen of spackle."

Harboring stolen art absolves Breitwieser of the needless interactions that he'd at one time endured, when he still had thoughts of assimilating to the world—hanging out, drinking beer, gossiping, and other small pleasures of life that he sees as absurd. "Art has taken the place of society for him," says the psychotherapist Schmidt. Most people, Breitwieser finds, are uninteresting or untrustworthy, or both.

"I'm a natural loner," he says. In his mind, he and Anne-Catherine and the art form an equilateral triangle, everything balanced, nothing else needed. A fantasy of his is to run off with his girlfriend and the loot, and settle on an island like Robinson Crusoe.

Anne-Catherine is a bit more outgoing. She interacts with her coworkers at the hospital, and she has a couple of friends with whom she and Breitwieser occasionally socialize, though never at home, not even on the ground floor. One errant glimpse and everything is over. They usually go out and get sodas. Still, Anne-Catherine and Breitwieser cannot be honest about who they are and what they do; they can't be themselves, which poisons the idea of true friendship.

"The two of us," says Breitwieser, "exist in a closed universe." Except for art news and reports of their thefts, he hardly pays attention to the outside world. He reads volumes of history, not current events. The couple seems for the most part hermetically sealed in the attic, their lives engulfed with color and punctuated by thrills, yet also monochromatic. Anne-Catherine finds this wearying at times, say people who know her. Living lawlessly demands discipline.

Their universe contains a third inhabitant, orbiting involuntarily: Mireille Stengel, his mother. She's the extroverted one; her friends visit regularly. On Christmas Day 1995, three months after stealing *Sibylle of Cleves*, Breitwieser films his mother in the living room. She's wearing a red blouse and black leggings, her wheat-blond hair pulled into a bun, lighting tall candles in ornate silver holders, preparing for guests to arrive.

Christmas music is on the stereo, flowers spring from glass vases, the tree blinks with lights. Cheese platters and cakes crowd a cloth-covered table. Anne-Catherine is here too, in a black blazer over a black strapless top, with gold hoop earrings. Dimples pleat her cheeks as she tugs the video camera from her boyfriend's grip, then turns it on him.

"So tell me," says Anne-Catherine, inquiring about his New Year's resolutions. "What beautiful things are you going to do?" Breitwieser's gray polo shirt is buttoned all the way up, his hair swept back and center-parted. He interlaces his fingers and flattens his lips, assuming an expression of dignified formality.

"Pick my nose," he says. Breitwieser may enthuse over art like Stendhal and steal like a pro, but really he's still just a kid. "That's it. What else is there to do?" He lifts one hand and mimes drilling a nostril. "Anything else, and I go to prison."

He stares doe-eyed at the lens until his face dissolves into a toothy grin, charade over. Anne-Catherine keeps filming. Breitwieser falls silent for a while, resting his head on his right hand. Then he arches his eyebrows and announces, "I'm going to try to steal, if I can."

Anne-Catherine, behind the camera, encourages him to reveal more. "Paintings, weapons." He waves his left wrist casually. "Antiques." His resolution, he says, is to swipe art worth millions—dollars, euros, francs, whatever. Millions and millions. He'll cry, he says, if he isn't successful. "I won't feel right in my skin."

The living room is small, the whole house is small, and his mother is still there. Secrets need space. His mother has, she admits, spotted him carrying pieces upstairs. But that's it, Stengel later says under oath, explaining that when her son comes home from trips, he swiftly deposits the pieces in the attic and locks the door.

Even if the couple unfailingly sets the bolt, all the interior rooms in the home open with the same key. His mother has one on her key chain. Perhaps Stengel strictly keeps out of her son's room. Possibly she accepts that the couple buys everything from bric-a-brac shops. She might not have seen any piece long enough to suspect the truth. Breitwieser says that if you don't have a sharp eye for art, and sometimes if you do, it can be difficult to tell whether a work is priceless or fake. He says that his mother, unlike his father and him, has no inner drive to collect, or to acquire new items. She's worn the same watch all her life, he says. But it is clear from the home video that his mother has some idea of what's going on.

Breitwieser plucks the camera back from Anne-Catherine and zooms in on his mother as she glides through the room, chin high and spine straight, projecting elegance and poise. "Did you hear my speech?" he asks her directly, referring to his resolution to steal art worth millions. He knows that she did.

Stengel says nothing. She pivots away from her son and strides past armchairs upholstered in bold red and white stripes, over to the stereo. She bends down and increases the volume. Breitwieser calls out to her challengingly: "Did you just turn the knobs, Mom?"

The muscles in her face tighten. She retreats farther from the camera, glancing back toward her son. An unhappy smile crosses her face and she emits a brief, high-pitched laugh, more of a cackle, seemingly forced and exasperated.

He quits filming. His mother's complicity, he says, is mitigated by a willful ignorance. "She knows, and she doesn't know. She buries her head in the sand." An acquaintance of his mother's, a book editor living in Paris, describes Stengel as well educated and cultured. "She forgives her son every stupidity," says the book editor, "because she loves him, despite all his nonsense, and wants to protect him."

Breitwieser understands the bind in which he's trapped his mother, pressed to choose between her son and the law. She seems incapable of severing ties with her only child. She's not willing to kick him out of the house, let alone attempt anything worse. "What is she going to do," asks Breitwieser, "turn me in?" 13

Each time Breitwieser delivers a new painting to the attic the Cranach is his sixth in six months—he realizes that without a frame even a superb work loses some dignity, as if in a state of undress. He plans to replace the frames, but only in a way that honors the art.

Roaming the cobbled streets of old Mulhouse on an idle day, a brief drive from his home, Breitwieser comes across a corner shop that he hadn't noticed before, with a modest gray business sign advertising an artisan framer, and a cluttered window display of paintings and frame parts. He steps inside. Amid a splendid mess, beneath a bramble of curly black hair, Christian Meichler, the proprietor and sole employee, calls out *bonjour*.

Curious, Breitwieser introduces himself. Hearing his family name, Meichler points out one of the works he has on offer, a vibrant canvas by Robert Breitwieser, and a connection is formed. Breitwieser doesn't make friends easily, he doesn't make them at all, but Meichler is the exception that proves the rule. The framer, six years older than Breitwieser, is a fellow art addict. "Great paintings," says Meichler, who agrees to a lengthy interview, "transport you to a place of luminance and memories. Inside of paintings is where I keep my second home."

Meichler is probably the only person beyond Breitwieser's insular quartet—Anne-Catherine, his mother, his grandparents—who knows the art thief in a personal way. "He's sensitive," says Meichler, "and sentimental and perceptive and discerning, a true collector." Meichler is not alone in this opinion. Even the psychotherapist Schmidt, whose assessment of Breitwieser is often harsh, admits in his report that Breitwieser is "an exceptional aesthete" and "in some ways sympathetic, with a big heart, in love with beautiful objects."

The French psychologist Lucienne Schneider met with Breitwieser in 2004, assigned by the judicial system, and found him to be narcissistic and obsessional, unable to properly handle frustration, but also particularly sensitive and vulnerable. When you wear your heart on your sleeve, it's exposed to the elements. The noxious atmosphere as his parents split up, reported Schneider, "marked a point of mental rupture," and he immersed himself in artwork to find solace and peace. "All of his misconduct," Schneider suggested, "is attributable to psychological suffering brought out by his intense attachment to art." Schneider is the only psychologist, Breitwieser says, whom he doesn't consider an asshole.

The type of art that most captivates Meichler is the style that also enthralls Breitwieser—the exuberant European oil works that blossomed at the end of the Renaissance and the dawn of the Baroque. "Paintings that distill dreams and poetry," is how the framer sees them. At the outset of their friendship, says Meichler, Breitwieser is quiet and reserved. "He hardly speaks. But when he does open up, his enthusiasm overflows. It's rare for someone his age to appreciate art more for beauty than value. He's a connoisseur. He talks about art in a way that's cultivated and intelligent. And honest."

Breitwieser's initial lie to Meichler is one he's said before—that he is the grandson of the painter Robert Breitwieser, when he's actually a more distant great-grandnephew. Breitwieser also lies about the source of his art collection. He tells Meichler that he purchases the pieces at auctions. Otherwise, Breitwieser insists, he is authentically himself in front of Meichler, more than with anyone except Anne-Catherine.

Fine-art framers do not cross-examine clients. They often handle irreplaceable items for eminent families. Their code is discretion. Breitwieser shares the surname of a distinguished artist and appears to come from money. Some frames he selects cost more than a thousand dollars, a price Breitwieser accepts despite the couple's meager finances. Anne-Catherine is aware of these extravagances; sometimes she accompanies him to the shop, says Meichler, and provides counsel on the selection of frames.

The first item that Meichler frames for him is the first painting he stole, the portrait of an elderly woman taken with Anne-Catherine on their way to a ski trip. The result is beautiful. When Breitwieser arrives at the shop to collect Meichler's second framing job, the icon of Saint Jerome, the work, now in a handsome black-and-gold frame with arabesque scrolls, is propped in the window display for passersby to enjoy. It has been there for days. That's how you get captured: a softening of caution. Permitting a friendship to form was foolish indiscipline. Breitwieser is shaken, but he does not want to end the relationship. He has spent so much time in Meichler's shop over the previous weeks that he's become an informal apprentice. He has learned how to attach and detach all types of brads, as framing fasteners are known. After the Saint Jerome incident, Breitwieser preserves the friendship by lying again. He says he's too nervous about damaging items while transporting them, and will no longer bring pieces from home. He'll just describe the work to Meichler and provide dimensions. Once the frame is ready, Breitwieser will affix the brads himself.

Despite this unusual level of caution from his client, Meichler seems to have no idea that he's commenced a relationship with one of the biggest art thieves in history. The framer sees a lot of himself in this skinny, jittery kid who's obsessed with the past. Meichler uses the lovely French word *intemporel*, timeless, to help describe their connection. Hours seem to pass without either of them noticing. "We learn from each other," says Meichler. "We study auction listings. We dream aloud about the art that we want."

Meichler also senses, not even knowing that his friend is a thief, that Breitwieser is destined for trouble. "Art is spiritual food," the framer says, but a fanatical desire to possess it is gluttonous. "His passion for art is beyond all reason, a tormented love, like Tristan and Isolde, that won't be fulfilled or diminish."

14

"Thief!"

A word that no thief ever wants to hear shouted at him *shrieked*—cuts through the bubbly conversations of the artbuying crowd at the European Fine Art Fair in the southern Dutch city of Maastricht.

"Thief!"

Even though he's not stealing at the moment, Breitwieser flinches before realizing that the shouts are not directed at him. He watches as security officers rumble down the carpeted lane between booths. Heads in the exhibition hall turn.

A thudding tackle and muffled blows bring even the owners out of their lounge-like areas. Richard Green, the iconic London dealer who is always granted prime placement at the fair, looks on, cigar in his mouth, as the thief is subdued and escorted away, the stolen item recovered. Entertainment over, Green returns to his stand, Renaissance oils arranged on pedestals, prices climbing from a million dollars. The dealer then discovers that one of his pedestals has a large empty space. Breitwieser's giddy thought, as he and Anne-Catherine pull out of the parking lot a few minutes later, is that his car is currently worth more than the Lamborghinis they pass, if you include the souvenir in their trunk. The frame's still attached, despite his stealing requirement; freak situations have their own set of rules.

The artwork, an innovative 1676 unstill still life by Jan van Kessel the Elder, butterflies flitting around a bouquet of flowers, had hooked Breitwieser and Anne-Catherine from the art-show aisle, well outside Green's booth. He'd never seen anything like it. The colors were incandescent. The work reeled them into the booth, through a mirage of shimmering hues that seemed impossible until they realized, up close, that the piece had been painted on a thin sheet of copper.

They'd met Richard Green previously, at another art fair, where they had inquired about his price for a seventeenthcentury landscape. According to Breitwieser, the dealer sized up the young couple, perhaps a touch too eagerly attired in their pre-owned Armani and Hermès garments, and dismissed them from his booth without a respectful reply.

"Fuck Richard Green," says Breitwieser. "And his Montecristo cigars and his Rolex too."

The European Fine Art Fair is a good place to covet items, though not to steal. The security unit is professional, with some undercover, Breitwieser says. Also, a potential deal breaker for Breitwieser, attendees are often searched at the exit, sales documents required. The copper painting sang to him and Green's comeuppance felt ordained, but attempting a theft with almost zero chance of success is only the act of a fool. Providentially, a fool appeared as if on cue. With two piercing shouts, the fair shifted. The booths nearly emptied as the rubbernecking crested. Breitwieser was as surprised as anyone. Yet in the commotion that followed, he ascended into a sort of art-stealing nirvana, seemingly able to visualize the whole crime from above. The guards at the exit, he intuited, would abandon their post to assist the arrest. He'd bet a prison term on it.

He whispered to Anne-Catherine, who scooted over to the only employee remaining in Richard Green's booth and posed a question, positioning herself so the salesman's view was blocked. That's all it took. The painting was freed from Green's display in an instant, though its frame, Breitwieser saw, was fixed with too many nails for a speedy removal. The couple beelined to the doors anyway, the work not fully hidden, and Breitwieser's bet paid off as they pranced out the exit, unnoticed.

A crime isn't over, Breitwieser feels, until international borders are behind them. Even within the European Union, there are still official crossings, and cars can be searched. As they're entering France, as they do at every border, they present themselves as a young, stylish couple out for a jaunt. The officer waves them through. They park the car in the short driveway of his mother's house, ascend the stairs with the still life on copper, and cross the threshold into the attic.

He'd recently begun a tradition with the paintings they took, adding a personal note to the museum stickers, family crests, wax seals, and stenciled inventory numbers that are often collaged on the back. On a slip of paper he writes, "For the love of art, and for Anne-Catherine, my two passions." He signs his name and uses adhesive tape to fix it in place.

The copper painting is enchanting, but the way he stole it was not. Far from it. He's amassing art, not adventures; the optimal crime, to Breitwieser, is the most boring one possible. If you want skylight entries and infrared sensors, download a movie. If you want to steal art, you should learn how he accomplishes the silicone slice.

Museum display cases are made of tempered glass or a clear acrylic like Plexiglas or Lucite, usually fused at the edges with silicone glue. A fine surgeon's cut releases this seal, and if he operates on a corner with the sharpest blade of his Swiss Army knife, hairline incisions both vertical and horizontal, the panels will loosen. Acrylic has a fair degree of flexibility, and even glass typically bends enough to snake a hand through.

In a one-employee museum on the west coast of France, Breitwieser dissects a cube-shaped case and wriggles three ivory figurines and a tobacco box out of the gap. He pushes the remaining works around, extending his reach with a pen, to try to evenly rearrange the display. Then he eases the panels into their original shape. The planned ending to every silicone job is for the display to seem untouched. The case's lock, throughout the crime, remains secured.

At a castle on the Rhine River in Germany, he similarly frees a silver-and-gold trophy from 1689, honoring the region's resistance to French troops, an item of such enduring cultural pride that the stolen trophy's image is promptly distributed on police wanted posters. Breitwieser spots one of these posters at a customs booth as he drives back across the German border a few hours later, with the trophy in his car. He is not stopped.

Visiting a Swiss castle in May 1996, he stretches for a bronze hunting knife and finds out what happens when glass flexes too much—there's a gunshot-like pop as the panel erupts. Shards lance his hands and blood spurts, and Breitwieser is abruptly unnerved. He abandons the knife and flees with Anne-Catherine, leaving behind a car-crash mess of shattered glass glazed with blood. But within a minute, his natural composure begins to return. The castle is sprawling and inadequately guarded, and soon it's clear that no one else heard the smash, so Breitwieser doubles back and retrieves the knife from the rubble.

After an escapade like that, way too unboring, Breitwieser and Anne-Catherine tend to finish their weekend stressfree, calling off any more larceny. They'll embark on a nature hike or a city saunter, perusing boutiques, surveying architecture, or visiting a museum and signing up for a tour. Once the tour starts, they obviously won't steal: a museum employee is escorting them; their faces are known.

Breitwieser's art-stealing epiphanies emerge from the spot where spontaneity and simplicity meet. "Don't complicate things," is his mantra. "A tool is worthless until you can control your gestures, your tone of voice, your reflexes, your fright. And you accept that there will be moments of grand tension, when everything hinges on a tiny motion, and you can't be sure how things will turn out."

On a guided tour of an eight-hundred-year-old castle, Breitwieser spies a terracotta apothecary jar called an albarello, sensuously curved like a Coke bottle, displayed high on a shelf, alone and unprotected. And enlightenment strikes. Something that a thief would obviously never do is *precisely* what a thief should consider doing. He tarries as the guide and the tour group and then Anne-Catherine turn to file into the next room, everyone's attention on the treasures ahead. There are few security cameras or guards in the castle. He hasn't been required to leave his backpack in a locker.

Cameras and people have similar limits, both of which Breitwieser can deduce—the field of vision of a lens, the bounds of human observation. The albarello's absence would leave no imbalance in the room, no distinct gap. He's confident that its disappearance won't be noted for hours at least. He slips the albarello in his pack. Normally, when Breitwieser removes an object, he and Anne-Catherine gravitate to the exit, unhurried but steadily doorward. A thief would never purposely remain inside a museum with stolen loot, and certainly not mingle with employees during a delicate escape.

They continue the tour to the end and cheerfully chat with the guide. If the crime does happen to be rapidly detected, Breitwieser predicts that their familiarity will make it more likely they'll be eliminated as suspects, that no one will even ask to search in his backpack. He doesn't have to test this idea; his instincts are correct. The theft isn't discovered until long after they've left. He steals during guided tours a half dozen more times. And from the albarello theft on, they're friendly while purchasing tickets, and often stop to ask guards for directions, and sometimes wave affably goodbye, all for the same reason. That's not how art thieves behave.

Once, after stealing a clay figurine from a museum in

southern France, he calls the authorities himself. Arriving at his car, he sees that his vehicle has been scratched, likely with a key. Breitwieser is so furious about this violation of his property that he phones the local police. An officer shows up to inspect the damage and file a complaint, while the figurine sits in the trunk.

Another time, emerging from a museum with a pair of sixteenth-century altarpiece panels, he and Anne-Catherine reach their car and find, terrifyingly, that a police officer is already there. The wooden panels, both nearly two feet long and a foot wide, are under Breitwieser's jacket, one on each side, and he has to hold his arms unnaturally against his body to keep them hidden, so unwieldy he can't sit down. The couple, graced with the ability to radiate serenity in fraught situations, politely inquires about the reason for the officer's presence. The policeman explains that he is writing them a parking ticket. Breitwieser, forever trying to save money, hadn't fed the meter. A circumstance that any other thief would likely accept with relief isn't treated that way by Breitwieser. Recklessly, he begins arguing with the officer, awkward arms and all, and persuades the cop to withdraw the ticket.

In July 1996, while visiting a tranquil museum in northern France dedicated to the artistry of ironwork, displaying items like door knockers and spice grinders, Breitwieser observes that the glass-doored display cabinets are themselves beautiful antiques. One cabinet in particular, exhibiting among other pieces a detailed alms box, reminds him of the Louis XV armoire, purchased by his grandparents, that serves as a display in his attic. Breitwieser is attuned to the minutiae of form, to wood grains and file scrapes, and he considers the possibility that both cabinets were made in the same workshop. Even the outline of the keyhole seems familiar.

He keeps his attic display locked, as does the museum of ironworks. His key is stashed in a pouch in his wallet, and when no visitors are around, he fishes it out. Locks were less precise a few centuries ago, with limited variations. He inserts his key into the museum cabinet's slot and rotates it a quarter turn to the left. He hears the click of a receding bolt. "Crazy, incredible, a miracle," he says. He takes the alms box and relocks the museum display.

Screws are his perpetual nemesis. Undoing a single screw, the ideal, nets him a bronze fireplace tool off a mantel. Removing two screws provides a portrait of a musketeer in a feathered cap. Three screws nets a sixteenth-century candleholder. To steal a ceramic tureen, he extracts two screws on one visit and two more the following week. He twists out twelve screws on one Sunday to procure a gilded ceremonial medal. During a theft, he stores the screws in a pocket, then tosses them away when outside.

Breitwieser's screw apotheosis unfurls at the Alexis Forel Museum near Geneva, where he is seduced by a threehundred-year-old serving platter from the studio of the famed Dutch ceramicist Charles-François Hannong. The platter is entombed in a plexiglass case, studded with screws. There are too many fasteners, but his desire is primed and Anne-Catherine agrees to station herself on lookout, so he tries for it. The Swiss Army knife twirls in his palms, five screws, ten screws, fifteen, relentless, though he can't shake the sense that he should quit. He cuts a deal with himself—he'll never try this many again in his life—and plows on. Twenty screws, twenty-five.

Twenty-six, twenty-seven, twenty-eight, twenty-nine. And, mercy, thirty. The case opens, the platter vanishes under his coat, and they leave, but not before he feels acutely that there's a peril he hasn't quite seen, and as usual he's right. 15

Hunched over a computer in an upper-floor office of the regional police station, Alexandre Von der Mühll, one of two inspectors in Switzerland who specializes in art crime, examines the surveillance footage from the Alexis Forel Museum. The images are grainy, the faces unclear, but the actions are not. A man and a woman—youngish, smartly dressed, apparently unaware of the slyly concealed camera—boldly perform a midday heist. Thirty screws are removed to steal a serving platter.

There's been a spate of savvy museum thefts in Switzerland, and Von der Mühll is convinced that most of them are linked. The inspector is intense, physically imposing, and intolerant of vice, very much a cop. He's also garrulous and debonair, and a fervid collector of affordable nineteenthcentury art. Museums are secular churches, says Von der Mühll, and to steal there is blasphemous.

Von der Mühll recognizes the crimes' shared traitsdaylight thefts of tidy precision. He notes that the stolen goods, brass scale to battle-ax to oil portrait, are primarily from the late Renaissance, with a particular fondness for anything Flemish. The slickness of the heists, the frequency and proximity, tells Von der Mühll that the criminals feel as if they were leaving behind no incriminating evidence or eyewitnesses. There's only the taunt, where a painting has been stolen, of an empty frame. They feel they're uncatchable. Such cockiness, thinks Von der Mühll, opens the door to arrest.

The thieves seldom swipe the most famous or obvious items. They take the lesser-known greats, the pieces that are easiest to fence and filter back to the market. Von der Mühll suspects that he's chasing one or more of that rare breed of criminal who knows something about art. Even so, art crime is complex, and a major mistake is inevitable. Sometimes the blunder is simply failing to notice a museum's hidden camera—so well disguised in the Alexis Forel Museum that Von der Mühll refuses to publicly reveal its location. The footage, the inspector hopes, is the break he's been seeking.

Von der Mühll understandably assumes that the thieves are motivated by financial profit. Art prices have soared, almost without pause, for decades. This seems to be matched by surging theft, though the fine-arts market, lacking in transparency and regulation, is resistant to accurate data. The Association for Research into Crimes Against Art, an international group of professors and security experts who publish *The Journal of Art Crime* twice a year, reports that art and antiquities theft is among the world's highest-grossing criminal trades. Globally, there are at least fifty thousand art thefts each year, the majority from private homes, not museums, with a total value of several billion dollars. Pablo Picasso is the gangland champion, the most pilfered artist of all time, and perhaps he deserves it. One of the first arrests following the 1911 *Mona Lisa* theft was actually Picasso, then twenty-nine years old and living in Paris. He was hauled into the central police station and accused of masterminding the crime with an acquaintance of his, a Belgian con man and serial thief named Géry Pieret. Picasso was terrified. Though innocent of the *Mona Lisa* job, he had in fact commissioned Pieret to steal from the Louvre a few years earlier.

In 1907, Picasso had reportedly offered Pieret fifty francs, or ten U.S. dollars, to steal a pair of ancient stone figurines from Picasso's native Iberia that the painter had seen on display at the Louvre. Pieret filled the order, smuggling the carvings out under his coat. The figurines had distorted faces, and Picasso kept them in his studio as templates, he admitted in his autobiography, for the groundbreaking *Les Demoiselles d'Avignon*, a painting that had inaugurated cubism.

Neither Picasso nor Pieret, police investigators swiftly concluded, had anything to do with the *Mona Lisa* disappearance, and Picasso was released after half a day in custody. Picasso did not tell the police about the two figurines, but he was so rattled by his arrest that he had a friend drop them off anonymously a few days later at the offices of the *Paris-Journal* newspaper. The editor of the paper returned the works to the Louvre, and Picasso and Pieret were never punished.

Runners-up for the most stolen artist include Salvador Dalí, Andy Warhol, and Joan Miró, but none approach Picasso's total of about 1,000 swiped works. This includes the theft of 118 Picassos at once, from an exhibition at the Papal Palace in Avignon, France, in 1976. An armed gang in ski masks struck after closing hour, beat and gagged the night guards, raided the exhibition, and drove off in a delivery van. Eight months later, all the Picasso works were recovered and seven gang members captured when they tried to sell their loot to a man who they thought was a black-market art broker, but was really an undercover cop.

The law-enforcement success in Avignon, due to an officer's ability to infiltrate the art underworld, helped accelerate the modern age of specialized art-police squads. Italy had formed the first national art-crime unit, in 1969, and the Carabinieri Command for the Protection of Cultural Heritage remains the world's largest, with around three hundred detectives. Twenty other countries have since followed suit, though many, like Switzerland, employ only a couple of inspectors. In the United States, the FBI's Art Crime Team consists of twenty special agents and produces its own Ten Most Wanted list of missing art.

The thirty-person French art force, the OCBC—the acronym translates to the Office for the Fight Against Trafficking in Cultural Goods—is generally considered second to Italy's team in skill and accomplishment. In the summer of 1996, as Alexandre Von der Mühll is quietly compiling his own case in Switzerland, an esteemed OCBC agent named Bernard Darties, number two in the chain of command, issues an internal memo. In the memo, Darties lists fourteen art thefts in France that may be related, and just like that Breitwieser and Anne-Catherine are being actively pursued in two countries.

16

Among the crimes mentioned in Bernard Darties's memo is the theft of an ivory figurine from a small-town museum in Brittany, in August 1996. A witness there reported seeing a man and a woman hovering near the sixteenth-century ivory just before it went missing. A few months earlier, in an even smaller town on the east side of France, a male-and-female team had been suspected of stealing a silk-embroidered tapestry, again from the sixteenth century.

Darties, with little wire-framed glasses settled on the end of his nose, had studied all the recent art crimes in France and sensed a comparable pattern with a dozen more. The perpetrators, he conjectures, are a husband and wife, highly cultured and educated, plausibly college professors. They clearly have a taste for art, says Darties, and considerable talent for robbing museums. If they're guilty of half the thefts in his memo, they are astoundingly active.

Before working art crime, Darties had spent a decade

in antiterrorism. He sees parallels between art thieves and terrorists—crimes that destabilize society, with psychological fallout. The crime on Darties's list that feels closest to terrorism may be the 1996 theft of a portrait by Corneille de Lyon, a court painter during the reign of François I, the famously art-struck French king. It was François who purchased the *Mona Lisa* directly from Leonardo da Vinci's studio, for four thousand gold coins, which is why the indelible work, created by an Italian, hangs in France.

In 1536, Corneille de Lyon painted François's teenage daughter Madeleine. The piece is a feat of artistic restraint a plain-green background, a single strand of pearls and rubies, a straightforward expression—imbuing the work with unreserved sadness. Madeleine suffered from poor health, and rather than shy away from this fate, Corneille de Lyon seemed to capture life's brittle impermanence. A year after the portrait was completed, Madeleine died of tuberculosis at age sixteen.

Madeleine de France, selected by a committee of French art historians as one of the nation's most historically important paintings, was the star of the Museum of Fine Arts in a castle in Blois, a town on the Loire River where Madeleine had been sent from Paris to live, in hopes that more temperate weather would heal her. The portrait, small as a greeting card, was monumentally framed—double framed, in fact, with an inner border of gilded wood inserted into an immense outer mount.

The work was displayed in the museum's entry room, the most crowded spot in the building. Late on a July afternoon, visitors stirring, guards roving, nothing appeared out of the ordinary. No one was seen running, or handling a weapon or tool, or carrying a suspiciously shaped package. No windows were opened, no side door jimmied. There were no unusual distractions, no commotions.

Madeleine was there; then she wasn't. The large outer frame remained in place, but suddenly—stunningly, bafflingly—there was a hole in the middle. A work that had hung undisturbed in the museum for 138 years, since it had been given by a private donor so the painting could be seen by the public, had just vanished like a soap bubble into the air.

This is Darties's problem: there is nothing solid to grasp on to, no clear images or hint of the criminals' names. He has only hunches. Any publicity at this point will tip his hand to the thieves and harm his chances of safely recovering the art. Darties has little choice but to keep the investigation discreetly restricted to the French art force. He is not aware of Alexandre Von der Mühll's efforts. Still, traps are set. Detectives in Switzerland and France, even if unknown to each other, are working the case, and every new art theft in either nation is scrutinized to see if the crime adds to the evidence.

Several do. In Switzerland, in 1996, a two-person team, male and female, is described by witnesses after the Historical Museum of Basel loses a seventeenth-century violin. And in France, in 1997, a couple is spotted in a museum in Saintes, where a Flemish still life evaporates from its frame. A couple is also observed in a museum in Nantes, where a bronze statuette of a wild boar is missing. And again in Vendôme, and Orléans, and Bailleul—so many similar sightings that yet another independent investigation is launched, by a division of the French regional police.

With three agencies prowling, two French and one Swiss, it is merely a matter of time. No one gets away with bold crimes for long. Luck always runs out, it's inevitable. The couple is going to get caught. 17

The *Madeleine* theft, Breitwieser realizes, seemed impossible. There is no way to think otherwise. When Breitwieser and Anne-Catherine visited the museum in the Royal Château of Blois and saw where the portrait was displayed, they both felt the same. Too many guards, too many tourists. The work had long been on Breitwieser's mental list, but they agreed that attempting to steal it would be madness. So they continued on to other rooms, and soon enough, as usual, Breitwieser had talked Anne-Catherine into taking another peek before they left. To him, the force of the painting was undeniable.

And they had traveled so far to see it. Breitwieser had driven halfway across France, disregarding speed limits, in one long day—Anne-Catherine does not have a driver's license. They'd reached the Loire valley, playground of French nobility for centuries and a fairy tale still, a procession of vineyards and castles lining the meandering river. Shortly before closing time at the castle in Blois, where Joan of Arc had stayed in 1429 on her mystical wanderings, they returned to *Madeleine*.

The room was still buzzing with visitors and guards, the typical troubles. But there were also some new criminal wrinkles, like the double frame. How did that work? Was the inner part, with the painting, solidly attached to the outer? He wouldn't know for sure until he laid his hands on it. Further, it was summertime, too hot to wear his overcoat without rousing suspicion. He was in his shirtsleeves, no backpack either. The inner frame measured less than a foot on each side, and he doubted there would be time to remove it. Even this modest size was a challenge. If he did grab hold of the portrait, where would he put it?

There was no time for such questions—he'd have to rely on impulse—because a group of guards had just clustered. It seemed like an impromptu meeting, possibly delegating who would do what as closing approached. Clearly, the huddle would be brief. But for the moment, the guards were all looking at each other, not *Madeleine*. At the same time there was a fortuitous lull in the visitor flow. Anne-Catherine, monitoring the scene, signaled okay.

The inner frame, he discovered with one firm tug, was fastened solely by a few strips of velcro. The sound of ripping velcro dissipated in the large room, and in an instant the painting was loose. Without hesitation, he shoved it down the front of his pants, still in the frame, his shirt hanging over, awkward and lumpy, but if any guards glanced up, they'd have seen only Breitwieser's back, which he had promptly turned to them. Then it was a quick handful of steps across the tiled floor, and abracadabra right through the door. A crime like that, with so many variables and none can go wrong, seems unbearably harrowing, but Breitwieser insists that it's not. Stealing *Madeleine* was like threading a needle, he says—a steady hand finessing a tiny opening. He's well practiced by now, nearing his one hundredth heist, he and Anne-Catherine maintaining their three-times-a-month stealing pace. *Madeleine* is one of the premier paintings in France. For virtually any other art-crime team, stealing the portrait would be a career-crowning achievement after immense planning. For Breitwieser and Anne-Catherine, it wasn't even their only theft of the day.

Before spotting *Madeleine*, they'd plundered the Château de Chambord, a sixteenth-century palace that was one of the prototypes for the most visited castle on earth: Cinderella Castle of Disney World, Florida, finished in 1971. At Chambord, the display cases in the museum were antiques, matching the château's decor and permitting Breitwieser to deploy a signature Swiss Army knife trick.

He tucked the tip of a blade under a display case's sliding door panel—old cases are often a bit loose here—and used the knife as a mini crowbar, delicately levering the door off its bottom rail. The door hung like a mailbox flap even as the case remained locked, and he snuck his hand through, scooping up a folding fan and two tobacco boxes. He redistributed the rest of the display and remounted the door, then drove twenty minutes down the road and stole *Madeleine*. 18

Breitwieser and Anne-Catherine are aware that the police are after them. Newspaper articles on their crimes have occasionally reported that there's been an eyewitness. Local police, unlike Darties's federal art-crime team, have not been ordered to keep silent, so the couple has hints if they've been spotted stealing and whether the descriptions from witnesses are accurate.

Some papers, quoting law enforcement, mention that a network of international traffickers must be systematically stealing art—the Italian Mafia, maybe, or a Russian cartel. One article states that a couple is suspected, but that the man is fifty or sixty years old. "I laughed at that," says Breitwieser. He has yet to turn thirty. His habit of discarding a painting's frame facilitates the crime, and he knows from the newspapers that it also taunts the authorities. He begins leaving frames in smug-seeming spots in museums—on an armchair, behind a curtain, inside another display. "It's my calling card," he says. Breitwieser had always insisted that he derived no pleasure from stealing, but this seems like showboating.

When they spot a police car circling the block near their home, Breitwieser says that he and Anne-Catherine feel tinges of panic. How could they not? They've committed so many crimes. The police car doesn't stop. All inspectors, Breitwieser thinks, possess the same fatal flaw: they're consistently logical, and to fool them is easy. Police logic, Breitwieser knows from studying art crime, dictates that after a work is stolen, there are really only three options that thieves will pursue.

First: sell the loot to a crooked collector or dealer. Dishonest merchants are everywhere—a University of Oslo study documented illegal art or antiquities transactions in forty-three nations. The going rate for stolen works is 3 to 10 percent of retail; the better known the work, the lower the figure. At 3 percent, a million-dollar item yields thirty thousand, which doesn't seem that impressive, considering the risk. Some pieces shift owners and countries, ascending through pawnshops, antiques stores, and art galleries, generating bills of sale and certificates of authenticity, a years-long shell game that permits the work to slip back into the legal market, often via a minor auction.

Second: extort payment from fleeced museums or private owners, or their insurance companies. Art-napping, it's called. This works best with recognizable pieces that can't be fenced, and requires a broker who is able to bridge art's legal and illegal shores—not far apart, but a morally perilous crossing. Paying ransom is prohibited in many places, because it may encourage further crime, so the transaction is often murkily labeled "a reward for information." Such rewards have been used since at least 1688, when an ad placed in *The London Gazette* by a Mr. Edward Lloyd offered one guinea, about \$1.50, for the return of five pocket watches. Lloyd later founded Lloyd's of London, providing art insurance worldwide.

Third: spend the stolen art like currency in the underworld. A valuable painting that fits in a file folder, the size thieves most often steal, can represent a significant sum of money in a compact space. Compared with suitcases full of cash, art moves easily across airports and borders. Russian intelligence officers have identified, in just their own country, more than forty organized crime groups that accept art as collateral. A Picasso painting lifted from a Saudi prince's yacht in 1999 was traced to ten different underworld owners, propping up deals along the way for weapons and drugs.

The three strategies—fencing, extorting, monetizing involve art changing hands. These exchanges are the soft spots, where law enforcement tries to intervene. Pinpointing the transfers is an art force's principal task. Working an art crime, unlike other police cases, prioritizes recovering items over making arrests. "What's the worth of a vulgar burglar," asks the French art inspector Darties, "compared to a Rembrandt?"

Agents nurture underworld contacts, listen to wiretapped calls, and wade through auction listings while cross-checking stolen-art databases. One of the most extensive global inventories, the London-based Art Loss Register, contains more than half a million items. That total, growing daily, reveals that a lot of art is lost and not much is found. Overall, art inspectors admit, less than 10 percent of pieces are retrieved. Fully solving a crime, catching both the thieves and the work, is rarer. For museum pieces, the recovery rate is significantly higher. A rough estimate is 50 percent, and some art-crime units claim nine out of ten. To pursue famous items, top detectives occasionally go undercover.

At dawn on the first day of the 1994 Winter Olympics in Norway, two men propped a ladder on an outer wall of the National Gallery in Oslo and broke a second-floor window. An alarm rang, but a guard thought it was false and reset it. The men clipped the wires securing Edvard Munch's *The Scream*, and scampered out. They left behind the ladder, the wire clippers, and a note that said, in Norwegian, "Thank you for the poor security." Norway does not have an art-crime squad, but one of the art-hunting greats, Charley Hill of the United Kingdom's Art and Antiques Unit, was invited by Norwegian authorities to join the pursuit.

Hill transformed himself into one of his stock characters, a fast-talking, foulmouthed, ethically vacant dealer. Undercover work, says Hill, is like performing in a play except flubbing a line might bring a gun to your head. Hill never wore a wire or carried a weapon, good ways to get shot. He liked flashy clothing and an American Express card embossed with his undercover name. Over the course of three months, Hill initiated contact with the Norwegian thieves, gained their trust, and baited them with cash. In a remote cottage overlooking a fjord, he recovered *The Scream*. The local police arrested four co-conspirators.

One option that is not on the agenda of most art thieves is hanging stolen works on the wall and admiring them. Aesthetic sophistication has been the essence of nearly every fictional art thief in books and movies, but for art-crime inspectors these imaginary characters are all a big joke. Alexandre Von der Mühll, the Swiss detective chasing Breitwieser, uses as his cell-phone ringtone the twangy notes of the James Bond theme song. It's a playful homage, he says, to the first Bond film, *Dr. No*, in which the villain's lair is loaded with art, including the Francisco Goya portrait *The Duke of Wellington*.

Dr. No, starring Sean Connery, opened in 1962. The year before, the Goya had actually been stolen from the National Gallery in London, and the James Bond filmmakers put a copy of the painting, then still missing, in their film as a gag. The real thief, an unemployed, heavyset former taxi driver, had clambered in and out of one of the National Gallery's bathroom windows at night. He hid *The Duke of Wellington* under his bed, wrapped in brown paper, and didn't seem to have mentioned it to his wife as he struggled to exchange the work for any form of payment. After four years, he gave up and surrendered the painting for nothing.

The bumbling Goya burglar, says *The Scream* rescuer, Charley Hill, represents most art thieves. "There is no Dr. No," is a line that every art cop seems to repeat. "There's almost never been a criminal who knew about or cared about art," says Noah Charney, the professor who founded the Association for Research into Crimes Against Art. It would be implausible for inspectors like Von der Mühll and Darties to deduce that the thieves they're chasing are stealing for pleasure, not money. The detectives are expecting an exchange of art that will never come.

Breitwieser appreciates these favorable odds while also trying to further confound the police by stealing as erratically as possible. He and Anne-Catherine lurch from city to village to town, switching among museums and auctions and art fairs, seizing silver or sculpture or paintings, bouncing between France, Switzerland, Germany, Austria, and the Netherlands. The authorities, Breitwieser believes, have no chance to catch them at all. 19

In his early stealing days, Breitwieser rummaged scattershot through museums, grabbing objects from the medieval era to the onset of modernism, a millennium-wide spread. He took only what seduced him, but in several cases—the weapons, particularly, and anything bronze, and items from both ends of the age spectrum—his initial lust faded, as many trysts do, without maturing to love.

As the attic has flourished, he and Anne-Catherine have often lounged in bed, he says, and tried to identify the elements that attract them to specific works. He's engaged Meichler in similarly abstract discussions at the frame shop, and his library studies further hone his senses. He knows his sweet spot—northern European works from the sixteenth and seventeenth centuries. And with every piece he steals now, he seems to achieve steady devotion.

Can we account for his taste? Not really. Until recently, no one could adequately explain why art even existed at all.

Art seems to contradict Charles Darwin's theory of natural selection, which states that a species survives on a hostile planet chiefly by eliminating inefficiency and waste. Creating art consumes time, effort, and resources without providing food, clothing, or shelter.

Yet art is present across every culture on earth, varied in style but communally revealing what lies beyond words. Art may in fact have a Darwinian basis, perhaps as a way to attract a mate, though many art theorists now believe that the reason for art's ubiquity is that humanity has overcome natural selection. Art is the result of facing almost no survival pressure at all. It's the product of leisure time. Our big brains, the most complex instruments known in the universe, have been released from the vigilance of evading predators and seeking sustenance, permitting our imagination to gambol and explore, to dream while awake, to share visions of God. Art signals our freedom. It exists because we've won the evolutionary war.

Sociologists have conducted global surveys that show general preferences for art. We like landscapes with trees, water, and animals. The most popular color in the world, by far, is blue. We don't like jagged shapes and the color orange. The way color works, though, is that we see only wavelengths of light that objects cannot smoothly absorb, and instead reject and throw back. Yellow is the hue least harmonious to a banana. We also see everything upside down, and our brains expend a lot of energy rebuilding the world right side up. Our cultural background contributes to what woos us—carpets in Iran, calligraphy in China, palm-frond baskets in Sudan. Aside from these social guideposts, attraction to a piece of art is tied to the essence of who you are. Beauty is in the eye of the beholder.

Or maybe not. In 2011, Semir Zeki, a professor of neuroscience at University College London, used MRI scanners to track neural activity in the brains of volunteers as they looked at works of art on small screens. Zeki discovered the exact place, he announced, from which all aesthetic reactions flow—a pea-sized lobe located behind the eyes. Beauty, to be unpoetic but precise, is in the medial orbital-frontal cortex of the beholder.

Breitwieser is beguiled by oil paint, made from the pressed seeds of the flax plant, with translucent properties that generate luminous colors. Northern Europe primarily switched to oil paint during the Renaissance, while southern places like Florence stuck with tempera, in which egg yolk is used as a binding agent for pigment, producing more muted hues. Beyond color, many of the paintings Breitwieser steals, especially the genre scenes of village life, seem to evoke a feeling of liberation. Breitwieser is mesmerized by the era of individualism, when European artists escaped from church control and started determining their own imagery and style. For the first time, art began to be signed.

The Picasso thieving club does not interest Breitwieser. Modern art leaves him cold, he says, made less to be felt than dissected. The work of some Renaissance superstars as well, like Titian, Botticelli, and even Leonardo da Vinci, is "admirable" or "impressive," Breitwieser will grant, but not more. Breitwieser says that he can detect these painters' servitude to wealthy patrons, who could dictate a work's style, composition, and color. The greats, he feels, sometimes skated by on talent alone, their senses not fully present, and that ruins it all. He says that his eye is pulled to less gifted artists who display deeper emotional sincerity.

Also, these works are probably easier to steal than ones by the heavyweights, and that's a factor. Breitwieser takes "cabinet paintings," as small works are known, because they can hide under his jacket and fit well in the attic. During the Renaissance, cabinet paintings were sold on the street, sized for the homes of the newly emerging middle class. These works often evoke an aspirational, salt-of-the-earth feel sentiments that do not exist in the giant, stilted pieces made to aggrandize nobility.

As for the tobacco boxes, wine goblets, and household objects that Breitwieser takes-beauty in functional formmost were created shortly before the European industrial revolution of the early 1800s. Until then, every part of every item was fashioned by hand, through craft and often painstaking toil. Engines, electricity, and mass production have eased everyone's life, but these advances, Breitwieser says, have made the world progressively uglier, and there's no going back. Expertise was once conferred from master to apprentice, one generation to the next, ingenuity gradually accruing. Now factories pound out widgets that are cheap, identical, and disposable. The period just before machines took over, Breitwieser feels, marked the height of human civilization, of maximum beauty and skill. These are the pieces he steals. Time marches ruthlessly on, with the exception, Breitwieser hopes, of one small, suburban attic.

20

By the time Anne-Catherine's winter vacation from work approaches, in early 1997, she and Breitwieser have stolen on three out of every four weekends for close to two years. In several museums, they've taken multiple pieces at once, and this pace does not include Breitwieser's solo jobs, another one or two per month. Some two hundred works are displayed in the attic.

Their relationship, Breitwieser feels, remains enduringly strong. On brisk days they sometimes stroll outside wearing identical wool fisherman sweaters they purchased together. "Like twins," Breitwieser smiles. During long drives Anne-Catherine often naps with her head on his shoulder, and the miles melt away. They've been together more than five years.

Anne-Catherine sees their connection a little less rosily, those who know her say. They're still a couple, but she's had her fill of Bonnie and Clyde. No police have arrived at their door, though the authorities, they gain from newspaper reports, are sniffing around. Anne-Catherine's previous work vacation, six months before, was dedicated to stealing in Normandy. While there, one of the regional papers, *Ouest-France*, ran a headline shouting "Raid on Museums!" above photos of several missing works. The article shot her with fear. They cut the trip short and fled home.

Anne-Catherine's impending vacation seems a good time to throw the police off their scent, Breitwieser says—not by pausing, he never wants a break, but by exploring farther afield. He senses that even in the open-bordered European Union, police aren't adept at sharing information, perhaps slowed by language barriers. When the couple's boldness in one country reaches their safety threshold, usually determined by Anne-Catherine, they temporarily shift nations. From their attic in France, a dozen countries are less than a day's drive away.

Breitwieser consults his brochures and guidebooks. He scans his mental list. A weekend mission to Belgium is his conclusion. He's never stolen in Belgium. They can observe the security scene there, and maybe return for a longer stay when Anne-Catherine is off work two weeks later. They depart on a Saturday morning in January 1997 at dawn.

If two hundred pieces in the attic isn't enough, what is? The German psychoanalyst Werner Muensterberger is the author of *Collecting: An Unruly Passion*, the authoritative textbook on impusive collectors. Muensterberger, who died in 2011, earned three doctoral degrees—medicine, anthropology, art history—and said that unhealthy collecting, as opposed to a clutter of snow globes on your bedroom shelf, takes over one's life, arising most commonly in people prone to depression who feel out of place in society. A meaningful collection, Muensterberger wrote, offers these outcasts "a magical escape into a remote and private world," and the collector's cycle of hunting and gathering, that primal human rhythm, is often the only activity that makes their life worth living.

Erin Thompson, a professor at John Jay College of Criminal Justice in New York City, is the only full-time art-crime professor in the United States. Thompson writes in her 2016 book, *Possession*, that the handful of collectors who steal generally believe that their emotional attachment to a piece is deeper than that of the museum or individual who legally owns it, and they don't feel immoral by taking it. Visiting desired works in museums isn't acceptable enough for criminal collectors, Thompson says, because they're denied "the pleasure of touch," a literal contact with the past.

"One trait shared by all true collectors," Muensterberger warned, is that "there is simply no saturation point." The thirst to add more is unquenchable. According to Muensterberger, there will never come a time when someone like Breitwieser feels he has enough. Brain scientists agree. Obsessive collecting, Stanford University neurologists have shown, may be caused by neurochemical imbalances that produce an impulse-control disorder, one capable of creating an unstoppable and sometimes criminal collector. The intoxicating flood of brain chemicals peaks during the pursuit, researchers found, not the capture. When the quest outshines the treasure, you don't want to stop questing. This helps explain the ceaseless nature of a collecting addiction. Breitwieser has never undergone testing, so the state of his brain is unknown.

What stops the unstoppable? Mistakes, bad luck, police. Breitwieser has been fortunate, unscathed by precarious moves, never burned by an error. In one of his early thefts in Switzerland, he was pushing an oil painting into his pants when the large buckle on his Pierre Cardin belt detached and landed, *bang*, on the floor. A security guard was nearby. All the guard had to do was take a quick peek, but didn't bother. Breitwieser has not worn a big buckle since.

For the couple's initial trip to Belgium, their destination is the capital, Brussels. They drive six hours, winding on secondary roads, not once paying highway tolls. Their travel budget is tight, about a hundred dollars per day—they each pay half—and a journey on European expressways can easily eat the majority of their funds. Even if they could afford it, Breitwieser says, they still wouldn't pay. Highways bulldoze the land, and dispensing money to use one rewards ugliness. Backroads blend in. They lower the windows and inhale the scenery, farmland soil to corner boulangerie, and sometimes have to fold in the side mirrors to squeeze through old village lanes.

Their early start permits them to reach Brussels by lunchtime. Parking doesn't matter to Breitwieser; anywhere near a museum is fine. They are not thieves who dash to a getaway car. They find a spot at the Art & History Museum, one of the largest museums in Europe, in a neoclassical building with marble columns and a grand rotunda. It's the Louvre of Belgium. Breitwieser never steals from the actual Louvre in Paris—Anne-Catherine says it's too risky and forbids it but this huge national museum in Brussels is the nearest they come to a Louvre-like theft. And it is here, Breitwieser says, that he initiates a crime that feels as close as he ever gets to perfect. 21

The display case that first grabs his attention, the one that sets the whole heist in motion, does not exhibit artwork he likes. Medieval items sometimes feel judgmental and pious to him. What catches his eye, as he's rambling with Anne-Catherine toward the Renaissance rooms in the vast Art & History Museum in Brussels, is the way the objects in this case are arranged.

It appears as if someone has already been stealing, recently and sloppily, the thief not bothering to redistribute the remaining pieces so the display might look normal to guards passing by. Then Breitwieser notices that an index card has been creased in half and placed like a little tent in the exhibit. Leaning in, he reads the note printed on the card. It says, in French, OBJECTS REMOVED FOR STUDY. Nothing has been stolen, he realizes. And he reaches for his Swiss Army knife.

The next display case to grab him, a few rooms later, glints with Breitwieser's second-favorite material, according to what he calls his "personal passion rankings" of artistic mediums. First is oil paint. Third is ivory. Silver gets the silver, but he prefers a specific sort. In southern Germany in the late sixteenth century, around the austere Protestant towns of Augsburg and Nuremberg, a frenetic competition seemed to erupt between master silversmiths to see who could create the most exuberantly over-the-top work. Each new design for a couple of decades appeared to up the ante. They were the Fabergé eggs of their time, coveted by royal families across Europe, and are now among the more valuable of all silverworks.

Gathered in one large case are more than a dozen of these treasures—chalices, goblets, and tankards crawling with dragons and angels and devils. In the middle of the display, raised on a stand, is a spectacular warship, likely meant to be the centerpiece of a banquet table, silver sails billowing, silver soldiers on the silver deck firing silver cannons. Every piece in the case is thrillingly attic-worthy.

There's a camera in the room whose vision, he determines, fades just shy of the display case, though he must be careful where he walks. The interval between guard visits allows time to work. His challenge is with the case itself. His usual tricks—levering the access panel, the silicone slice will not provide a big enough gap for any of the silverworks. He needs to slide the door fully open, but it is bolted with a modern lock, virtually unpickable.

Breitwieser had recently worked a stint at the French bigbox hardware store chain Lapeyre, where he was assigned, serendipitously, to the doors and locks department. There he learned that a significant percentage of locks have been improperly installed, including the one in this display case.

Madeleine de France by Corneille de Lyon, 1536, oil on wood. Stolen from the Museum of Fine Arts in Blois, France.

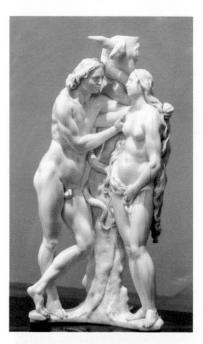

LEFT: *Adam and Eve* by Georg Petel, 1627, ivory. Stolen from the Rubens House in Antwerp, Belgium.

ABOVE: Tobacco box by Jean-Baptiste Isabey, c. 1805, gold, enamel, and ivory. Stolen from the Valais History Museum in Sion, Switzerland.

ABOVE, LEFT: *Sibylle of Cleves* by Lucas Cranach the Younger, c. 1540, oil on wood. Stolen from the New Castle in Baden-Baden, Germany. ABOVE, RIGHT: Still life by Jan van Kessel the Elder, 1676, oil on copper. Stolen from the European Fine Art Foundation in Maastricht, Netherlands.

RIGHT: *Festival of Monkeys* by David Teniers the Younger, c. 1630, oil on copper. Stolen from the Thomas Henry Museum in Cherbourg-en-Cotentin, France.

LEFT: *Allegory of Autumn* attributed to Jan Brueghel the Elder, c. 1625, oil on copper. Stolen from the Museum of Fine Arts in Angers, France.

RIGHT: *Sleeping Shepherd* by François Boucher, c. 1750, oil on wood. Stolen from the Museum of Fine Arts in Chartres, France.

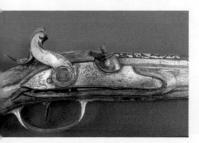

LEFT, DETAIL: Flintlock pistol by Barth à Colmar, c. 1720, walnut with silver inlay. Stolen from the Museum of the Friends of Thann in Thann, France.

ABOVE: *The Bishop* by Eustache Le Sueur, c. 1640, charcoal on paper. Stolen from the Museum of the Citadel in Belfort, France.

RIGHT: *The Apothecary* by Willem van Mieris, c. 1720, oil on wood. Stolen from the Pharmacy Museum in Basel, Switzerland. LEFT: *Soldier with a Woman* by Pieter Jacobsz Codde, c. 1640, oil on wood. Stolen from the Museum of the Citadel in Belfort, France.

BELOW: *Pietà* by Christoph Schwarz, c. 1550, oil on copper. Stolen from Gruyères Castle in Switzerland.

Village Entrance by Pieter Gijsels, c. 1650, oil on copper. Stolen from the Museum of Fine Arts in Valence, France.

Scene from the life of Christ, c. 1620, lindenwood. Stolen from the Art and History Museum in Fribourg, Switzerland.

Landscape with a Cannon by Albrecht Dürer, 1518, paper engraving. Stolen from the Fine Arts Museum in Thun, Switzerland.

ABOVE, LEFT: Chalice by I. D. Clootwijck, 1588, silver and coconut.

ABOVE, RIGHT: Chalice, 1602, silver and ostrich egg. Both pieces stolen from the Art & History Museum in Brussels, Belgium.

ABOVE: Warship, c. 1700, silver. Stolen from the Art & History Museum in Brussels, Belgium.

BELOW, LEFT: Albarello, c. 1700, terracotta. Stolen from Wildegg Castle in Mōkriken-Wildegg, Switzerland.

BELOW, RIGHT: Commemorative medallion, c. 1845, gold-plated silver. Stolen from the History Museum in Lucerne, Switzerland.

Lion and lamb, c. 1650, oak. Stolen from the Abbey of Moyenmoutier in Moyenmoutier, France.

NEAR RIGHT: Chalice, c. 1590, gold-plated silver and nautilus shell.

FAR RIGHT: *Three Graces* by Gérard van Opstal, c. 1650, ivory. Both pieces stolen from the Art & History Museum in Brussels, Belgium.

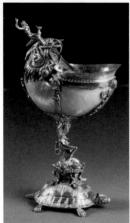

Musicians and Walkers in a Park by Louise de Caullery, c. 1600, oil on wood. Stolen from the City Museum in Bailleul, France.

He places an end of his Swiss Army knife against the lock and smacks the other end sharply with his palm. The entire cylinder pops from its housing and tumbles into the display, leaving behind a cleanly drilled hole in the display-case door.

The grand prize is the warship, but it's a large showpiece item far from an exit. Better to focus on the drinking vessels. The silversmiths' competition had coincided with the age of exploration in Europe, and the most aesthetically dizzying pieces to him are the ones that had incorporated newly arrived wonders, like ostrich eggs or coconuts. Best of all, to Breitwieser, are the chalices in which the wine flows from a nautilus shell, human imagination mated with natural geometric perfection. Breitwieser signals for Anne-Catherine to leave her lookout post at the doorway and join him. They gaze into the case. He can't decide, he says, which of the two nautilus creations to bring home.

"Take both," says Anne-Catherine. She offers her purse. Silver is high on her passion list too, and for these masterworks she loosens her size limits. Breitwieser glides one nautilus chalice into her bag and the other beneath his jacket, and with room to spare he takes a coconut tankard too. He pulls from his pocket the only item he'd stolen from the initial display case, the OBJECTS REMOVED FOR STUDY sign. He sets the sign down amid the remaining silver, slides the door closed, and reinserts the lock, which he's also grabbed from the display, in the hole.

They're at the car when he realizes that he's forgotten the lid to the coconut cup. *Merde*. Missing parts, or signs of restoration, are bitterly distasteful to him. The items in their collection must be wholly original and complete. Anne-Catherine knows that her boyfriend will never be able to fully enjoy the coconut piece as is. It doesn't matter that they've just escaped the museum. She removes one of her earrings and heads back. Breitwieser follows her. Anne-Catherine approaches a security guard at the entrance and says she's lost an earring and has a feeling she knows where it is. The couple is permitted back in. They return to the case and take the stein's lid, and while they're at it, two more goblets as well.

During the rambling drive back to France, he devises a plan. They can be chameleons, he says, and don't have to change that much to be different. For the next two weeks, he does not shave. Anne-Catherine alters her hairstyle. The day her vacation begins, Breitwieser drives six hours again, France to Germany to Luxembourg to Belgium. They each put on a pair of eyeglasses with round frames and nonprescription lenses and enter the Art & History Museum for their second visit.

The OBJECTS REMOVED sign is still there. A bent index card is the most effective art-thieving tool he has ever used. Confident, Breitwieser snares the warship. He'd been thinking of it incessantly. He fits the silver ship, the size of a birthday balloon and nearly as delicate, into Anne-Catherine's bag. Her purse appears bloated. Breitwieser also removes a twofoot-tall chalice and feeds it into the left sleeve of his coat, forcing him to walk unnaturally, his arm swinging stiffly like a soldier's.

On their way to the exit, they are stopped by a guard. Even a perfect crime can have moments of crisis. What keeps it perfect is the response. The guard says that he hadn't noticed the couple enter the museum and asks to see their tickets. Anne-Catherine's is at the bottom of her bag. Breitwieser's is in his left pocket, and with the silver up his sleeve locking his left arm, he reaches awkwardly across his body with his right hand and fishes out a ticket.

They are at the brink of terrible trouble, he senses. Breitwieser looks the guard in the eyes. "We are just heading to the museum café for lunch," he says steadily. He knows immediately he's said the right thing. The guard's suspicion is defused: criminals do not pause a heist to dine. The couple eats at the museum, her bag bulging and his arm held rigid the entire time.

They rent a basic room for forty dollars near the Brussels airport, at the Formule 1 hotel, their preferred budget chain. On the bedside table they place the chalice and warship. Breitwieser has a bank account but no checkbook or credit cards, to keep his movements less traceable. They try to pay for everything in cash, and if a card is required for a security deposit, they use Anne-Catherine's. Dinner while they're traveling tends toward filling and cheap—pizza, most often. Before bed, Breitwieser makes a telephone call. The world's greatest art thief must call his mother every night to let her know he's okay. If he doesn't, she'll worry. He tells his mother about their trip, except for the thefts.

The next day, and the following one, they avoid museums and instead go to the movies. Breitwieser doesn't like television, he hardly watches, but movies let him escape his own head and float away, sitting in the dark with Anne-Catherine. The genre doesn't matter; he's not picky with films. His favorite art-heist movie, he later says, is *The Thomas Crown Affair*, with Pierce Brosnan. After the two-day break, they disguise themselves lightly again. Anne-Catherine colors her hair in the hotel-room sink, and Breitwieser wears a baseball cap. The fake eyeglasses are discarded. They enter the Art & History Museum for their third visit and leave with more silver. They've now plundered a total of eleven pieces from the same museum in less than three weeks. The case with the OBJECTS REMOVED card is practically bare. Such is his level of euphoria that on the drive home, king of the world, he can't contain himself. He stops at an antiques shop displaying an immense urn, made of silver and gold, in the front window.

Anne-Catherine waits near the entrance while Breitwieser enters the store. The dealer calls from atop a staircase that he'll be right down, but by the time he descends, no one is there. Nor is the urn. They return to France, plunder-drunk and giddy, and for fun Anne-Catherine phones the shop and asks how much the seventeenth-century urn in the window costs. About \$100,000, she's told. "Madame," adds the dealer, "you really must see it." He hasn't yet noticed it's gone.

2.2

Four months after the great silver haul, while touring the medieval city of Lucerne in the Swiss Alps, they stop at a private art gallery. They rarely steal from commercial galleries, and Anne-Catherine signals that it's not time to try. The gallery is small, they're the only visitors, and the two employees on duty, Anne-Catherine notes, are keeping a loose eye on them. "Don't do anything," she urges. "It doesn't feel right."

Her counsel is wise and he knows it. It's also a hot day, Breitwieser has no jacket, and the gallery is across the street from the Lucerne central police station. The couple has no rules about stealing near the police, but it does seem like a bad omen.

And yet a radiant still life by the Dutch wizard Willem van Aelst is on display, unprotected, as if begging to be taken. Without a van Aelst in the attic his world isn't complete. The danger seems manageable: the employees aren't paying that much attention, and the door is a few strides away. He won't remove the frame; a jacket isn't necessary. "Trust me," he says softly to Anne-Catherine. "I know how to do this. I love you." He pecks her on the lips, lifts the van Aelst off the wall, and tucks it under his arm like a baguette, and they leave, nothing to worry about. They've walked maybe twenty steps when a hand grabs his shoulder from behind, roughly, and yanks him around until he's faceto-face with an employee from the gallery.

"What are you doing with that painting?" demands the man.

Breitwieser, stunned, can only stammer a half-formed excuse. He can't recall exactly what he said, but he remembers the response: "Liar! I'm taking you to the police." The employee's grip on him firms.

Anne-Catherine could have run off, but she stays to plead for her boyfriend's release. "Let him go. I'm begging you."

If they weren't so close to the station, they might have been able to talk their way out of it, or Breitwieser might have squirmed free. Instead, they are both arrested, and each escorted to a separate wing of the police station's holding cells.

Confined in his basement cell, Breitwieser feels as if he were being held underwater, he can hardly breathe. He'd been painfully stupid, stealing like a clown. He should have listened to Anne-Catherine. Now, pressured by the police, she could confess all their crimes. The authorities will search his mother's home; they may already be on the way. It is May 28, 1997, he's not yet twenty-six years old, and his life is over. The night creeps by miserably.

In the morning, he's loaded into a prison van, locked in a caged-off seat, for transport to the courthouse. Anne-Catherine is also on board, in her own cage. They're able to discreetly exchange a few words. She hasn't mentioned any other thefts, he learns. Their attic remains secret. Maybe there's hope.

"It's imperative that we agree on one thing," he whispers to her. "This is the only time we've ever taken something." She nods, understanding.

In court, speaking before a judge, Breitwieser offers a dishonest and tearful confession. He's never done anything like this in his life, he doesn't know what came over him. His girlfriend had nothing to do with it. He's deeply sorry, and he won't do it again. He seeks redemption.

The court seems to believe him. Neither of them has a criminal record in Switzerland, and no officer thinks of consulting the regional art-crimes inspector, Alexandre Von der Mühll, who later says that this doesn't surprise him; some police officers aren't aware that art detectives exist. A future court hearing will determine the punishment for Anne-Catherine and Breitwieser, but they can be released upon payment of bail.

The police have already called Breitwieser's mother and reported that her son has been caught stealing art. Stengel can no longer claim ignorance of his crimes, though his mother, like Anne-Catherine, does not reveal any additional thefts. Stengel even pays their bail. The couple drives home, Breitwieser says, in a state of shock.

Stengel has been lenient with her son all his life: when he was nabbed shoplifting as a kid; after he was arrested, twice, for aggressively arguing with a police officer; while he's lived rent-free with his girlfriend in her house. His imprisonment in Lucerne, though, snaps his mother's tolerance, and her fury fills the house. She pummels him with the unanswerable questions she's been holding inside her: "Are you completely nuts? Do you have any idea of the harm you're causing?" She detonates like the *Hindenburg*, and after ten minutes deflates.

Stengel's maternal protectiveness, always unconditional, kicks back in. She hires an expensive Swiss attorney. The attorney frames the case as a youthful mistake, a nonviolent first offense, and neither Breitwieser nor Anne-Catherine has to appear in court. They both receive suspended sentences and fines of less than two thousand dollars and are banned from entering Switzerland for three years. And that's it. The incident is swept under the rug, harmless and quick.

Legally, that is. Emotionally, things are more complicated. For Anne-Catherine, the arrest seems to wake every fear she's been attempting to suppress. She is afraid, most of all, for her future. She's been with her boyfriend for nearly six years, and they are still living in his mother's attic. Breitwieser keeps saying that they'll break free and get a place of their own, but she sees that this is a fantasy. He earns no money. And if they and the art do actually move, living amid a mountain of loot will never offer true freedom. The police will keep hunting them. What will they ever do with this stuff? What's the endgame?

Several months before the arrest in Lucerne, Anne-Catherine had realized she was pregnant. Starting a family might prove to be more fulfilling than life as an outlaw and rooms filled with riches, yet there is no option for a child in their conscribed existence. The threat of prison looms over them always. They can't even entertain visitors.

Anne-Catherine did not tell Breitwieser about the preg-

nancy, and he never noticed. She told his mother. Devotion to her son aside, Stengel apparently felt the same way as Anne-Catherine—that Breitwieser wasn't fit to be a father. The two women planned a road trip through Germany and the Netherlands, a chance for the three of them, as Anne-Catherine explained it to Breitwieser, to vacation together for once. This didn't prevent Breitwieser from stealing a piece of silver while they all visited a castle, a theft witnessed by Anne-Catherine but not by his mother.

The day after the castle visit, Anne-Catherine mentioned to her boyfriend that a gynecological issue had cropped up and that she had made a doctor's appointment nearby in the Netherlands. Breitwieser dropped off Anne-Catherine and his mother at the clinic. In truth, this had been planned in advance: an abortion far from gossipy Alsace meant a better chance of keeping it private.

Just a benign cyst, Anne-Catherine informed him. She and his mother have shared this significant secret for months. They've said nothing to Breitwieser. Maybe, the way Anne-Catherine views it, there's a silver lining to their arrest. After the extreme scare in the art gallery and the lucky resolution, now may be the time to figure out an endgame.

Breitwieser doesn't know about the abortion, but the couple have discussed raising a child. He says that he is willing to become a father, and Anne-Catherine is adamant that they will never have a baby while they possess stolen art. "This is a poisoned gift to a child," she says. Her words slice into him because he sees that she's right. He muses about how to empty the attic in a clean way that won't implicate either of them. Perhaps they can abandon the collection at a police station in the middle of the night. Then they can start their lives anew without stealing. They can grow up.

But maybe not quite now, Breitwieser adds, because there is also something else he's discerned. The worst thing possible had occurred: they were caught red-handed stealing a valuable work. And they were hardly punished! A ban on visiting Switzerland is nothing. Plenty of other countries remain accessible. There is no urgency to embrace maturity or find an endgame. They're still young. Anne-Catherine may be chastened, but Breitwieser feels bulletproof. 23

She loves him. He is so wrong for her that she had a secret abortion. He breaks the law constantly and she enables him. He loves her too, and that's why they're still together—love, and the chains of crime. These are the elements of Anne-Catherine's dilemma: leave him or stay? He isn't willing to seek an endgame, so she forces the issue. She gives him an ultimatum.

"It's art or me," she says. "You choose."

The world's beauty, to Breitwieser, peaks with Anne-Catherine and their art collection. He has inscribed this truth on the back of their paintings. Now he's been commanded, the way he sees it, to sacrifice half of his happiness. He refuses to answer.

Breitwieser's silence says plenty. In his report, the Swiss psychotherapist Michel Schmidt expresses no doubt which choice Breitwieser would make, if forced. "His collection," Schmidt writes, "takes precedence over everything, even above his girlfriend and mother." But he isn't forced. Anne-Catherine realizes, it seems, that she already knows the answer to her dilemma: she wants to stay. She had hoped to confirm that she is more important to him than the art, a validation that she is apparently not going to hear, if he's being honest. Maybe, upon reappraisal, she decides that inanimate objects, even illegal ones, are acceptable mistresses. Breitwieser yearns endlessly for new art, yet since the day they met, she's just about certain, he has remained steadfastly faithful to her.

No love can endure without compromise. Anne-Catherine backs down from her ultimatum and offers him a generously nonspecific settlement: he must steal much less often and far more cautiously. Switzerland is entirely off limits. Their fingerprints had been taken by the Swiss police and possibly distributed across Europe, so he must now wear surgical gloves. She will bring them home from her job at the hospital.

Breitwieser readily agrees to her terms, and for nearly a month after their arrest he does not enter a museum or gallery. Then, in late June 1997, they travel to Paris for a weekend getaway and attend a presale viewing at the Drouot-Montaigne auction house. In an uncrowded side room, he spots a lush scene of a grape harvest by the Dutch landscape master David Vinckboons, painted on copper.

He's brought his surgical gloves to Paris, and he tugs them furtively on. Anne-Catherine doesn't want him to do what he's clearly bent on doing, though there is no obvious reason to call off the theft. They both see that this nook of the auction house is poorly secured. If she refuses to serve as lookout, this only increases the likelihood that he will be caught. And if he is in trouble, she is too. She keeps watch. The French therapist César Redondo, who analyzed Anne-Catherine, felt that she has been pressured from the outset of the relationship into stealing and also that Breitwieser's coercion has metastasized into abuse, emotional and perhaps physical too. "The relationship," reported Redondo, "is one of dominance and submission." Anne-Catherine is being held captive, according to Redondo, forced against her will to abet his thefts. She's not an accomplice but a victim.

Redondo's evaluation may be correct. Those who know Anne-Catherine defer to the experts, unwilling to speculate further on her psychological entanglement with Breitwieser. Anne-Catherine herself will not respond to journalists' questions about his mistreatment, preferring to keep private on this subject, along with every other. Redondo has never watched the couple's home video in which Anne-Catherine relaxes amid the treasures, seemingly elated and playful, as if celebrating her criminality. When Bernard Darties of the French art police sees the recordings, he says that his initial conception of Anne-Catherine, as a pawn in Breitwieser's game, is overturned. She does not appear to be suffering or persecuted. "She's sparkling," Darties says, more a queen than a pawn. Anne-Catherine is strong-willed; she's the one in the relationship with a steady job. Staying with Breitwieser, more likely than not, is her choice.

In the Paris auction house, Anne-Catherine on lookout, Breitwieser feels strangely unsure of himself. There's been a bust and a monthlong stealing layoff, an eternity for him. His hands are unsteady in gloves. Doubt will destroy his stealing style, he knows, and he attempts to snuff it by simply initiating the heist and hoping that muscle memory takes over. He grasps the seventeenth-century copper painting and flips it over, a nice, familiar motion, and he pops off the brads as easily as opening soda cans. He ditches the frame in the room, and he and Anne-Catherine walk out of the auction house onto the Paris side streets, and no hand comes down on his shoulder.

Anne-Catherine's summer break begins soon after, in July 1997, and they return to the Loire valley west of Paris. For an entire week, almost, he's a law-abiding citizen. In a museum on the last day of their trip, he encounters another copper painting, of townsfolk and deer rambling through a marshy forest, titled *Allegory of Autumn*, unsigned but attributed to Jan Brueghel the Elder.

Yes: a Brueghel, the greatest family name in Flemish art, counterpart to the Cranachs of Germany. He doesn't have a Brueghel yet; what a coup this would be for the attic. The painting is hung formidably high, but the only other people in the museum are a cashier and a guard, kissing each other two floors below. Anne-Catherine positions herself at the stairwell. She'll cough if the guard takes his eyes off the cashier. Breitwieser climbs a chair, gloves on, and retrieves the work. He slides the frame under a display, and Anne-Catherine returns to wipe down the chair with her handkerchief, eliminating shoe prints too. They descend the stairs, the copper painting under his jacket, and say goodbye to the lovebirds on their way out.

From a small museum in western France a few weeks later, he nabs a pair of porcelain statuettes. In Germany, he acquires an oil painting, and then another in Belgium. Then it's back to Germany, in January 1998, for a trumpet. He feels as if the Lucerne disaster had never occurred.

This is precisely what Anne-Catherine doesn't want. Her compromise was meant to curtail his stealing, not rejuvenate it. On his latest heists, Breitwieser says, Anne-Catherine had in fact tried to constrain him, to talk him out of it, but he had exploited her tolerance. Give him a millimeter of wiggle room to steal, and he'll take it. Unless there's an obvious danger, he steamrolls ahead with his thefts and says to Anne-Catherine that she can wait outside, knowing full well that she'll consent to stand watch. After they return to the attic, her worry lifts, or so Breitwieser insists. At home, everything feels fine to him, and there's no more talk of curbing his crimes. They are a team of two, he believes, united against the rest of the world, and they're winning.

One day he sees in the house, amid a clutter of junk mail and torn envelopes, a bill from a medical clinic in the Netherlands. The statement documents an abortion. He notes the date and searches his memory. They had been traveling with his mother; Anne-Catherine had suffered a medical problem. He'd dropped both women off at a clinic. And in a rush it becomes clear: Anne-Catherine had colluded with his mother about terminating the life of their child. Anne-Catherine, the only person with whom he's been wholly himself, cleansed of secrets, the woman he trusted entirely, has been lying to him.

He bolts to his car and drives to the hospital where she works and heads up to her ward. *Their child*. The confrontation is awful, Anne-Catherine later says under oath. He's always had a temper, like his mother, and when he encounters her, incoherent with anger, wounded by betrayal, there's no attempt at discussion. He raises his hand to her and slaps her with his palm, hard across the face. Then he storms off.

She leaves work and takes the bus, he speculates, or gets a ride from a coworker to his mother's house. When she arrives his car isn't there—he's driving around trying to calm his head. Anne-Catherine climbs the stairs and packs her belongings, and then, he thinks, she calls a cab or her mother. She moves into her parents' apartment on the other side of Mulhouse, fleeing him and the attic and the art, every piece of it.

24

Anne-Catherine earns her driver's license and buys a Ford Ka, gumdrop shaped and raspberry red, and motors back and forth to work. After a couple of weeks with her parents, she rents a studio apartment on the outskirts of Mulhouse. The spring of 1998 warms into summer, and Breitwieser begins phoning her from his mother's house. For a while she looks at her caller ID and doesn't pick up. Then, four months after leaving him, she does.

Over those four months, Breitwieser had not stolen once. He felt sulky and rudderless without Anne-Catherine, sleeping alone in the four-poster bed, and his enthusiasm to pillage dried up. To keep himself occupied, he took a few temporary jobs, gift wrapping boxes, selling fur coats, but otherwise he holed up in the attic and brooded, he says. The sheen was scoured off his life and his art. Anne-Catherine's new phone number was listed, and he called her daily until she answered.

Breitwieser knows how to conjure artful words, in a

museum or on the phone with Anne-Catherine. He'd been blinded by obsession, he says to her, and subjected her to his volatile moods. He was like an obnoxious child who always needed a new toy. He accepts how the abortion was decided and vows to hold no more anger about it. He loves her, and he hasn't said that enough. She's the only possible woman for him. He has stayed faithful. Her absence has broken his artstealing addiction.

Anne-Catherine has a car, an apartment, and a daily commute. Without Breitwieser, her life chugs in predictable circles. But a steady flow of excitement, suggest those who know Anne-Catherine, is her drug. With him, there's a secret treasure chamber, literally, and weekly art heists. And something about his lunatic passion, or maybe just his blue eyes, is unquittable to her, or nearly so. "If you ever lift a hand to me again," she says, "I'm gone forever." She does not forbid him to steal, she knows the deal by now, but she doesn't want to play an active role in the thefts. Anne-Catherine keeps her apartment, a refuge free from art, and moves back into the attic with him.

The bed feels warm to him, the oil paintings bright. His malaise lifts; he's reincarnated. And suddenly he's aesthetically starving. He forages at a few local museums while Anne-Catherine is at work, taking a charcoal drawing one week and a hardwood keepsake box the next.

Of the 250 items he's stolen by late 1999, only a few, early on, came from churches. Anne-Catherine had been upset by these thefts, and Breitwieser was uncomfortable too. He is not religious, but his mother is a practicing Catholic, and if she ever found out he had robbed churches, he thought, she'd be 1 3 1

particularly pained by these sins, more so than by any of his others. So he abandoned church stealing.

Now that he's working alone, churches offer exactly what he is seeking: nearby places he hasn't yet plundered, with art he savors, often secured so poorly that no lookout is necessary. He takes a wooden winged cherub from one church, a bust of Christ from another, and a wooden bas-relief of Mary Magdalene from a third. The church heists are uneventful, netting high-quality art, and he rolls on—a candleholder, a marble holy-water basin, a stonework angel.

The walls and shelves in their attic are nearly full, and Breitwieser begins stacking items on the floor. The shoe caddy in their closet becomes a cubby for brass works. The calendar flips to 2000, and the couple, observing their usual New Year's Eve custom, stays home and does nothing. Their three-year ban on entering Switzerland expires. Salaries are higher there, and Breitwieser, able to speak German and French, finds the best-paying job of his life, earning upwards of four thousand dollars per month waiting tables at an upscale brasserie, an hour-and-a-half commute from home.

Flush with money, he strives to satisfy Anne-Catherine's need for excitement in legal ways. He buys plane flights across the Atlantic, and he and Anne-Catherine both take time off from work and embark on a two-week romantic adventure in the Dominican Republic. It's a relationship-affirming trip, Breitwieser feels. While there, he does not steal once. After the Dominican vacation, he promptly starts planning another trip for the two of them.

Anne-Catherine, concerned about where her boyfriend is working, explicitly cautions him. Even though they're allowed back in Switzerland, she says, stealing there remains forbidden. They were lucky once, but a second arrest would likely be catastrophic. In theory, Breitwieser agrees with this stealing ban. In fact, each time he drives through Switzerland to his restaurant job, he thinks of every museum along the way. 25

His resistance crumbles, of course, dramatically. In rapid succession, he brings home a silver sugar bowl, two Communion chalices, a stained-glass windowpane, a soup tureen, and a commemorative medallion. He lies to Anne-Catherine about stealing in Switzerland. She doesn't seem to notice that he's stopped adding newspaper articles to their scrapbook.

On a day off from the restaurant, he visits a museum alone and swipes ten items at once, his one-day record, stuffing his backpack, his overcoat, and his pants with a teapot, two serving spoons, six silver cups, and a wooden box containing a cutlery set. In February 2001, he returns by himself to Gruyères Castle in the Swiss Alps, where he and Anne-Catherine had taken their first painting, six years before, on their way to a ski resort. He has looted about a dozen museums more than once; from Gruyères Castle, he steals four different times in total, three of the occasions with Anne-Catherine, taking two paintings and a fireplace tool.

For his solo trip to Gruyères, he hides an empty duffel

bag in his pants, wrapped around one of his legs. His target is an enormous, seventeenth-century tapestry, ten feet wide and ten feet long, that had transfixed him from the initial visit with Anne-Catherine. She was always a moderating presence, unwilling to risk prison for an artwork this size. But he's moving on without her, and attempting the tapestry feat seems like a natural progression.

The tapestry depicts forests and mountains and villages, an entire world sewn within, a work he could never grow tired of seeing. His plan is to sneak the duffel bag past the front desk on his way out, possibly by holding it low to the ground. He detaches the tapestry from the wall, but no matter how he folds the thick fabric, he can't zip his bag. With visitors approaching, he revives a ploy he'd used long before, while stealing a crossbow in another castle, during his second-ever theft with Anne-Catherine. He hoists the duffel out a window. He leaves the castle, slogs around the outside through mud and cow manure, and retrieves it, victorious.

On a stormy day, he tests one of his church-stealing ideas. He chauffeurs Anne-Catherine to work in her car, rain pouring down, and drops her off at the hospital entrance. There's no need for her to get soaked while walking in from the employee parking lot. He'll be back to pick her up after work, he says. His chivalry has an ulterior motive: the seats in Anne-Catherine's car fold down in a way that offers significantly more storage than his vehicle. He drives to Saint Sebastian Chapel, perched on a hill overlooking the red-tiled roofs of an Alsatian village, a church that he has visited periodically since childhood.

Inside by the altar, carved in limewood in 1520, is a four-

1 3 5

foot-tall statue of the Virgin Mary, robes flowing, head tipped heavenward. On a previous trip, Breitwieser studied how the piece was bolted to its pedestal, and he has borrowed the proper wrench from his mother's toolbox. A caretaker, he'd observed, lives in the cottage behind the chapel. Parishioners arrive throughout the day, but the nasty weather, he hopes, will keep them away. When he pulls up to the church, the only car in the lot is the caretaker's.

Unbolting the piece isn't a challenge. The issue is hauling the 150-pound carving up the aisle. He grasps the Virgin around the waist and staggers a couple of steps, then puts her down and rests. He makes no attempt at stealth; if he's seen, he's busted. He is gambling that no one will enter the church while he's there, and nobody does. He heaves the sculpture out of the chapel and into Anne-Catherine's hatchback, and drives through the rain and lugs it inside the house. He's drenched, exhausted, and thrilled. He collects Anne-Catherine at work.

Even before she sees the carving, she's angry. The odor of incense permeates her vehicle, the smell of church, and he reveals what happened. She'd been at work all day, but her brightly colored car, so easily spottable, has been used in a crime, without her permission. There is no room in the attic to display the giant piece, which he'd jammed in a corner and partially covered with other items. The tapestry he's dragged home from Gruyères requires a hundred square feet of wall space when they have none, so he has shoved it unceremoniously under their bed. He can't even look at it.

Worse, he's mistreating the works. Breitwieser has always insisted that protecting the art is his primary concern, but a delicate tapestry like the one from Gruyères doesn't benefit from flying out a window or being stuffed under a bed. As for Renaissance paintings, he knows that they should rarely be budged, let alone yanked off walls, hastily unframed, and rattled through city streets in the back of a car. In the attic, the three conjoined wooden panels that form the oil painting of the apothecary shop, the valuable piece that he had stolen with his back to a surveillance camera, begin to separate and warp.

He's devastated, he says, about the decay of the apothecary painting. A skilled professional restorer, employing technical tools and surgical precision, can gradually untwist wood and reconnect panels, rendering a work nearly new. Breitwieser knows this. He could anonymously drop off the painting at any museum or art gallery, and an expert would surely be brought in to handle the repairs. Instead, he tries to fix it himself. Employing a method that no art restorer has ever recommended and one curator calls "brutal," he forces the panels into approximate position and seals them with Super Glue. The painting remains in the attic.

Then a ceramic platter decorated with cherubs, from a museum in the Loire valley, slips to the floor and shatters. The damage is irreparable and the work is thrown out. Breitwieser seems to have passed some tipping point in his life, and a demon has emerged. He also stumbles over a small still life of a roasted chicken that they'd acquired in Normandy, crushing it so badly that this piece too is swept in the trash.

Anne-Catherine had respected his clean eye for beauty, but at this point, she later says to investigators, his stealing has become "dirty" and "maniacal." His aesthetic ideals about idolizing beauty, treating each piece as an honored guest, have 1 3 7

descended into hoarding. She doesn't like most of the work he brings home now, and some of it, she says, is ugly.

Yet despite his wild stealing, and appropriating her car, she doesn't abandon him and flee to her apartment. She stays. They both turn thirty years old in 2001, first Anne-Catherine on July 5, then October 1 for him. Unless he specifically shows her a piece, she hardly pays attention to new items anymore. The attic is less a room in the Louvre than the world's most valuable junkyard. It's just one thing after another, without end. 26

He carries home a four-hundred-year-old bugle in flawless condition, with gleaming brass tubing and an ornate leather shoulder strap. When Anne-Catherine returns from work, he can't resist flaunting the new treasure and telling her about the stylish theft.

The bugle had been exhibited in a sealed display box, mounted in the museum at almost ceiling height. He had to climb onto a radiator and reach out with his Swiss Army knife to unscrew the front panel. In the midst of this effort, he paused a few times and hopped down to the red-carpeted floor and tromped about. This way, the cashier one story below, the only other person in the museum, would hear him and not grow suspicious.

With the display open and the front panel stashed in an adjacent room, he scaled the radiator again, pushed away a hanging light fixture that was hindering his access, and swiftly cut the nylon cords holding the bugle in place. By the time the lamp had stopped swinging, he'd stowed the instrument under his dark green Hugo Boss trench coat, and headed out.

Anne-Catherine is unimpressed. They already own a better bugle, a triple-coiled instrument they had stolen together in Germany. Also, a few details are missing from his tale.

"Did you wear gloves?" she asks.

"I'm really sorry," he says. He'd required maximum dexterity to pull off the heist.

Gloves are one of her two ironclad rules. She learns then that he's broken the other: the Richard Wagner Museum, where he had stolen the bugle, is in Switzerland. You wouldn't think his behavior could get any worse, but it could. The Wagner Museum is in Lucerne, the very city where they'd both been arrested.

The anger in her eyes, Breitwieser says, is of a voltage he'd never seen. His fingerprints are all over another crime scene in Lucerne, she fumes, and soon they would both be going to prison. Frightened by her outrage, Breitwieser promises that he will make things right. He will drive back to the museum and erase his fingerprints.

No, says Anne-Catherine. That's too risky. Instead, she will take the day off from work and go to the museum early in the morning and clean the prints by herself. Breitwieser says that at least he should drive, and she warily consents.

They use Anne-Catherine's car, and the mood in the vehicle is frosty. They scarcely speak. But as they pull in to the Richard Wagner Museum, in a manor where the composer had resided in the 1860s and '70s, his mood is lifted by a sublime sweep of natural beauty. The Wagner Museum sits on a promontory in a gorgeously landscaped city park on the edge of Lake Lucerne, cupped in glacier-clad mountains. Anne-Catherine opens her door, a handkerchief and a bottle of rubbing alcohol in her bag, and he feels for a moment that maybe they can again find their love.

"Stay in the car," she tells him. "I'll be right back."

"I'm just going to take a little walk," he says. "Don't worry." And he too gets out, pulls on his green trench coat, and hands her the car keys to hold in her purse. Then he leans in and gives her a kiss, one that he hopes carries with it the start of their thaw.

She enters the museum, purchases a ticket, and walks upstairs to the second floor. Breitwieser circles around the outside of the mansion, three stories high with whitewashed walls and forest-green shutters, and watches her progress as she's framed in one window, then another, a vision of elegance in her fitted gray suit.

Finally she disappears into an interior room, and he waits. There are only a few people around, including an older man walking a dog who seems to stare curiously at Breitwieser before trotting off. Swans bob on the lake; waves splash rhythmically against the shore. A church bell tersely chimes the quarter hour.

Anne-Catherine exits the museum and walks quickly toward him. She's nearly jogging, which is odd. They never want to appear as if they were fleeing, although this is one of the rare times that they've gone to a museum with no thought of stealing. He has the impression that she's attempting to tell him something, but she is too far away to hear. He's trying to decipher her anxious face and twitchy hand gestures as a police car rolls to a stop on the gravel path behind him.

Two uniformed officers emerge from the car, and for an instant Breitwieser believes that they're not here for him. He has no loot under his jacket. He's not even inside a museum. Yet the officers promptly approach, and one pulls out a pair of handcuffs. Breitwieser is startled, though he doesn't resist, and while he's shackled, he makes eye contact once more with Anne-Catherine. She appears frantic and confused, but she's fortunate that the police do not notice her as he's loaded into the back of the squad car and taken away. 27

Breitwieser passes an anguished night in a basement holding cell in the same Swiss police station where he was detained for stealing a painting four years before. The next morning, Wednesday, November 21, 2001, a police inspector arrives at his cell and politely introduces himself.

Roland Meier is nearly the same age as Breitwieser, both men new to their thirties, with similarly lean features and gem-blue eyes. They speak to each other in German, each with a native Alsatian accent, geographic brothers. Before heading to the cell, the inspector had studied the report on Breitwieser's initial arrest in Lucerne. Meier figures that he's dealing with a petty thief—and not a particularly talented one at that, judging from the two busts—who was seeking to make a quick profit from the area's lightly protected museums and galleries.

The inspector escorts Breitwieser, without handcuffs, from the underground cell area to an elevator, then up to a main floor of the modern police station and into a boxy interrogation room. The two of them sit across from each other at an empty white desk, enclosed by sterile white walls, no lawyer or anyone else present.

"What do you know about the disappearance of the bugle?" asks Meier.

"There must be some mistake," says Breitwieser. "I had nothing to do with it."

The inspector is not in a rush. In his free time, Meier is a mountaineer and a marathon runner. Both at work and at play he favors the long game. Meier patiently clarifies Breitwieser's predicament.

The day of the bugle theft was unusually quiet at the Wagner Museum. Three visitors in total entered. The one employee on duty, Esther Jaerg, liked to walk through the rooms when no tourists were there, and on one of her rounds, after a visitor in a long green coat had departed, she spotted the bugle theft. The instrument is valuable and historical, having been acquired by Wagner himself. Jaerg called the police, and two officers promptly arrived and searched for fingerprints, shoe prints, and DNA.

An article about the crime appeared the following day in *Luzerner Zeitung*, the local paper. The report was read by a retired radio journalist who walked his dog daily near the museum, and when the dog walker noticed a man strangely circling the mansion, staring up at the windows, he hustled into the museum to alert an employee. Jaerg was working again, and she stepped outside and recognized the green coat. Once more, she called the police, who came and arrested the man in the overcoat.

Hearing this, Breitwieser can't hide his distress. The

return trip to the Wagner Museum, demanded by Anne-Catherine, had been not just risky and unwise but also utterly pointless: all the evidence had already been gathered before Anne-Catherine and her handkerchief had arrived.

The inspector sees Breitwieser's hurt, and presses on. "Your prints were everywhere," says Meier. Forensic evidence, the inspector reminds him, is definitive. You can't talk your way out of it.

Breitwieser stays silent. "We know it's you," Meier nudges.

The inspector does not, in truth, know it's Breitwieser. Not a single identifiable fingerprint has been reported by the Lucerne crime lab. The inspector is bluffing; he needs a confession. He falsely informs Breitwieser that prints found at the Wagner Museum perfectly match those collected after his first arrest.

"What's more," Meier adds, going for the kill, "you were spotted in Lucerne the very night of the bugle theft." He's been recorded on video, Meier says.

And with that overreach, Meier tips his hand. Breitwieser had driven straight home after the bugle theft, nonstop, not even for gas. The inspector, Breitwieser realizes, is lying about Lucerne, and therefore he might be lying about the fingerprints too.

Breitwieser forcefully maintains his innocence, and to his grateful surprise Meier calmly accepts his denial. The inspector, Breitwieser now senses, has no real evidence. If Meier did, he'd push harder. This is how Breitwieser pictures most police inspectors—underskilled and overconfident. He thinks he can get away with the bugle crime if he handles everything right.

It's clear to Breitwieser that the inspector believes he was alone when arrested at the Wagner Museum. If the police don't know he has an accomplice, they won't be searching for her. He can leverage this advantage by phoning Anne-Catherine and asking her to quietly return the bugle. If she just tucks it under a bush near the museum for a pedestrian to find, that should provide enough of an alibi. The authorities will have to release him, and this will settle his dominant fear—police entering the attic and finding the hoard.

After his half-hour meeting with Meier, Breitwieser is brought back down to the basement cells. There he learns that he's been classified as a high-security inmate and can't make any personal telephone calls.

Meier's original intuition, that Breitwieser is a small-time criminal, still holds. But during the terse interrogation, Breitwieser was sharper and more poised than Meier had expected. It was impressive, perhaps suspiciously so, that Breitwieser didn't crack when rattled, and how smoothly he had navigated the inspector's bluff. Meier is now freshly curious about the two art crimes, four years apart. Two thefts could be the extent of it, or the start.

Meier speaks with a judge. Breitwieser is potentially a serial art thief, and the inspector is given legal permission to continue jailing him in high-security conditions. Meier is also granted authorization from the judge to obtain an international search warrant so officers can travel from Switzerland to France and comb through his house. $\mathbf{28}$

Days drip past, a week's worth. Securing an international search warrant is a bureaucratic tangle. Meier awaits approval and Breitwieser languishes in jail. The only phone call Breitwieser can make is to the French embassy; his only visitor can be a lawyer. The embassy provides no help, and a public defender has not yet been assigned. Criminal charges against him remain undecided.

Breitwieser, unaware of the pending search warrant, does not know what he is waiting for, or when the oblivion might end. He can see other inmates, though he's nearly in solitary confinement. Even the worst piece of modern art would distract him here, but there's nothing on the walls of his cell. He's alone with his negative thoughts.

Meier eventually drops by, unlocks the cell door, and stands in the doorway. "Have you had a chance to think about things, Mr. Breitwieser?" The inspector invites him to the interrogation room to confess. Breitwieser remains strong enough to say no. "No?" probes Meier. He rebolts the door.

Breitwieser is allowed to send and receive letters, though they will be examined by court officers. "I feel far away from everything and everyone," he writes to Anne-Catherine. "The world has abandoned me. I suffer constantly, I'm regretful, I cry and cry some more." He draws two little hearts at the bottom.

Ten more days elapse. No letter arrives from anyone. Where is Anne-Catherine? He thinks that while she was erasing his prints in the Wagner Museum, she overheard the conversation between the dog walker and the employee about the suspicious man outside. Anne-Catherine understands German, and she must have hurried out to try to warn him. Then, too late, what did she do? And what did she tell his mother that would also prevent her from writing?

The first time he'd been arrested in Lucerne, his mother had helped him after one day. Now the silence from both women is torture. The longer he refuses to cooperate with the police, he becomes convinced, the greater number of years he'll spend in prison. When Meier stops by again and asks if he'd like to reveal more, Breitwieser says that he would.

His confession is recorded in the interrogation room. Meier begins: "Are you ready to provide truthful statements to the police?"

"Yes," says Breitwieser.

"Why did you visit the Richard Wagner Museum?"

"I'm interested in classical music," Breitwieser lies. He mentions that he traveled by train, alone, from France. This is so the inspector won't question why his vehicle was not found in any parking lot. Meier does ask why he had no train-ticket stub on him when he was arrested, and Breitwieser says that he threw it away.

"What did you plan to do with the bugle?"

"I thought I'd give it to my mother for Christmas. It had such a radiance." If he'd known how precious it was, Breitwieser says, he never would have stolen it. "I promise that I did not want to sell the instrument. I'm very sorry for my act."

Meier and Breitwieser rehash the theft—how he had removed the instrument from the display case, how he'd left the museum with it under his coat. This part Breitwieser is honest about. Breitwieser even draws a sketch to help clarify the building's layout.

"Did you carry a weapon?"

"No."

"Did someone assist you?"

"I was alone." The theft, he says, was entirely unplanned. "I acted on a sudden impulse."

"Are you guilty of any other thefts?"

"I only stole this one musical instrument, I swear." The last time he tried to steal, he says, was at the gallery in Lucerne, four years back.

"Where is the bugle now?"

"Hidden at my mother's house in a cardboard box in the garage, next to some tires. She doesn't know it's there." He had actually hung the bugle's strap over a corner of one of his oil paintings, but he has resolved never to mention the existence of the attic to Meier.

"Why did you come back to the museum?"

After the theft, Breitwieser says, he grew increasingly agitated and no longer wished to give the bugle to his mother for Christmas. He wanted to give it back. He returned to the museum by train to erase his fingerprints and look outside for a good place to hide the horn. This is when he was arrested. His plan was to bring the bugle on a following trip and anonymously alert the museum where to find it.

This cover story, Breitwieser feels, will shield his girlfriend and mother from punishment, keep the police out of his attic, and minimize his own penalty. Now that he has admitted to stealing the bugle, he will send letters to both Anne-Catherine and his mother, begging them to bring the piece back to Lucerne. They don't have to be secretive about the return. One of them, he's counting on, will receive his note and comply. And when the instrument is handed over to the museum, in perfect condition, that should be the end of any police investigation. He'll be imprisoned for no more than a month, he hopes, even for a second offense. Switzerland has a reputation for leniency. He should be home by Christmas.

To Meier, this story—a thief who's had a sentimental change of heart and wants to undo his crime—is beyond his limits of credulity. Picking out whatever kernels of honesty Breitwieser might have scattered in his fairy tale isn't worth the inspector's effort. Meier concludes the session without inquiring further and escorts him down to his cell. If the truth won't come from Breitwieser, the inspector will look for it elsewhere.

Six more days pass. Breitwieser mails letters to Anne-Catherine and his mother about returning the bugle to Lucerne, but there's still no contact from either of them. He loses faith in his ability to worm out of trouble. He's condemned to a black hole; he feels increasingly sick. By the time the international search warrant is approved, Breitwieser has been in custody for twenty-three days. On December 12, 2001, Meier travels across the border with another Swiss inspector, and they join a pair of French police detectives. The four officers drive to the Mulhouse suburbs, where the housing developments cut into the cornfields, and arrive at a modest unit painted coral white, with a clothesline out back, number 14-C. It's 5:30 on a Wednesday evening. They knock on the door.

Mireille Stengel answers. A few wisps of gray streak her blond hair. "There's no need to search here," she says after the officers show her the warrant. She claims that she has no idea what they're talking about. "My son didn't bring any objects home."

Stengel has no choice, though, but to step aside and permit the officers entry. Soon they climb the narrow stairs to the attic. The door is unlocked, and they open it.

There is no bugle inside. Nor is there any other musical instrument. There are no silver objects, no antique weapons, no ivories or porcelain or gold. Not a single Renaissance oil painting, not so much as a picture hook. Nothing but clean, empty walls surrounding a lovely four-poster bed.

29

Meier opens a desk drawer in the interrogation room and slides a photograph over to Breitwieser. The image is of a goldplated medallion from the seventeenth century, big around as an appetizer dish, that he had taken in Switzerland two weeks before the bugle theft. A medal that he'd once thought would bring him good luck now appears faded and scuffed, and Breitwieser wonders what happened to it.

"We are sure that you also stole this," says Meier. Again, though, the police are unsure. The search of Breitwieser's home yielded only disappointment, but the inspector remains wary of his lies, and Meier has one more idea to determine if Breitwieser is a big fish or not. "Tell us," Meier says, "and after that everything will be okay. We'll let you go home."

That's all Breitwieser wants, to go home, and Meier knows it. Christmas has come and gone without visitors or holiday cards. New Year's Day 2002 recently passed. Breitwieser is still being held under high-security lockdown. He has heard nothing from his mother or Anne-Catherine, and isn't aware that the police have searched his home. He has no idea that his collection has disappeared from the attic, along with his clothes and his books. Until now, he has only admitted, semi-honestly, to stealing the bugle. But after more than two months of imprisonment, he feels as if he's been buried alive, and when Meier offers a lifeline he takes it.

"Yes," he admits about the medallion, "it was me."

Meier opens the drawer again. There's one additional thing, Meier says, his tone almost apologetic. The inspector passes another photo across the desk, of a gold tobacco box that he and Anne-Catherine had stolen from a Swiss castle. It was Anne-Catherine's favorite of the half dozen tobacco tins they took. In the photo, the box looks slightly dirty. Meier requests one final confession, a few simple words will suffice, and then Breitwieser's nightmare can be over.

He confesses to stealing the tobacco box as well.

For the third time, Meier pulls out the drawer. The inspector reaches in with both hands and scoops up a mass of photographs and spills them onto the desk. There's a picture of an ivory flute from Denmark, a bronze figurine from Germany, a silver goblet from Belgium, and the very first item that he and Anne-Catherine took, nearly eight years before—the flintlock pistol from France.

Breitwieser, usually astute at reading a scene but broken down badly by jail, realizes that he's been outplayed. For the first time in his life, he has no moves left. It's checkmate. He confesses, one by one, to stealing every piece in the photos. When the stack of pictures is exhausted, Breitwieser has acknowledged 107 thefts.

Meier can scarcely grasp the scope of the case he's just

cracked, but the inspector does not overtly gloat, that isn't his style. Meier sits there, a little stunned. On the interrogation room desk, accidentally left open among the photos scattered like playing cards, is the folder that had held all the images. In the folder, faceup, is a typed police report. Breitwieser scans the document, and only now, in defeat, does he find out why so many of the pieces seem discolored.

A week after his arrest at the Wagner Museum, Breitwieser learns from the report, a senior citizen named James Lance was strolling at sunset alongside the Rhône-Rhine Canal in eastern Alsace. Lance spotted a pair of objects glinting through the murky water. He assumed it was junk, but Lance was intrigued enough to return the next day carrying a rake with a telescoping handle.

This section of the canal, part of the system ordered by Napoleon to connect the rivers of France, is shaded on both banks by sycamore trees, hidden from the roadway that runs parallel. Lance raked to shore a chalice, seemingly made of silver, imprinted with the date 1619. He dragged in another silver drinking goblet, equally extraordinary, then a third, then a fourth. He also fished out a hunting knife engraved with a woman's portrait. Lance reported the remarkable find to the local police.

A pair of officers arrived at the canal, then a team of police, then divers from the River Brigade of Strasbourg. At times, thirty officers worked at once, scooping with nets and searching the shallows with metal detectors, the divers plunging as deep as ten feet into the murky water in the middle. The canal was then partially drained along a half-mile stretch. For three days, piece after piece was piled on the shore. Platters, bowls, tumblers, mugs, a dazzling warship—an extravagance of silver—were mixed with medieval weapons, a knight's helmet, two Gallé vases, six gold pocket watches, an hourglass, a table clock, and works in pearl and wood and ceramic. An oil painting was also found, the water damage minimal because it was composed on copper, and an abundance of ivory, including a virtuoso carving of Adam and Eve.

A total of 107 items emerged from the water, which the district police stored in an empty jail cell at the station. The Strasbourg antiques dealer Jacques Bastian, known for his discerning eye, was asked to inspect the haul. When Bastian arrived, he was awed. Whoever had owned them, he said, was "a real connoisseur." The works needed a professional cleaning, but were otherwise in fine condition or fully repairable. They evidently hadn't been submerged very long. Bastian estimated the total value at fifty million dollars. Police transported the lot by armed convoy to a secure storage area at a museum in the nearby city of Colmar, where each piece was diagnosed for restoration and photographed.

The canal treasure was a big news story in the region, and the French art-police force, the OCBC, swooped in and discovered that every work had been stolen. Here was evidence of the serial thieves the OCBC had been tracking, the slickstealing couple with a sharp eye for art, plus enough extra loot to satisfy a dozen more gangs. Could one couple possibly have stolen this much art, and if so, why did they throw it away? The OCBC was baffled; they still had no clue who the thieves were.

Over in Switzerland, Meier was intrigued by the canal find. After his failed search in the Mulhouse suburbs, he requested a copy of the canal photos. Meier received the images, ushered Breitwieser into the interrogation room, and cleverly induced the confessions. A few days later, on February 7, 2002, after seventy-nine days imprisoned in Lucerne, Breitwieser is handed the clothing he'd been wearing when he was arrested and told to change out of his jail uniform. He's pulled from his basement cell and loaded onto a train, in a prison car.

He is one of ten inmates in the train car, each of them locked in a tiny cell, with guards in the aisle. He's the only one wearing a Hugo Boss overcoat. Breitwieser had always felt superior to other criminals, but now, despondent and gaunt, he's envious of the toughness and apathy they all seem to naturally project. He doesn't know where he's headed, nobody tells him anything, but wherever it is, he's worried to the point of tears that things are only going to get worse. 30

The train clatters a few hours southwest through the Swiss mountains and foothills, and Breitwieser is removed a little before Geneva. He's locked in another jail, older and dirtier than the last, and escorted the next day to the jail's interview room. There he meets, for the first time, Alexandre Von der Mühll, the art-crime detective who had stalked him for six years. They sit facing each other at a table. The only other person in the room is a stenographer.

Von der Mühll is barrel-chested and big-bellied, his head nearly bald. Instead of a police uniform, he wears a buttondown shirt and a blazer, the fabric stretched tight, intimidating. The detective, who consents to an in-depth journalistic interview in which he recounts all of his interactions with Breitwieser, pulls out five more photos of artwork from his wallet. Von der Mühll places the photos in front of Breitwieser.

"That's not me!" yelps Breitwieser, pushing back his chair.

"Relax," the detective says. Breitwieser has not requested

a lawyer, and Von der Mühll wants to keep it that way, so the detective is playing up his compassion, not his size. Muscle isn't needed here; flattery is. "These works are from my house."

Breitwieser settles. A couple of pieces in the photos, an oil portrait and a marble figurine, despite being a century too new for Breitwieser's usual taste, are items he might have considered stealing.

"I'm a collector," Von der Mühll says. The detective explains to Breitwieser that after the canal find, an art-crime specialist was needed on his case. Breitwieser had been sent by train to the town of Vevey, where Von der Mühll's office is in the regional police station. "I know you're not an ordinary thief," the detective says. "You're a collector too, and that's gratifying." He says that Breitwieser's crimes all seem motivated by passion, not money.

This burly detective is the first police officer Breitwieser has ever met whom he hasn't hated right away. They talk to each other in French, soon shifting into the informal syntax and addressing each other by their first names, neither of which he ever did in German with Meier.

Von der Mühll says that a full and voluntary confession will please the court and result in the lightest possible sentence. The detective starts again with the canal photos, dealing them out geographically, beginning with items stolen in Switzerland and spiraling out from there, eventually encompassing seven countries in Europe. Von der Mühll asks what he recalls of each theft, and Breitwieser, buttered up, adds layers of detail to his previous confessions. At times, he seems to describe every turn of every screw.

They meet six or more hours a day, five days a week, for

just shy of a month. Von der Mühll sometimes smokes a pipe while they chat, and often sends Breitwieser back to his cell with an art book or auction catalog. One afternoon, he drives Breitwieser around in his personal car. Von der Mühll devotes almost all his time to the case, trying not to be overly menacing or judgmental. "I can't excuse that, but I can understand," is a phrase the detective is fond of saying. The Swiss authorities have been able, so far, to prevent the story from leaking to the press; media attention is almost always disruptive to an investigation.

After the canal items are covered, Von der Mühll mentions other museum thefts. These are crimes in Switzerland and beyond where objects from the late Renaissance or early Baroque, often in silver or ivory, were stolen during daylight hours. In a few places, witnesses reported seeing a young, well-dressed couple. Yet none of these items were found in the canal.

Breitwieser does not forget that Von der Mühll is a cop, but he believes that the detective is sympathetic to his plight, and likely the best ally he'll find in law enforcement. He has been advised by Von der Mühll to admit to any additional crimes he's committed. If he refuses to cooperate and the police have to expend effort proving their case, this defiance, Breitwieser is told, will come back to haunt him in court.

He confesses to dozens more thefts, though none that Von der Mühll doesn't first prompt. Breitwieser generally hews to honesty, except about Anne-Catherine. He repeatedly describes her as an innocent bystander who was using the bathroom while he stole, or was in another gallery, and never knew what he was doing. He's trying to minimize her 1 5 9

potential punishment. In his cell, he keeps a sheet of notes, written in code and stashed in a book, recording what he has said about Anne-Catherine's location in each museum or auction house. That way he won't contradict himself in future interrogations or at a trial. His mother, he emphasizes, was completely unaware of his actions. "I'm the only one responsible," Breitwieser says several times, throwing himself under the bus.

Von der Mühll has seen the surveillance videos and read the witness statements, and realizes that Anne-Catherine played a more active role than Breitwieser is saying, but the detective tolerates these elisions. Neither Anne-Catherine nor his mother faces criminal charges in Switzerland; the French authorities will deal with them. If Von der Mühll aggressively tries to implicate either woman, Breitwieser will probably stop talking and ask for a lawyer. Treating Anne-Catherine and his mother as innocent is the unspoken price of his confessions.

Together, the detective and Breitwieser discuss the items he stole, in silver, ivory, porcelain, and gold—they talk about everything except oil paintings. Paintings are the highestvalue items, and Von der Mühll holds back on these questions, waiting to build the maximum possible trust between them. The detective eventually decides that they've reached this point.

"We have to talk about the paintings you stole," Von der Mühll says directly. Only one painting was found in the canal, a work on copper. The detective is sure that this was not Breitwieser's only painting. His first arrest in Lucerne, before the bugle, was for a still life, an oil on wood. Von der Mühll estimates that there are ten to twenty paintings missing from European museums for which Breitwieser may be responsible, worth an incredible sum. "How many are there?" he asks.

Before Breitwieser can filter out the truth, it slips pridefully through. He admits that he has stolen sixty-nine Renaissance paintings.

Von der Mühll maintains his composure even while thinking that this has just become one of the largest art crimes in history. The essential step now is to recover the works. The longer the paintings are hidden, the more likely they'll be damaged. "Where are they all?" the detective asks.

"The last time I saw them was in the attic," says Breitwieser. When he had read the police report about the canal dump, he'd been shocked, but as with so much in his life now, he was forced to live with the confusion. He figured that one day everything would be clear. The canal items had all withstood their bath; dumping the pieces in water was not an action Breitwieser could ever recommend, or understand, but it wasn't fatal. He hopes that the paintings are being treated far better, and perhaps are still hanging on the attic walls. Von der Mühll finally tells him about Meier's search warrant and the empty attic, and Breitwieser's bewilderment grows, along with his panic. "Now I don't know where the paintings are," he says.

The detective had wondered at first if Breitwieser had secretly ordered the attic cleaning, or if he had a plan in place with his mother and Anne-Catherine, designating where to stash the paintings in an emergency. The canal dump could even have been a grand ruse, a diversion to make inspectors think that's all there is, while the true treasure remains hidden. Von der Mühll has spent enough time with Breitwieser by now to be able to read him, and the detective is almost certain that the art thief really doesn't know where his paintings are located.

Von der Mühll confers with a judge, and in early March 2002 permission is granted for Breitwieser's mother to travel to Switzerland, with immunity from arrest, to discuss the paintings and, the detective hopes, to inform officers where to find them. And also to see her son, who has been imprisoned without visitors for more than three months. Anne-Catherine does not respond to requests from the Swiss police, and Von der Mühll is unwilling to try to force her to speak, so only his mother is brought in for questioning.

Stengel drives herself across the border, and the meeting is held in the judge's chambers. In the room is Von der Mühll, the judge, Breitwieser, and his mother. Straight off, Von der Mühll asks Stengel where she put all the stolen paintings.

"Paintings?" his mother says flatly. "What paintings?"

Breitwieser doesn't understand why his mother has come all this way only to be obstinate. "But, Mom," he pleads, "you know."

"What are you talking about?" she says, glaring at her son as if he's insulted her.

Von der Mühll again asks his mother to reveal the location of the works, and the judge asks too, but Stengel does not budge. The judge, frustrated, terminates the meeting after just a handful of minutes.

Before his mother leaves, there's a moment when Von der Mühll chats with the judge and Stengel is alone with her son. Her demeanor changes entirely. Stengel wraps her son in a tight hug, tears seeping, an uncharacteristically affectionate embrace. The moment passes, and as Breitwieser is about to be pulled away and led back to jail, his mother whispers in his ear. "Don't mention the paintings," she says gravely. She doesn't know that he has already told the detective about them. "There are no paintings, and there never were." His mother has come specifically to deliver this warning, but that is all she has time to tell him. It is his first hint of what's happened. 31

This much Breitwieser knows: Anne-Catherine had witnessed his capture at the Wagner Museum in November 2001, and she herself had avoided arrest. Her car was parked at the museum and the keys were in her purse.

After that, he's unsure. Anne-Catherine has spoken of what follows only once on the record, under oath, in front of Von der Mühll and a French officer. In May 2002, two months after the unhelpful visit to Switzerland by Breitwieser's mother, Von der Mühll travels to France, still struggling to find the paintings. Anne-Catherine is subpoenaed and submits to an interview, but her comments about the attic cleanout are brief. She insists that she played no role in anything that happened to the art. "I never helped any of the objects vanish," she says, and does not elaborate further.

Also in May 2002, Breitwieser's mother is arrested and subjected to a police interrogation, though only by French investigators. Under oath, at a police station, Stengel confirms the general chain of events, and says that she did everything by herself, without Anne-Catherine. Stengel says that she feels "tormented" by the decisions she made, and refers to the night of the attic purge as "my crisis," but does not fully clarify how everything unfolded, or why.

Eight years of stealing, more than two hundred heists, some three hundred works—the attic is Breitwieser's masterpiece. For his mental and physical health, he needs to comprehend its final hours. Even if the news is bad, the stress of not knowing the news is worse. He tries to learn the story from his mother, but it's difficult to find privacy in a jail's visiting room. Not until 2005, three years after his mother's first whispers, is he finally able to ask her for more specifics, beyond her statements to the police. Breitwieser gleans information from police inspectors as well, yet he remains unsure of the precise timeline of the night, or if his mother had help, and anyone who might know will not speak. At least Breitwieser is convinced of the result. The very end, he's certain, is always the same.

Anne-Catherine's drive back from the Wagner Museum is the start. Breitwieser's clearest understanding of the story is that Anne-Catherine, alone in her car, travels straight to his mother's house, a two-hour trip. Anne-Catherine then tells Stengel why her son isn't there. He can only imagine his mother's response. Four years earlier, she had paid a top-tier attorney to rescue him from an art theft in Lucerne, and now he's been jailed again for the same crime in the same city.

His mother climbs upstairs—for the first time in years, she tells the police. Stengel is aware that her son is a thief, though nothing can prepare her for the sight of the attic, the insane magnitude of it. But his mother is not spellbound by color or caught up in beauty, not now. Her unemployed adult child might have just ruined her life. She suspects it's all stolen, Breitwieser says, and for harboring stolen goods, she could be charged as an accessory, three hundred times over. She'll be humiliated, imprisoned, and financially destroyed. Every piece of art in the attic, she says to the police, feels like a "personal assault."

And it's right then, on the same day as his arrest at the Wagner Museum, that Breitwieser thinks his mother starts. Stengel describes what happens as "a bolt of anger" and a "destructive frenzy" in which she attacks "everything in one outburst." She sweeps off the furniture—the bed tables, the armoire, the dresser, the desk—and sends scores of displayed objects crashing to the floor. She yanks down paintings, lots of them. "Twenty, fifty," she says, "I don't know." She retrieves garbage bags and cardboard boxes from downstairs, then returns to the attic and stuffs silver, ceramic, ivory, and other items into them—all the "metal junk," she says—along with one painting on copper. She fills seven or eight bags, Stengel says, and overloads a few boxes.

According to Anne-Catherine's story, she is already back in her own apartment by this point, clueless about anything taking place in the attic. Breitwieser thinks that she actually stays at the house for a while, begging his mother to stop, though when his mother makes a decision, he says, there's no bending her will. "My mother is like a wall." It's also possible that Anne-Catherine stays at the house and supports Stengel's actions. Maybe she throws some things in cardboard boxes. Anne-Catherine has wanted an endgame, and she's getting one now. Stengel carries the bags and boxes from the attic to her gray BMW hatchback, she tells the police, and drives north for thirty minutes, alone, after nightfall, to a place where a narrow bridge arcs over a secluded segment of the Rhône-Rhine Canal. She used to walk here with her dogs. She parks among the trees near the water, unloads the bags and boxes, and moves up and down the shore, tossing items in the canal. She admits to the police that she doesn't feel bad about this. "The pieces don't mean anything to me." Some objects flow with the current a bit before settling into the mud, and two silver goblets are not thrown far enough to prevent them from glittering up through the water in the light of day.

His mother returns home for a second carload that night, he believes, picking up the rest of the silverworks, and more paintings on copper, and bulky items like the tapestry he had thrown out a castle window, and the Virgin Mary he'd dragged from a church on a rainy day and driven off with in Anne-Catherine's car. The Virgin, he knows, weighs 150 pounds. "It's inconceivable that my mother could carry it alone," says Breitwieser. She had to have help.

His mother had recently embarked on her first romance since his parents split a decade before. He's a painter, it so happens, named Jean-Pierre Fritsch, long-haired and personable, known for his murals. On Fritsch's property is a private pond, accessed through a locked gate, and when the authorities learn of Stengel's relationship, police divers search the pond and retrieve ten more stolen works, all in silver. Fritsch is interviewed by the police, and he says that he has never assisted Stengel with transporting even one piece of artwork, and denies any knowledge of how the items ended up in his pond. In the end, Fritsch is not charged with a crime, but Breitwieser is convinced that Fritsch helped his mother for at least part of the night.

The 150-pound Virgin Mary is abandoned on the grounds of a country church, amid farmland not far from Fritsch's pond, where Stengel had often attended Mass. Stengel claims that she was able to move the Virgin by herself. "It took a long time. It was very hard. I had to put the piece down on my boots, and I walked step by step with a lot of difficulty." It was discovered by a passerby and later reinstalled on a pedestal in its original church, using several new bolts.

The tapestry that had been flung from the castle is now tossed in a roadside ditch, along National Route 83 by the German border. A few days later, a motorist pulls over to pee and spots it. The tapestry looks valuable, so the driver turns it in to the district police, who assume it's a cheap rug junked by a litterbug. It is colorful, though, and the officers place it on the floor of their break room, tucked beneath the billiards table, and walk on it for weeks, until they learn of the canal find and contact French authorities and Von der Mühll. The seventeenth-century tapestry is shipped to the same museum where the canal pieces are stored.

Three copper paintings, wrapped in red Air France blankets, are discarded in a forest near the tapestry drop. A timber cutter finds them. He is more excited about the newlooking blankets, though he also sees worth in the coppers: his henhouse has been leaking, so he hammers the works to the roof. One of them, *Allegory of Autumn*, is the piece attributed to Brueghel. Taped to the back is a note. "All my life, I will always adore art," it says, signed "Stéphane and AnneCatherine." A month later, the woodsman reads a newspaper article about stolen art recovered in the region, and the coppers, badly in need of restoration, soon join the tapestry and the canal items in storage at the museum.

The oil paintings on wood, according to Breitwieser, are the final step. He thinks they were also dealt with late that night, possibly near dawn. "I can't be precise about time," Stengel says to the police. Every painting remaining in the attic is crammed in her car, Breitwieser believes, for the third and last trip. His mother throws away, as well, her son's library of art books, his thousands of photocopied research pages, his scrapbook, and all of his clothing, Versace jackets to dirty socks. She removes the picture hooks, spackles the holes, and repaints the walls, yellow in the bedroom and white in the living area. By the time police officers arrive with the international search warrant three weeks later, there is no longer the smell of fresh paint, and none of the officers think to meticulously examine the walls for signs of recent repair.

Before any of this detail work, though, Stengel drives the paintings to a secluded spot. Breitwieser says that when he asks her where, specifically, she just says "the forest." He's unsure if Fritsch lent a hand, but he suspects that all of his oil paintings were gathered in a clearing, more than sixty works heaped in a pile, portraits wedged against still lifes, landscapes jackknifed into allegories, a stack consisting of nothing but beauty has become something singularly horrible.

Breitwieser wants to believe—chooses to believe, needs to—that his mother is doing this out of devotion. "She's protecting me," he says. She cleared the attic so the police wouldn't find proof of his crimes, a more extreme version of

flushing illegal drugs down the toilet. Her acts, he says, can be seen as the ultimate expression of maternal love.

Here is what Stengel says to the police: "I wanted to hurt my son, to punish him for all the hurt he caused me. That's why I destroyed everything that belonged to him."

She sparks a lighter, says Breitwieser, and sets the pile on fire. Gasoline might have been added as an accelerant, though it was probably not needed. The ancient wood panels are bone dry, and oil paints are combustible. Flames rise swiftly, Breitwieser envisions, hissing and popping, and the paintings start bubbling. The heat climbs and paint runs like mascara, streaming over the picture frames and dripping in flaming beads to the soil. Soon the entire stack is engulfed, the fire leaping and ravenous, the great mass burning and charring until there is almost nothing left but ash. 32

A television in the Swiss jail where he's incarcerated carries the news. In mid-May 2002, just after the police interrogation of Breitwieser's mother in which she admits to destroying the paintings, the story leaks to the press. It's catnip for journalists—an unprecedented crime spree and art carnage amid a mother-son-girlfriend relationship tangle—and the media pounces.

For the previous two months, all Breitwieser had known about the fate of his paintings was the cryptic, whispered message from his mother—"there are no paintings, and there never were"—and now he's learning the tale from TV, along with everyone else. His mother had been vague during her interrogation about many of her actions. "There's so much I can't remember," she'd said. The paintings had been obliterated, she confirmed, but she does not specifically mention a fire until Breitwieser learns about it three years later. Some media reports, speculating wildly, try to fill in the blanks. A story that circulates broadly is that his mother shoved every painting into her kitchen sink's garbage disposal. Breitwieser can't imagine a single painting on wood chewed up that way, let alone sixty. Also, there's not a garbage disposal in his mother's house.

One Alsatian newspaper, *L'Alsace*, reports that the total value of his loot is the equivalent of \$1 billion U.S. In England, BBC News puts the sum at \$1.4 billion. *The New York Times* estimates between \$1.4 and \$1.9 billion. The largest-circulation paper in Alsace, *Les Dernières Nouvelles*, says more than \$2 billion. Museum pieces, most of which have not been sold on the open market, can be difficult to price.

Breitwieser had always grossly underestimated the value of his collection, because he somehow felt less pressure that way about being the works' caretaker, he says. The figure in his mind is under thirty million dollars, though from his research he knows better. He fears that he will now have to reimburse two billion dollars—scarcely possible in fifty lifetimes. He will never have money again. Every interview request he receives in jail he turns down, although the authorities might not have permitted them anyway. Breitwieser doesn't speak one word publicly.

The TV news Breitwieser sees also reports that his mother has been imprisoned. Anne-Catherine remains free, though a trial looms for her. In Anne-Catherine's interrogation, she had denied playing any part in the thefts or destruction. Instead, it is his own mother—a pediatric nurse, a churchgoer, an admired citizen, innocent of all his thefts—who is locked up. His head "short-circuits," he says. He feels enormously sad. Breitwieser unspools a roll of dental floss in his cell and braids it together to form a cord, then knots it in a noose and ties it to his cell's light fixture. He's unsure if floss is strong enough to work, and doesn't have a chance to find out. A guard who has spotted his activity rushes in.

"I can't take it anymore," he tells the officer. Breitwieser is promptly placed on suicide watch and prescribed antidepressants.

Through the bars of his window, he says, he fixates on a traffic light in the street below, absorbing a slow cadence of green, yellow, red. Von der Mühll stops by, concerned, and delivers auction catalogs, a kindness Breitwieser appreciates even if he can't bear to open them. He stares at the traffic light for three days, he says, before his head starts to settle, and then he concludes that he has one last hope. His collection is gone, but not Anne-Catherine.

Their last communication had been an exchange of desperate faces as he was being arrested at the Wagner Museum six months before. Now she dominates his daydreams, he says; he envisions her dimply smile blooming as they're seated at the little restaurant in the medieval village of Rouffach, where they'd sometimes splurged on a proper date night. They always ordered a classic Alsatian tarte flambée. If he can revive their passion, he realizes, he'll retain his sanity. She's his motivation for living.

The authorities have forbidden him to contact Anne-Catherine, even by letter, ever since he'd confessed to the canal find—communication between them, the police think, could harm the investigation—but Breitwieser believes that a note might slip through. He mails her frequently, begging forgiveness and declaring his love. As soon as he's released from prison, he writes, he'll find legitimate work as a salesman. Then they will buy their own place, have children, and live happily ever after. By the time he turns thirty-one, in October 2002, he's sent her twenty letters. He doesn't learn if any are delivered; he knows only that he never receives a reply.

Later, in desperation, he manages to borrow a contraband cell phone in jail and dials from memory her hospital number. He's transferred to her department and asks the receptionist to page Anne-Catherine. He hears her name called, and his heart accelerates. But the receptionist returns to the line, asking who's on the phone.

"A friend from Switzerland," Breitwieser says. He hears whispering in the background.

"Anne-Catherine does not want to speak with you," the receptionist says, and hangs up.

Depression swallows him again. His mother is jailed and prohibited from speaking with him. He is allowed visitors, if approved by the authorities, but his grandparents are too frail to drive up. He has no friends. All that his attic collection has ultimately done is ruin him.

His father, of all people, saves him. A letter is dropped in his cell, the handwriting on the envelope, despite the passage of time, unmistakable. As he opens the envelope, he's buffeted by discordant memories, he says: furiously snapping the antenna off his father's Mercedes in the midst of an all-out fight; dreamily water-skiing on Lake Geneva as his dad steers the boat. The letter breaks eight years of silence, during which his father has remarried. Breitwieser has never met his stepmother or stepsister, and his father hadn't known that his son was in jail. Then Roland Breitwieser saw the television news, and picked up a pen. "I am reaching out to you," his father wrote, heartfelt and supportive. "Take my hand. I am here to help you. Put aside your pride and your hate." The letter is signed, "Your Father."

Breitwieser melts, and writes back immediately, spilling out a four-page reply. Not long after, his father arrives in person, carrying a care package of cheese and salami. The two men, with the same penetrating blue eyes and whippet physique, agree to start their relationship anew. His father begins coming every other Sunday, frequently opening the visit by clutching his son in a hug, then staying to talk for three hours, the maximum the jail allows. The two-billion-dollar figure, his father admits, is undeniably impressive, if looked at in a certain light. An officer from the French art police who'd appeared on the television news declared that Breitwieser's crimes will be etched in the record books, "forever part of the history of art."

One Sunday, his father is accompanied by his wife and her daughter, and in the jail's visiting room Breitwieser is introduced to his extended family. Breitwieser says that he genuinely likes them. And though his father's own parents have passed away, his father gives a ride to Breitwieser's cherished maternal grandparents. His grandparents, forever supportive, are forgiving of his crimes. "Museums didn't have to leave all that stuff lying around," his grandmother tells him.

Buoyed by the visits and no longer held under restrictive security or suicide watch, Breitwieser tries to adapt a little to the rhythms of jail. He obtains a job assembling hearing aids; he rides hundreds of miles on a stationary bike. He is schooled by fellow inmates in the fine art of money laundering. He discovers his jailhouse calling: he has no interest in sampling the illegal drugs circulating about, so Breitwieser becomes an "in-house urinator," as he calls it. He provides a clean sample to an inmate needing to pass a drug test, for the standard rate of a can of Coca-Cola.

Preparations for his trial drag bureaucratically on. He's charged with more than sixty art thefts in Switzerland, as well as failure to pay fifteen parking tickets—the Swiss take these seriously. Another trial is planned for later in France, with his mother, Anne-Catherine, and him as defendants. Potentially, there could be a trial in each of the seven countries from which Breitwieser stole. He often wonders if he will ever be freed. A second incarcerated Christmas passes, then New Year's Day 2003. He meets often with his court-appointed attorney, Jean-Claude Morisod, a skillful counsel selected for the case because he is also known in legal circles as an art lover.

On Tuesday morning, February 4, 2003, fifteen months after his arrest at the Wagner Museum, Breitwieser is loaded into a jail-transport van. He is groggy and disheveled, his hair a mess, after a bad night of nerves. He's escorted out of the van, handcuffed, in front of a thirteenth-century fortress, with tiny windows in the granite-block walls and a turret at each corner. The fort is now home to the Criminal Court of Gruyères. Breitwieser has stolen from at least one museum in sixteen of Switzerland's twenty-six cantons, and Gruyères was chosen to host the trial because it is the location of his first Swiss crime—the ski-trip theft of the oil painting, with Anne-Catherine.

Breitwieser walks across a snow-covered bridge, over a moat, and into the fortress, then through a strobing photographers' gauntlet. Questions are shouted at him indecipherably.

He wishes at that moment, he says, that he were better dressed and properly groomed. The courtroom he enters has solemn gray-and-white-stuccoed walls and a marble fireplace. Over the fireplace are inscribed the words "Art, Science, Commerce, Abundance," the virtues of Switzerland.

He's seated facing the judge, who is wearing rectangular glasses that focus attention on his eyes, projecting a daunting, no-nonsense demeanor. Next to the judge are the four jurors, three women and a man, all seemingly middle-aged, who will join the judge in deciding the verdict and, if any, the punishment. Breitwieser's attorney, well dressed and patrician, sits at a desk behind him. Extra chairs have been jammed in to accommodate the media horde. Breitwieser says that he can feel the eyes of everyone in the room converging on him. Order is called, and his trial begins. 33

His guilt is not in question. Breitwieser has signed dozens of detailed confessions. What is debatable, his attorney says, is the penalty. Breitwieser has now served 444 days in jail and that is enough, his attorney argues. His client should be released right away. Breitwieser stole peacefully, the attorney tells the court, one could even say politely. "He's not some cat burglar. He's a gentleman." He didn't smash his way into museums or vandalize, except for a glass case in a castle near Zurich, for which his client offers sincere apologies and full restitution.

Just two witnesses are called by the defense. Christian Meichler, the framer, says that he was stunned to learn that his friend was a thief, but his natural reaction was empathy. Becoming friends with Breitwieser, he comments, was a rare pleasure. "He has the soul of a collector," Meichler testifies, "but his excessive passion must have swept him away." Meichler mentions that he has traveled to Switzerland at his own expense, and the judge notes that the court can repay him. Meichler says it's not necessary. "It's for my friend that I've come."

"I regret disappointing you," says Breitwieser from his seat in the courtroom.

"You don't have to apologize," Meichler responds.

His father also testifies. Roland Breitwieser admits that the contentious divorce and his long absence make him feel partly responsible for his son's behavior, though even as a young boy his son was a loner. "He didn't have many friends," recounts his father. He preferred to be solitary, visiting museums or archaeological sites. "I am not surprised that he needed to surround himself with masterpieces." His son always seemed more attached to objects than people.

Breitwieser himself takes the stand. He insists, tearily, that he had always envisioned an endgame for his collection. Old works of art are like time travelers, he says, and his attic was only a way station. His collection would outlive him. "I was just their temporary custodian," he adds. He planned to give everything back—"in ten or fifteen or twenty years." Then his works could continue their journey.

"Don't fall for the trap of the tearful boy," rebuts the Swiss prosecutor, annoyed by this fantasy. "This is a dangerous man, a threat to society, who shows no remorse." The moment he's given the chance, the prosecutor warns the court, Breitwieser will steal again.

Breitwieser says no, he's finished forever. "The stealing is over, I guarantee it. Art has punished me enough." He repeats his claim of an endgame. "One day, I would have returned everything." Even the judge is dubious. "Do you swear to this on your honor?" he asks.

Breitwieser swears it.

What Breitwieser is saying, his attorney emphasizes, is that he wasn't really stealing; he was *borrowing*. The idea of art being lent to a thief seems preposterous, but was brilliantly argued by the British barrister Jeremy Hutchinson, following the 1961 theft of Goya's *Duke of Wellington* from the National Gallery in London. The fifty-seven-year-old thief, Kempton Bunton, kept the work in his apartment for four years, then deposited the painting at a checked-luggage office in a Birmingham train station and turned himself in. At his trial, Bunton was acquitted entirely of the painting's theft. He was, however, charged with stealing the frame, which was never returned, and served three months in jail.

For the *Mona Lisa* theft, in 1911, Vincenzo Peruggia was tried in his native Italy, where he was caught. His lawyer shaped the crime as aesthetic infatuation combined with patriotic fervor. "I fell in love with her," Peruggia said of the *Mona Lisa*, and it was his honor to bring the portrait home. Never mind that Peruggia had demanded cash for the painting and that France legally owns it—the ploy worked. For one of the most audacious art crimes in history, Peruggia spent a total of seven months and nine days incarcerated.

In both cases, the works were recovered intact. This is the outcome Breitwieser desired as well, his attorney points out. He has already spent more time in jail than the *Duke of Wellington* and the *Mona Lisa* thieves combined. The collection's fate is tragic, says his attorney, but you can't fault Breitwieser for its destruction.

You absolutely can fault him, counters the Swiss prosecutor. If Breitwieser had visited museums like everybody else, the pieces would all still be there. Any suggestion that Breitwieser is not a harmful criminal, says the prosecutor, is absurd. Breitwieser is one of the most malicious art thieves ever. The Swiss police have cataloged forty-seven different maneuvers he employed to steal art. He averaged a theft every twelve days for seven years. His crimes were in no way innocuous. The prosecutor presents to the court a stack of letters from museum curators, gallery owners, and auction houses, expressing outrage and demanding restitution. Breitwieser's disturbed mind may not see harm, but here in the real world, adds the prosecutor, he's damaged museums, cultures, and heritage. The victims are all of us.

The cultural director of the City of Lucerne is called to the stand by the prosecution. He eulogizes the bugle from the Wagner Museum, the last item Breitwieser took. "It was a unique piece of great beauty," says the cultural director made in 1584, plated in gold, celebrated for centuries. Even the shoulder strap, engraved with Lucerne's coat of arms, is historically important.

Along with dozens of other works from the attic, the bugle has not been found. Only the strap was recovered from the water. The horn might have flowed off with a current or sunk in the mud. Other items might have been dumped into rivers or ponds still undiscovered; Breitwieser's mother won't say. Some journalists have accused Breitwieser, his mother, or Anne-Catherine of stashing pieces away, but everything investigators have learned lends doubt to this. The more probable outcome is worse. Most of the wooden carvings remain missing, and Breitwieser's later inquiries into the last night of his collection cause him to suspect that the wooden items were consumed in the same fire as his oil paintings.

The curator of Gruyères Castle, testifying for the prosecution, recounts the four Breitwieser thefts in his museum. A gilded fireplace tool, found in the canal, has been restored, as has the tapestry that had been relegated to a roadside ditch and a police station's billiards room. But a pair of cherished paintings are gone forever. The curator reports that he's upgraded the alarm system.

Marie-Claude Morand, the director of a history museum near the Matterhorn, in the southern Swiss canton of Valais, speaks of the two items Breitwieser stole in one visit, a sword and a tobacco box. The sword was fished from the canal, but the tobacco box is lost. The box, commissioned by Napoleon, was painted by the renowned French miniaturist Jean-Baptiste Isabey. "It's a pastel on ivory," says Morand, "very rare and highly sought after." In 1805, in a grand ceremony, Napoleon bequeathed the tobacco box to Valais, an independent republic at the time, to commemorate its strong ties to France. "More than the monetary value is the sentimental value," Morand says, "and the relationship between the object and place." Pleading for the police to keep searching for it, she is overcome with emotion.

Even Breitwieser is taken aback. "I'm sorry, madame," he murmurs.

"We are not prepared for this kind of theft," says Morand. "We can't transform our museum into a safe. We serve the public. We can't demand that visitors, in winter, leave their coats. That's Dantesque." Her museum has four floors and two security guards. "We don't have the budget to hire more." The second item that Breitwieser took, adds Morand, was a hunting sword that was also awarded to Valais from France, two hundred years before Napoleon. The seventeenthcentury sword, Morand informs the court, is embossed, blade to pommel, with period silverwork.

"Excuse me, madame," Breitwieser pipes up from his seat, "I'm sorry to interrupt you, but only the blade was from the seventeenth century. Chemical tests proved the cross guard was a nineteenth-century copy of the work by the master silversmith Hans-Peter Oeri."

"How did you know that?" asks Morand, curious.

"I read a book on bladed weapons; then I went to the library at the Museum of Fine Arts in Basel and found an article in a scientific journal describing the chemical analysis of the sword," Breitwieser responds. "I was very disappointed." The wall label describing the piece as wholly original was false, he mentions, as if it were the museum's fault that he had stolen a flawed work. "You know, as a collector, I like my pieces to be perfect."

Morand is a historian and medievalist as well as a curator. She had studied the piece herself and suspected the same as Breitwieser, but wasn't aware that there was published proof. "I'd like to know the name of that publication," Morand says, as if speaking to a colleague in an academic forum.

Breitwieser provides it to her.

The prosecutor, immune to his charms, hammers Breitwieser in the closing argument. He reads from a letter Breitwieser sent to Anne-Catherine that had been intercepted by the authorities. "If I hadn't been arrested," Breitwieser candidly wrote, "I would now have my happiness, as well as twenty or more new works of art." The psychotherapist Michel Schmidt, in his report, says that Breitwieser is "incapable of feeling guilt" and that "his risk of recidivism is very high."

If people like Breitwieser are permitted in civil society, asserts the Swiss prosecutor, civilization is doomed. The prosecutor asks the court to impose a hefty sentence for aggravated theft. Breitwieser's own attorney pushes for clemency. The judge concludes the three-day trial and dismisses the jury to deliberate. 34

A decision is reached in two and a half hours. In the eyes of the law, how a thief steals is more significant than what's taken: robbing a candy bar with a gun is worse than carrying off a Cranach painting unarmed. Breitwieser never resorted to violence, or even threatened harm, so his offenses are deemed by the judge to rise only to the level of simple theft, a maximum five-year imprisonment.

The jury sentences him to four, which includes the year and a quarter he's already served. Breitwieser is also levied copious fines, owed to museums and galleries—a total of hundreds of thousands of dollars, not billions. Legal observers consider the verdict moderate to soft, but Breitwieser feels swindled. His understanding, from police inspectors, was that his voluntary confessions would be rewarded with a penalty of time served and no more, and he'd be released immediately after the trial. Meier and Von der Mühll, though, had only conveyed tantalizing hints of this, not assurances. As he's escorted from the courtroom, headed to jail, Breitwieser looks to his father in the gallery for comfort, and for the first time ever he sees his father cry.

He's held in a sprawling detention center in the Swiss countryside, permitted to work in the penitentiary during the day, dismantling old computers to salvage recyclable parts. He receives a small wage, but everything he earns is diverted to pay his fines. His father continues to visit a couple of Sundays a month. At his trial, Breitwieser had complained that the media had inflated the value of his haul, but in prison the two-billion-dollar figure gains him respect, so he no longer disputes it.

His thirty-second birthday passes, and his third Christmas behind bars, and the start of 2004. He discovers a sport he doesn't detest, ping-pong. Too bashful to shower nude like everyone else, he washes in his underwear. His prison term and all his fines are upheld on appeal. Just a single letter from Anne-Catherine, letting him know she's still there, would bring him enormous relief. But there's none.

On July 13, 2004, almost three years after he had departed to Switzerland with Anne-Catherine so she could erase his fingerprints at the Wagner Museum, he is shipped back to France. He's transported in a prison truck, his hands cuffed too tightly behind his back, he says, cutting into his wrists. The truck passes close to his mother's house and he feels even worse. His father had told him the news: due to her arrest, his mother had been fired from her job, and lacking substantial savings, she'd sold the home with the attic and moved in with her elderly parents.

Breitwieser is locked in an overcrowded prison near Strasbourg, confined with two other inmates in a cell with a cockroach infestation, he says, and dried excrement on the walls. In Switzerland, the guards had called him "Mr. Breitwieser." In France, they shout his inmate number. He does learn a bit of good news—his upcoming trial will be his last; other nations, to save time and expense, have partnered with France.

Two uncomfortable weeks pass, and then, without warning, Breitwieser is handcuffed and led out of his cell, up a few flights of stairs, and into the office of the French investigator in charge of the case, Michèle Lis-Schaal. A couple of lawyers are there, and—his insides clench into a knot—so is Anne-Catherine.

He calls out to her, but she doesn't respond. She just stares ahead, almost robotically. His cuffs are removed and everyone sits. The investigator says that she's convened the meeting because statements given to the police by Breitwieser in Switzerland and Anne-Catherine in France are incompatible, and she'd like to resolve this.

But Breitwieser is scarcely listening. He's focused only on Anne-Catherine. "Why didn't you give me any sign of life?" he blurts out.

The investigator answers for her. Anne-Catherine has been prohibited, under threat of imprisonment, to initiate any contact with him, until now. And at that, Anne-Catherine turns her head and offers him an affectionate look, which is nirvana to him after so long in jail. She's still there.

Breitwieser had always tried, while questioned by both Meier and Von der Mühll, to "round the edges of her role," as he put it. Anne-Catherine had accompanied him on nearly all his museum heists, he'd said, but every time he took an artwork, she wasn't near him or he had defied her pleas to stop. In her own interrogation, however, Anne-Catherine had stretched the truth, seemingly past snapping, by issuing blanket denials.

"I didn't even know he stole art," she told the police. She said she hardly ever went into the attic. "We spent our time in other rooms in the house." Home videos proving the opposite have been overlooked by detectives, and not entered as evidence.

But why, the French investigator asks, incredulous, are their versions so different?

"I can't explain it," says Anne-Catherine. "It's a real catastrophe."

The investigator turns to Breitwieser and asks him why their stories don't match.

After a bit of reflection, plotting a strategy, Breitwieser responds. "It's my fault," he says. He has misremembered their history, he adds. She's the one telling the truth. "Anne-Catherine was never my accomplice." They rarely even went to museums together, he says.

The investigator slams a fist on her desk, and Breitwieser shuts up and stays that way. He never says anything that exposes Anne-Catherine, and neither his lawyer nor hers cares to amend the record. The investigator, beset by a roomful of liars, kicks everyone out of her office.

In the hallway, Breitwieser is able to sneak a private moment with Anne-Catherine. Their faces are inches apart. She brushes an arm against him. Maybe she'll affirm her devotion, or thank him for the stunt he'd just pulled with the investigator. Maybe they'll kiss. But there's no chance for anything before he's marshaled away.

In his cell, the hallway moment loops in his mind, her scent lingering. He loves her. He knows this for sure. They had been together ten years, and he feels that they will be together some more. This thought keeps him warm for his fourth Christmas incarcerated, and through to January 6, 2005, the day his French trial begins.

Prepared this time, unlike his Swiss trial, he enters the wood-paneled Strasbourg courtroom in a gray Yves Saint Laurent suit and a blue shirt, without a tie though with handcuffs. There are at least twenty press photographers in the room, elbowing for position. He sees Anne-Catherine. He spots his father. It takes him a while to find his mother. She's wearing a headscarf and sunglasses, her head lowered. He hopes to exchange a glance with her, but she doesn't look up.

Anne-Catherine is called to the witness stand, not to testify yet, but to swear to tell only the truth, and Breitwieser turns from his mother to gaze at her. Anne-Catherine states her name and her birth date. She recites her address. Then she adds one more detail that until now he did not know: "I am the mother of a nineteen-month-old boy."

Breitwieser, a bullet through his heart, shuts down. He doesn't visibly respond; he can't, he's immobilized. What Anne-Catherine has just said means that ten months after his arrest, she had already become pregnant by somebody else. 35

His mother, the first of the three to testify at the French trial, cannot keep her story straight. Initially, when officers arrived with the international search warrant in 2001, Stengel insisted that her son had never carried works of art to her attic. When she was interrogated at the police station in 2002, Stengel admitted to destroying a huge number of pieces that her son had stashed. Now, on the witness stand in 2005, Stengel says that everything she previously stated about harming art was said under duress, and testifies that she did not in fact throw any items away.

She has never seen an oil painting in her son's rooms, Stengel vows. She did not remove any picture hooks or repair any walls. She did not enter the attic while he was living there, she says, because it was always locked and she didn't have a key; then Stengel mentions, minutes later, that whenever she walked into the attic she felt "fed up with seeing all the works." She tries to patch her mistake, attesting that she was sure everything had been lawfully purchased at flea markets. Stengel's stories are jumbled, but she is unemployed, without a home, distraught, frightened, and irate. She does express one further thing, this part brief and clear. "I hate my son," she says with icy finality.

The French prosecutor, jumping in, points out that for all of Stengel's words there has been no apology. "She committed an unimaginable, irreparable blow to cultural heritage," the prosecutor says to the court. "She is the central figure in this horrific disaster, the person who should be held most accountable."

Stengel's psychology report is entered as evidence. César Redondo, the therapist who also examined Anne-Catherine, expressed no doubt that Stengel "relentlessly destroyed, without regret, historical works of art." Stengel knew precisely what she was doing. Why didn't she take the simple, humane, and legal step of turning in the works to the police? The therapist tried to make sense of this. There is an extreme mix of love and hate, Redondo felt, in Stengel's possessive relationship with her only child: Stengel craves a bond with her son like the one he has with his art. The Swiss psychotherapist Schmidt, who examined Breitwieser, said the very same thing.

Stengel viewed the art as competitors for her son's affection, more powerful than even his girlfriend. As long as the pieces existed, in a museum or attic, they could hold her son captive. So while he was locked up and defenseless, she eliminated her rivals, and also, said Redondo, "punished him in a way that she knew was going to be excruciatingly painful to him."

The prosecutor begins enumerating all of Stengel's contradictory statements, and Breitwieser rises from his seat to defend her. "That's enough of mistreating my mother," he shouts. "She doesn't know anything about art. She had no idea that I stole." Breitwieser is pained by what his mother has said about hating him, but that doesn't change his feelings for her. "My mother is sacred to me," he says, before the judge demands that he sit down and keep quiet.

Stengel's attorney avoids speaking about art almost entirely, stressing instead that she is a respectable woman who worked in a hospital, caring for children, while singlehandedly supporting her troubled son. Prison for Stengel, her attorney says, would be senseless and cruel. She's already been abused and victimized by her son. Stengel covers her face with her hands and weeps.

Her attorney's portrayal seems to have a mollifying effect. Though Stengel is found guilty of handling stolen goods and destroying public property—a potential three-year sentence to go along with her significant fines—she spends less than four months in jail. She then serves probation for an additional eight months at her parents' house, wearing an ankle monitor and checking in at the police station every Monday.

Anne-Catherine, dressed in a long black skirt, is called to testify after his mother, and she doubles down on total denial. She testifies, in a timid voice that Breitwieser says he's never before heard, that she had not noticed any Renaissance works in the attic. She wasn't present on his road trips. She never saw any art in his car. The two of them barely dated, she says. They were more like acquaintances. "He scared me," says Anne-Catherine. Every day she was with him, she felt like his hostage. "He tormented me."

That's all Breitwieser can endure. Cutting her off, he

rants about their vacation to the Dominican Republic, shortly before his arrest, during which he'd given her a Cartier ring. He hadn't formally proposed, but he considered them engaged. He'd planned to spend the rest of his life with her. Yet burbling in a baby carrier here in the courtroom, Breitwieser has noticed, is her little boy.

"I'm not the one who had a child behind your back," he hisses.

"Why would I ever have a baby with a monster like you?" she retorts, and the judge calls for order.

Breitwieser realizes that Anne-Catherine, perhaps for the first time in court, has told the razor-sharp truth. She thinks he's monstrous. He wonders if she's right, and that he doesn't deserve mercy but maybe she does. His anger dissipates, and he continues to support Anne-Catherine's narrative that she played no role in the thefts.

The French prosecutor bluntly calls out Anne-Catherine's lies. "I am stupefied by her perjury," says the prosecutor. "She crisscrossed Europe with him. She lived with him. She didn't hesitate to serve as lookout and play an active role in the thefts, assisting him, advising him, and hiding loot in her handbag." Multiple witnesses reported seeing a couple, emphasizes the prosecutor. The two of them were even arrested together while stealing a painting. Yet, in part due to Breitwieser's help, Anne-Catherine has not been charged with theft or destruction of property—just handling stolen goods. The prosecutor urges the court to hand down the full two-year sentence.

Anne-Catherine's lawyer, Eric Braun, opens his defense by admitting that the prosecutor is right. Braun concedes that maybe Anne-Catherine has not been entirely accurate in her testimony. But that's to be expected from someone who's been bullied and beaten. "She was under the grip of this young man," says Braun. "She was dominated. She was in pain. She lived in fear." Now she has a baby. Is this really a person you'd want to imprison?

And with her lawyer's skillful parry, Anne-Catherine completes her escape. She spends exactly one night in jail. Braun even manages to have the conviction expunged from her criminal record, as if nothing had happened during her decade with Breitwieser. This permits Anne-Catherine, unlike Stengel, to return to work at a hospital, which she does, though her wages are garnished to pay fines. Still, she is able to purchase a two-room apartment and find day care, as the father of her child is no longer with her.

Breitwieser has provided forceful, if untrue, excuses for his mother and Anne-Catherine, but at the French trial neither woman offers a supportive word about him. He's sent back to prison to serve a two-year term. He enrolls in nearly every class the penitentiary offers—English, Spanish, history, geography, literature. He creates for himself the role of "public scribe," he says, writing letters for inmates. He grows a goatee. In less than a year, in July 2005, he's released on good behavior to finish his sentence at a halfway house. Between Switzerland and France, he had been incarcerated for three years, seven months, and fifteen days.

He can leave the halfway house on weekdays if he has a job, and he's hired as a lumberjack. It had been a long time since he'd challenged his body physically, as he'd sometimes done in museums, and he strangely likes being a woodsman, felling trees in the forest, an aesthete with a chainsaw. He continues to see his father on weekends, and in the first heart-toheart talk he has with his mother in nearly four years, he cries immediately and says that everything is his fault. In truth, though, his mother had done the worst possible thing she could do to him: she destroyed the items he loved most; she stripped him bare and exposed him as a thief. But at a juncture where the majority of relationships would cease, theirs starts again. "She kisses me and hugs me, and says she forgives me, as she always has." They share a box of chocolates.

There's friction only when he prods his mother for more details about the fate of his art, beyond those he's already learned. Who was involved? Where else was work dumped? What was burned and what wasn't? Where are the ashes? "I will never talk about any of that," his mother says. "Please promise not to ask me again." He promises.

When he's discharged from the halfway house, he rents a cheap apartment to live on his own, though his mother pays the rent. The logging job ends when winter arrives, and he finds work driving a delivery van and mopping floors. His apartment is spiritless, hardly better than prison and in some ways worse: now that he's free to display what he wants, possessing no art hurts even more. He feels as though he lived a hundred lifetimes while stealing, and at age thirty-four he's old and defeated.

By the terms of his three-year probation, Breitwieser is forbidden to visit museums or other places displaying art and is barred from contacting Anne-Catherine. But there's no one else he can talk to, and he refuses to see a therapist. He feels "lost and adrift," he says, and finds her new address, and in October 2005 he unburdens himself in a letter to her. "I'm falling apart," he writes. "I'd like to see you again. Let's meet. I know you're not doing well either. Let's go for a walk together and get some fresh air. I know it will be good for both of us." His mother, he adds, can look after her child.

The response comes from his parole officer. Upon receiving the letter, Anne-Catherine had called the police, and for breaking probation, Breitwieser is returned to prison for fifteen days. In his cell, infuriated, "a caged lion," he punches the window so fiercely that he cracks the glass and splits open a knuckle. Pursuing his passions, for Anne-Catherine or art, keeps compounding the grief, and the only way to survive, he thinks, is to hole up alone in his apartment. The gash on his hand requires stitches and their relationship finally dies, and he's left with a permanent scar. 36

"Breitwieser will be the great tragedy in her life, but nothing more," says Eric Braun, the lawyer who helped Anne-Catherine avoid prison time. Braun had worked with Anne-Catherine for weeks preparing for her trial, often discussing the private moments of her relationship, what it felt like when it was just the two of them and the art in the attic. Breitwieser was temperamental, Anne-Catherine had said, and generally not easy to be with. "Now," says her lawyer, "she only wants to live her life quietly and forget about him."

The quiet part she's accomplished. Her apartment is in a sleepy village outside Mulhouse; it cost her the equivalent of \$100,000 U.S., and she took out a twenty-two-year mortgage. Anne-Catherine's new place, as well as her parents' apartment, was searched by the police for stolen art, and nothing was found in either spot. She has discreetly raised her son, who was born in 2003. She continues to work at a hospital in Mulhouse. She has not been arrested again. She has never appeared on television to tell her story, and she apparently has no desire to be famous, or infamous. She has not, as far as it's known, been in contact with Breitwieser or his mother, and has not married or had further children.

Anne-Catherine is introverted, not too much different from Breitwieser, and after hiding in plain sight with him for so many years, she seems to have maintained the same style in her post-attic life. Braun believes that she has found peace and happiness.

From the first time they met, at a birthday party in 1991, when both were twenty years old, to Breitwieser's parolebreaking letter to her in 2005, almost fifteen years had passed. They spent the heart of their youth together. They'd driven on back roads all over Europe, filling up the attic with riches, and she'd gotten away with the whole thing nearly scot-free. That's close to miraculous. Bonnie and Clyde were killed in a shootout in Louisiana, dead at ages twenty-three and twenty-five.

"Anne-Catherine just wants to turn the page, once and for all, and forget," reiterates Braun.

She has stacked Renaissance silver on the bedside table of a cheap hotel room. She has eaten at a museum café with a stolen masterpiece in her purse. She has seen Mont Saint-Michel at dawn, and sunset high in the Alps, and the stained-glass windows of Chartres Cathedral. She has held an unframed Cranach in her hands. And a Brueghel. And *Adam and Eve*. She fell in love with a thief. She has kept watch on a lot of guards in a lot of museums. She participated in one of the world's greatest art-stealing sprees. She lived in Ali Baba's cave, and slept there in a four-poster bed. Anne-Catherine won't confirm it, but there is really no forgetting any of that. There is only avoiding the spotlight. 37

"I don't think he genuinely loved me," Anne-Catherine once said while being interrogated by the Swiss art detective Von der Mühll. "I was just an object to him." Breitwieser insists that Anne-Catherine does not actually believe this; she knew that he had truly loved her, and she would only say such a thing under pressure, or to manipulate the police. Yet in late 2005, not long after sending his final letter to Anne-Catherine, pleading for a reunion, Breitwieser seems to replace her.

A friend of his mother's introduces him to Stéphanie Mangin, who has the same job as Anne-Catherine, nurse's assistant—though not at the same hospital—and looks like her too, petite and pert with light hair. As when he first met Anne-Catherine, says Breitwieser, this new connection is immediate and strong. They're paired like dancers, he says, right down to their first names. "Stéphane and Stéphanie, a beautiful match." A month after punching the cell window because Anne-Catherine will no longer see him, Breitwieser moves in with Stéphanie, to her apartment in Strasbourg. "She's my rock, my love, the only thing essential in my life," Breitwieser says about Stéphanie, and for the first time in a while he looks to the future with hope.

He also reaps a windfall, more than \$100,000, from a French publishing company, for permitting a ghostwriter to interview him for ten days. The ghostwriter then composes a swashbuckling account of his crimes, with Breitwieser credited as the author on the cover, along with a dashing photo of him, eyes blazing blue. Breitwieser hopes that the release of *Confessions of an Art Thief*, in French and German editions, and the ensuing publicity, will grant him a restart on life.

His plan, outlined in the last chapters of his book, is to establish himself as an art-security consultant, in the style of a computer hacker turned cybercrime expert. He'll suggest simple and economical security upgrades to his clients, which he thinks will include museums, galleries, and collectors guidance like replacing outdated display cases, inserting motion sensors in exhibits, and installing brackets that solidly anchor paintings to the walls. Royalties from *Confessions*, Breitwieser envisions, will accrue on top of his advance, and if there's widespread demand for his consulting services, he'll be able to pay down his fines and establish a respected career in the art world that his parole officer will allow.

"I'll live off my passion," Breitwieser says. "I know about art, and I know about security. I am prepared to help any and all institutions." He says that he now wants to be useful to society. He also plans to shower gifts upon Stéphanie, to whom he's dedicated the book. His life, at last, is working out for him, he feels. His Paris publishing company buys him a plane ticket, flying him in from Strasbourg so he doesn't have to drive. The publisher wants to meet him and discuss his media tour. He finally achieves respect, he's a big shot, something he has always craved to feel. Maybe they'll make a movie about him.

He lands in the Paris airport of Orly on June 29, 2006. Flush with money from the book, and with Stéphanie's birthday approaching, he stops at a clothing boutique on his way out of the airport. He'd been thinking about his securityconsultant job, and he sees, "in two seconds," he says, that this boutique is sadly unprotected. No video cameras, few security guards. A strange instinct kicks in, "a muscle memory," and he selects for Stéphanie a white pair of Calvin Klein pants and a T-shirt from the French designer Sonia Rykiel, and stuffs them in his carry-on bag. He strolls out of the boutique.

Then he thinks how nice it would be to wear new clothes on his book tour. And to give his father a present, thanking him for the support over the past grueling years. Less than a minute after he leaves the boutique, he turns around and returns. He picks out seven more items, a total of about a thousand dollars in clothing, and departs again. He heads to the taxi stand to make his meeting with the publishing company.

Breitwieser had failed to accurately count the security guards in the boutique. Those he'd missed, unlike ones in nearly all museums, are plain-clothed. The guards dash out of the boutique and pounce on him, and he's handcuffed and handed over to the city police. While he's held in custody, his publisher, concerned by his absence, contacts his mother. Stengel panics and begins calling hospitals. His father and Stéphanie also try to find him. Breitwieser is kept by the police overnight, out of contact, "furious with myself and terribly ashamed," he says.

Once the truth emerges, his father sends him a text message. "You really don't understand anything," his father types, exasperated, and soon after, he begins postponing their planned meetings. Then he drops out of his son's life again. Meichler, the framer, had supported Breitwieser in court, believing that his stealing days were over. "I feel betrayed," Meichler tells him, and ends their friendship.

His mother follows form and forgives him. And when he promises to resume seeing a therapist, Stéphanie stays with him too. The legal ramifications of the clothing theft are minor, one night in custody and three weeks of communityservice work in Alsace, cleaning city warehouses. He doesn't have to return any money to his publisher, but his book launch, in October 2006, is ruined. Nearly all the publicity is taunting and negative. "It's nonsense about a loser," says a typical critic, this one on a television talk show. The securityconsultant idea is treated by everyone except him as a joke.

The French art journalist Vincent Noce, who attended the trials in both Switzerland and France, publishes his own book on the case. *The Selfish Collection*, available in German or French, is merciless, suspecting that almost everything Breitwieser says is dishonest. Even his so-called sensitivity to art, Noce thinks, could be an act to make him appear honorable. "All he was trying to do in his life," says Noce, "is prove to his mother that he is someone important." Noce wonders if Breitwieser actually likes Renaissance art, or if those items were simply the most convenient to steal. Noce also calls Breitwieser's crimes "the biggest pillage of art since the Nazis."

Breitwieser is so upset by Noce that he sends him a letter, threatening the journalist physically. Breitwieser informs Noce that he's asked some Russian mobsters he met in prison to hurt the journalist. This reckless statement becomes part of the publicity for Noce's book, seeming to support the art journalist's contention that Breitwieser is a mentally unstable con man and punk. No museum asks Breitwieser for security advice.

He retreats, battered and demoralized, to Stéphanie's apartment. He'd blown his chance at redemption, and with his criminal background he has difficulty finding even a minimum-wage job. One he lands involves cleaning restaurant toilets on Sundays. He is increasingly recognized and gawked at on the streets, and takes to wearing his old thieving disguises. Then he hardly goes out. The walls in Stéphanie's place, he thinks, are bleak and dispiriting, and there's little he can do to alleviate his pain. He remains coupled with Stéphanie, but his dark and depressive moods return. The world is worthless; no one appreciates beauty. And soon enough, everything reaches a boil.

He drives to Belgium, in a car his mother bought him, where an antiques fair is being held near Brussels in November 2009. He sees a wintertime landscape, oil on copper, seventeenth century, by Pieter Brueghel the Younger—a work appraised at more than fifty million dollars. The fair is closing for the night, the employees in the booth tidying up. He doesn't even try to stop himself. He replaces his Brueghel, to go along with his new girlfriend, and now he hopes he can feel better again.

And he does! He hangs the Brueghel in the bedroom of

Stéphanie's apartment, and senses immediate joy, he says, without worry or guilt. He can breathe; he's alive. He wishes he had stolen again sooner. "One beautiful piece," he says, "makes everything different."

The few people Breitwieser has permitted into his life his mother, his father, his grandparents, Meichler, Anne-Catherine—had all reacted to his thieving in strangely tolerant ways, almost validating his behavior as acceptable for someone who seems as smitten by art as him. "There is no parental figure in this group," says the art journalist Noce. "No one ever said to him, 'You must stop, you have to give back the works, you must act like an adult,' and that was part of his problem, I think."

The vast majority of people do not condone stealing art, and Breitwieser might have forgotten this. Stéphanie, it turns out, is not like Anne-Catherine. When Breitwieser tells Stéphanie how he'd procured the Brueghel, she doesn't take the news well. There's now a painting on her wall, highly valuable, taken by a known art thief recently released from prison. She's become an accomplice. The gall of him to put her in that position at least offers Stéphanie a moment of clarity: he's not going to change.

Stéphanie severs the relationship and boots him out of her place, but not before snapping a photo of the painting on her cell phone. She shows the picture to the police, who track down Breitwieser and the Brueghel in a rented room in Strasbourg, and he's arrested and imprisoned again. 38

Another trial, another guilty verdict, prison time, probation. Breitwieser is not untethered from the penal system until 2015, when he's forty-four years old, creases at his eyes and a hairline in retreat. His few assets, including the car his mother paid for, have been seized. His primary bank account has a balance of five euros and fifty-two centimes, about six dollars, and even if he had money, his criminal record blocks him from obtaining a lease.

His mother signs for him and funds the rent on a small place near his grandparents' farmhouse. Sometimes she stops by with groceries and stocks his refrigerator. Stengel caretakes the farmhouse and tends to her own mother. Stengel's father, Breitwieser's adored grandfather who had guided his boyhood expeditions, pointing with a cane while he dug, has passed away. Stengel buys her son another car, and Breitwieser drives to the farmhouse most days for lunch. Otherwise he passes the day without eating. His only income is government assistance, and he has to deduct a token payment of fifty dollars a month to chip away at the fines from his original trials.

"All I want to do is take my car and go to the mountains, and walk alone," he says. He hikes to ruined forts; he picks mushrooms. Other times he goes to the movies, hides in the bathroom between shows, and sees a couple of films on one ticket. He doesn't read books anymore. "Nothing interests me. I've kind of given up."

In his apartment, he hangs a framed reproduction, in true dimensions, of *Sibylle of Cleves*, the Cranach he stole with Anne-Catherine at a German castle on his twenty-fourth birthday, while his mother walked her dachshund outside. He says that *Sibylle* and *Adam and Eve* were his two favorite works. The *Sibylle* reproduction, though, haunts him a little, reminding him of the real one that died in a fire. He doesn't visit museums anymore, he insists. "Too many memories. And I don't want to wake up old demons."

His remaining connection with the art world is through auction catalogs, which he scans each week in the faint hope that one of his lost pieces will turn up. Accounting for all of his stolen art that was found in the water and elsewhere, and assuming that all of his paintings and objects in wood were burned, Breitwieser is still missing about eighty of his stolen items, half of them silverworks. These pieces continue to be listed on international databases of stolen art, as do all of his paintings and wood items. No ash pile or remnants have been found, though none of the paintings or carvings have been seen since 2001.

The statute of limitations for stealing has expired on all of

the works. Still, his mother is an impenetrable fortress when it comes to the final resting place of the last eighty pieces. "She will go to her grave with this secret," believes Breitwieser. And her former boyfriend, if he even knew anything, has died. Their relationship hadn't lasted long, though it's unclear if the night of art destruction had anything to do with their breakup. Breitwieser never spots any of the missing works up for auction, and neither do the police.

Anne-Catherine, he thinks, may hold the key to the eighty lost pieces. Breitwieser doesn't have internet service at his apartment, but the farmhouse does, and while there he finds Anne-Catherine on Facebook. He sees that she's working and raising her son. He just wants to meet with her one more time. For once, he makes the smart decision and leaves her in peace. He does not send her a message, and he deletes his account. He has not contacted Anne-Catherine since his final letter in 2005, he says, and there's no evidence to the contrary. "Some things will have to remain a mystery," he shrugs.

He wastes away for more than a year, 2015 into 2016, without earning income, and with no prospects for doing so. "I've walled myself in," he says. Finally, he accepts that he's good at only one thing, and this realization feels immediately freeing. He sets off on a driving tour of Alsatian museums that he hasn't stolen from yet. At the House of Archaeology, north of Strasbourg, he slips five Roman coins, from the third and fourth centuries AD, into his pocket, along with a filigreed gold earring with a dangling pearl. Nearby at the Crystal Museum, he takes a couple of paperweights. In another museum, south of Strasbourg, he walks off with a fine piece of marquetry, inlaid wood with ash, rosewood, and fir, depicting a scene from the Trojan War. He grabs a few items from a neighboring French village, and steals more over in Germany.

None of these are pieces he loves. "I've stolen them because it's easy," says Breitwieser. And also for another reason: "I need money." He fences the works on eBay and other auction websites, via the farmhouse internet, always using aliases. He swiftly shifts incoming money, the equivalent of tens of thousands of dollars, from bank accounts into cash before any is garnished—techniques he'd learned from inmates over his years in prison.

Perhaps there's a reason all of his advisers were imprisoned. The French art-police force is tipped off by a careful art buyer about the possible sale of stolen works, and inspectors, habitually wary of Breitwieser, wiretap his phone at one point and spy on his banking and internet use. Eventually, his methods are clear: Breitwieser has become like every other art thief. In February 2019, the police raid Breitwieser's apartment and arrest him. He's jailed for a while, awaiting trial, then moved into home confinement as the Covid pandemic rages.

New laws with stiffer penalties have been passed in recent years, in Europe and the United States, specifically governing the theft of art and cultural heritage. And with these new statutes in place, it's possible that Breitwieser's punishment for his most recent art thefts and his sale of stolen goods will keep him imprisoned or under probation until he's close to sixty years old. He doesn't think he will ever be gainfully employed, he says. "I'll probably just sweep the streets."

He does experience, though, one of his life's most intense encounters with art, a few months before his 2019 arrest. The encounter comes soon after he sees a brochure—he still looks at brochures, it's an ingrained custom—for the Rubens House museum in Belgium. He doesn't want to peek at the pamphlet, but he does. And there it is, a little picture of *Adam and Eve*, evidently back on display. He's rattled, he's repelled, and then his mind as always won't let go.

He drives five hours to Antwerp. He disguises himself in his usual style, a baseball cap and eyeglasses, and buys a ticket with cash. For the first time in twenty-one years, he enters the Rubens House. Everything seems nearly the same, he says, as if time has compressed. He walks through Rubens's former kitchen and living area, to a small gallery at the back. The plexiglass display box is sturdier, he notes, and there are more cameras in the museum, and more guards.

Hands on his knees, leaning forward, nose nearly touching the display box, he studies the ivory. *Adam and Eve* looks no worse for wear after its time in the canal. The serpent remains ominously coiled around the tree of knowledge; the sensuality between the first humans is unmistakable. Eve's hair scrolls down her back. Breitwieser's eyes widen; his forehead scrunches. He feels, he says, as if he were witnessing someone who had died come back to life. From his four-poster bed, for years, he had reached out and caressed *Adam and Eve*. He doesn't want to make a scene in the gallery, so he hurries from the room and into the museum's courtyard.

It's quiet in the courtyard, with just a couple of people around. The air is warm; spring is coming. Breitwieser shuffles foot to foot on the pale cobblestones. The wisteria on the walls is starting to bud. The last time he had been in this courtyard, the ivory was under his jacket. This time, tears slide down his cheeks, and he mourns his lost years—not when he was stealing, but since he has stopped. He says he only realizes now, in hindsight, what he couldn't possibly have known then: his previous visit to this museum might have marked the high point of his life, the pinnacle. There will never be a grander moment than driving home with Anne-Catherine, windows down, ivory in the trunk, young and triumphant.

Breitwieser says that when he used to lounge in the fourposter bed, he had sometimes envisioned the last instant of his life. He'd be surrounded by every piece of his collection, drawing his terminal breath in a room packed with beauty. He would be gone, and his works—he always thought of them as his—would endure. But he had pushed everything too far, and his mother had lit a fire in the Alsatian woods. "I was a master of the universe," he says. "Now I'm nothing."

He heads to the Rubens House exit, through the gift shop, where a booklet with highlights of the museum's collection is sold. In the booklet, along with a few paragraphs recounting the ivory's theft and return, is a full-page photo of *Adam and Eve*. Maybe he can frame this image too, and perhaps this one won't haunt him. Breitwieser has no cash, no job. Just to drive here, he had accepted gas money from his mother. Out of habit, he notes the locations of the gift-shop cashier, the security guard, the customers. He checks to see if there are any surveillance cameras. There aren't. And he picks up a copy of the four-dollar booklet and walks out the door.

MERCI

To my Louvre: Jill Barker Finkel

To my little Pompidous:

Phoebe Finkel Beckett Finkel Alix Finkel

To a curiosity cabinet unto himself:

Stéphane Breitwieser

To the chief curators:

Andrew Miller Stuart Krichevsky Paul Prince Gary Parker To the appraisers and aesthetes and connoisseurs:

Bill Magill Ian Taylor Laurence Bry Adam Cohen Brian Whitlock Diana Finkel Ryan West Larry Smith Alan Schwarz Paul Finkel Lorraine Hyland Sarah New **Emily Murphy** Maria Massey Laura Usselman Kathy Hourigan Anne Achenbaum Sonny Mehta

Mike Sottak Geoffrey Gagnon Jeanne Harper Rachel Elson Abby Ellin Michael Benoist Ben Woodbeck Randall Lane Mark Miller **Riley Blanton** Tiara Sharma Chip Kidd Paul Bogaards Kristen Bearse Maria Carella Aemilia Phillips Jenny Pouech Reagan Arthur

To the early impressionists:

Vincent Noce Roland Meier Raphaël Fréchard Erin Thompson Julian Radcliffe Anne Carrière Jean-Claude Morisod Noah Charney Daniel Schweizer Natalie Kacinik Genia Blum Marion Wahl Alexandre Von der Mühll Eric Braun Kristine Ellingsen Matt Browne Yves de Chazournes Andrea Horstmann

To the muses and iconoclasts and provocateurs:

Toni Sottak Dada Morabia Bobby Small Cindy Stewart Gary Howard Chris Anderson Adi Bukman Beth Ann Shepherd Ryan Stewart Leslie Howard Marion Durand Frits Bukman Christopher Maratos Doug Schnitzspahn Tilly Parker John Byorth Arthur Goldfrank Julie Barranger Barbara Strauss Max Reichel Brett Cline Tara Goldfrank Mohamed El-Bouarfaoui Tim Thomas Kate Roehl Kristof Neel HJ Schmidt Patty West Scott Thompson Christian Meichler

A NOTE ON THE REPORTING

Learning the story of Stéphane Breitwieser required more than a decade of intermittent work. I first requested an interview with him in 2012, via a personal letter sent through the company that published his book, *Confessions of an Art Thief.* At the time, Breitwieser had not spoken with any journalist in a half dozen years, and had never granted an interview to an American.

More than two years elapsed before he responded with a brief note, written in blue ink, asking what I wanted to know about him. In the time between our letters, I had moved, along with my wife, Jill, and our three children, from the mountains of Montana to the South of France, a lifelong dream that had nothing to do with Breitwieser and everything to do with immersing ourselves in another culture and language. Breitwieser's response, which he mailed to Montana, was sent back across the Atlantic to our address in France by a friend who was collecting our mail. Breitwieser and I exchanged a few further notes, each growing slightly more pleasant and familiar in tone.

In May 2017, four and a half years after my initial letter, Breitwieser finally agreed to meet me for lunch—though just for an introductory chat, without my notebook or recorder. I took the high-speed train from Marseille north to Strasbourg, a four-hour trip. Then I rented a car and drove through the gorgeous green hills of Alsace, snacking on cherries purchased from a farm stand along the way, to the old Roman town of Saverne. At Breitwieser's suggestion, we met at Taverne Katz, a restaurant in a historical halftimbered Alsatian home, built in 1605, and filled with local art. We spoke to each other in French.

Breitwieser was quiet and cagey at first. People at adjacent tables, he mentioned, could overhear our conversation, so we stuck to innocuous subjects such as his favorite local hikes, the people I'd previously written about, and movies we each enjoyed. But over a long lunch of *baeckeoffe alsacien*, a traditional stew of beef, pork, mutton, and potatoes, as well as several glasses of Coca-Cola— I never saw Breitwieser drink alcohol—he grew increasingly comfortable. He eventually agreed to sit for a series of formal interviews. For privacy, Breitwieser proposed that we speak in my hotel room.

Whenever Breitwieser entered a hotel room I'd booked, he'd first examine the art on the walls. He'd stand close to the work, eyes wide, forehead furrowed—a look I came to know well. Breitwieser possessed a prodigious memory for the details of his crimes and an impressive, self-taught knowledge of art in general.

"This is a print by Jean Tinguely," he once said, examining a colorful doodle, unsigned, in my hotel room. He wrinkled his nose. "Not my style."

Unfamiliar with the name, I flipped open my laptop and confirmed that he was correct: Tinguely is a twentieth-century Swiss artist best known for his kinetic sculptures. I closed my computer and left it on the hotel room desk, in case I needed to look up anything else, and we commenced the interview. The room was tiny, with only one chair, which Breitwieser sat on. I used the luggage rack as a stool. The desk was between us.

I prefer to maintain eye contact during an interview and permit my digital recorder to capture the conversation, but I do take written notes, documenting nonverbal reactions like gestures and facial expressions. In the midst of a series of questions about how Breitwieser was able to deftly steal while people were near, a skill I couldn't quite fathom, he stopped the conversation and said, "Well, did you see that?"

"See what?" I said.

"What I just did."

"No," I replied. "What did you do?"

"Look around," he said.

Nothing seemed out of place in the cramped hotel room. "I'm sorry," I eventually said. "I don't see anything."

Breitwieser stood up from the chair, turned around, and lifted his button-down shirt. At the small of his back, tucked partially into the waistband of his pants, was my laptop computer. He'd taken it during an instant in which I'd lowered my eyes to scribble a note, and I simply hadn't noticed its absence. But I now understood his thieving ability in a visceral way.

In total, over the course of three multiday visits, Breitwieser and I spent about forty hours together, including sit-down interviews, visits to museums and churches from which he'd once stolen, several long walks, and a couple of full-day road trips. Additionally, I attended his most recent trial, for selling stolen art, in 2023—eleven years after I mailed my first letter. I also accompanied him, in March 2018, on the drive to the Rubens House in Belgium, more than five hundred miles round trip, where he saw *Adam and Eve* again after twenty-one years, the journey for which his mother had given him gas money. I was with Breitwieser when he stole the museum booklet from the Rubens House gift shop.

During that drive, on our way to Belgium, we stopped at a freeway rest area to use the bathroom. There was a turnstile at the entrance to the men's room; it cost seventy centimes to go in, less than a dollar, but required exact change. The rest area was busy, people streaming in and out. I fished in my pocket to see if I could find the right coins, while Breitwieser, with perfect timing, ducked athletically under the turnstile and appeared on the other side, quick as a flash, a deft and balletic move. No one except me seemed to notice it.

Breitwieser looked over at me and gave a quick turn of his neck, encouraging me to follow him under the turnstile. I wanted to, but I had a feeling I'd get stuck, or make a scene, or somehow find myself embarrassingly caught trying to sneak into a rest-area bathroom. I simply did not have the gumption to try it, and could scarcely comprehend attempting anything like this in a museum, with the stakes infinitely higher. I also didn't have the correct coins. I walked over to the cashier in the snack shop to get change, while Breitwieser used the bathroom.

I was never able to speak with Mireille Stengel, Breitwieser's mother, despite several requests, though Breitwieser informed me that his mother's tacit permission was the only reason I was even meeting with him. Stengel had read the French translation of one of my previous books. "She liked it," Breitwieser told me. "She's very wary of journalists, but you made a good impression." Stengel told her son that she wasn't opposed to his talking with me.

Anne-Catherine Kleinklaus also did not speak with me or reply to any of the three letters I sent. A handful of people who know her did grant an interview. Her attorney, Eric Braun, chatted with me openly for several hours and informed me, only somewhat joking, that because I had been with Breitwieser when he took the Rubens House booklet, I was guilty of complicity and could be charged with a crime.

Stengel's lawyer, Raphaël Fréchard, willingly spoke with me, and during a reporting trip through Switzerland, retracing some of Breitwieser and Anne-Catherine's stealing sprees, I spent a day with Jean-Claude Morisod, Breitwieser's attorney for his Swiss trial. Morisod permitted me to borrow several boxes of detailed trial materials.

Roland Meier and Alexandre Von der Mühll, the Swiss police officers who elicited all of Breitwieser's confessions, both granted me in-depth interviews. Von der Mühll also showed me the surveillance footage he'd obtained from the Alexis Forel Museum, where Breitwieser had removed thirty screws to steal a serving platter while Anne-Catherine stood watch.

Vincent Noce, the French art journalist who wrote the 2005 book on Breitwieser, *La collection égoïste*, or *The Selfish Collection*, spoke with me several times and generously offered access to the materials he'd collected. I spoke as well with Yves de Chazournes, the ghostwriter who composed *Confessions d'un voleur d'art*, or *Confessions of an Art Thief*, and vividly described what it was like to spend ten full days listening to Breitwieser's tales. Breitwieser's book editor, Anne Carrière, also chatted with me.

The Swiss filmmaker Daniel Schweizer, who had attempted to make a documentary about the case, only to have Breitwieser quash the project—Breitwieser had legal power of approval—selflessly sent me his work. Schweizer's footage included the home videos filmed by Breitwieser and Anne-Catherine. Breitwieser's former friend, the framer Christian Meichler, spoke to me candidly and at great length and, in a single conversation, referred to Einstein, Mozart, Napoleon, Goethe, Wagner, and Victor Hugo.

The professional translator Laurence Bry helped me navigate the French and Swiss legal systems and translated all of Breitwieser's trial transcripts, as well as many of the police interrogations, and most of my recorded interviews. Breitwieser granted me signed legal permission to examine the lengthy psychology report by the Swiss psychotherapist Michel Schmidt.

Erin Thompson, a professor in the Department of Art and Music at John Jay College of Criminal Justice in New York City, spoke about the power of aesthetic reactions and the intense emotion that sometimes accompanies touching a work of art. Natalie Kacinik, a professor of psychology at Brooklyn College, hypothesized about the mindset and motivations of art thieves in general, and Breitwieser specifically. Julian Radcliffe, the director of the London-based Art Loss Register, answered detailed questions about the methods of recovering stolen art. To gain insight into the threads that connect the long history of art crime, I spoke with Noah Charney, the founder of the Association for Research into Crimes Against Art, the editor of *The Journal of Art Crime*, and the author of several books that aided my research, including *Stealing the Mystic Lamb*, *The Thefts of the "Mona Lisa,"* and *The Museum of Lost Art*.

Geoffrey Gagnon, the executive editor of GQ magazine, edited the article I wrote about Breitwieser for the March 2019 issue. Matt Browne checked the facts for GQ. Riley Blanton fact-checked the details in this book. No names or identifying details have been changed, and no one, including Breitwieser, had any editorial control.

Jeanne Harper, expert researcher, dug up hundreds of documents on obsessive collectors, Stendhal syndrome, laws governing art crime, and myriad other topics. For research purposes, I even burned a pile of inexpensive oil paintings. I lit the fire in my backyard, attended by my children, and witnessed the phenomenon of flaming beads of paint falling to the ground.

I read a heap of books to prepare to write my own. Valuable works about art crime include *The Rescue Artist* by Edward Dolnick, *Master Thieves* by Stephen Kurkjian, *The Gardner Heist* by Ulrich Boser, *Possession* by Erin Thompson, *Crimes of the Art World* by Thomas D. Bazley, *Stealing Rembrandts* by Anthony M. Amore and Tom Mashberg, *Crime and the Art Market* by Riah Pryor, *The Art Stealers* by Milton Esterow, *Rogues in the Gallery* by Hugh McLeave, *Art Crime* by John E. Conklin, *The Art Crisis* by Bonnie Burnham, *Museum of the Missing* by Simon Houpt, *The History of Loot and Stolen Art from Antiquity Until the Present Day* by Ivan Lindsay, *Vanished Smile* by R. A. Scotti, *Priceless* by Robert K. Wittman with John Shiffman, and *Hot Art* by Joshua Knelman.

Books on aesthetic theory that were most helpful to me include The Power of Images by David Freedberg, Art as Experience by John Dewey, The Aesthetic Brain by Anjan Chatterjee, Pictures & Tears by James Elkins, Experiencing Art by Arthur P. Shimamura, How Art Works by Ellen Winner, The Art Instinct by Denis Dutton, and Collecting: An Unruly Passion by Werner Muensterberger.

Other fascinating art-related reads include So Much Longing in So Little Space by Karl Ove Knausgaard, What Is Art? by Leo Tolstoy, History of Beauty edited by Umberto Eco, On Ugliness also edited by Umberto Eco, A Month in Siena by Hisham Matar, Art as Therapy by Alain de Botton and John Armstrong, Art by Clive Bell, A Philosophical Enquiry into the Sublime and Beautiful by Edmund Burke, Seven Days in the Art World by Sarah Thornton, The Painted Word by Tom Wolfe, and Intentions by Oscar Wilde which includes the essay "The Critic as Artist," written in 1891, from which this book's epigraph was lifted.

Despite all this reading, I never found any art thieves who really compare to Breitwieser and Anne-Catherine. Nearly everybody else did it for money, or stole a single work of art. The couple is an anomaly among art stealers, but there does exist a group of criminals for whom long-term looting in service of aesthetic desire is common. In the taxonomy of sin, Breitwieser and Anne-Catherine belong with the book thieves. Most people who steal large quantities of books are fanatic collectors, and there have been enough of these thieves that psychologists have grouped them into a specialized category. They're called bibliomaniacs. This is Breitwieser's tribe.

Alois Pichler, a Catholic priest from Germany stationed in Saint Petersburg, Russia, modified his winter jacket with a special inside sack and took more than four thousand books from the Russian Imperial Public Library, from 1869 to 1871. Stephen Blumberg, from a wealthy Minnesota family, stole twenty thousand books from libraries in the United States and Canada. Duncan Jevons, a turkeyfarm laborer from Suffolk, England, stole forty-two thousand library books over thirty years, starting in the mid-1960s, mainly by stashing them a few at a time in his battered leather briefcase.

Breitwieser's favorite book thief is a fellow Alsatian, Stanislas

Gosse, an engineering professor with a passion for religious tomes. Gosse stole a thousand volumes over two years from a securely locked library in a medieval monastery. The locks were changed three times during his binge, to no avail, for Gosse had learned, in the course of his constant reading, of a forgotten secret passage behind a hinged bookcase connecting to a back room of the adjacent hotel. He filled suitcases with books that felt to him abandoned, soiled with pigeon droppings, and he entered and left the premises by blending in with tourist groups. Gosse cleaned the books and stored them in his apartment. He was arrested in 2002 after police hid a camera in the library, but merely served probation. Stanislas Gosse is the only thief that Stéphane Breitwieser ever spoke of with deep respect.

Image Credits

- Page 1 Madeleine de France by Corneille de Lyon, 1536 / © Bridgeman Images.
- Page 2 (top left) Adam and Eve by Georg Petel, 1627 / RH.K.015, Collection of the City of Antwerp, Rubens House.
 (top right) Tobacco box by Jean-Baptiste Isabey, c. 1805 / Valais History Museum, MV 1444. © Musées cantonaux du Valais, Sion. Photograph by Heinz Preisig. Photocolorization by Dana Keller.

(bottom left) *Sibylle of Cleves* by Lucas Cranach the Younger, c. 1540.

(bottom right) Still life by Jan van Kessel the Elder, 1676 / © Christie's Images / Bridgeman Images.

Page 3

(top right) Festival of Monkeys by David Teniers the Younger, c.1630 / © Musée Thomas Henry, Cherbourgen-Cotentin / courtesy of the Rubens House, Antwerp. (middle left) Allegory of Autumn, originally attributed to Jan Brueghel the Elder, later attributed to Hieronymus Francken II, c. 1625 / © Musées d'Angers / Pierre David. (middle right) Sleeping Shepherd by François Boucher, c. 1750 / © RMN-Grand Palais / Art Resource, N.Y. (bottom left) Flintlock pistol (detail) by Barth à Colmar, c. 1720 / courtesy of La Société d'histoire, "Les Amis de Thann."

- Page 4 (top left) Soldier with a Woman by Pieter Jacobsz Codde, c. 1640 / inv. 845.5.1 C Besançon, musée des beaux-arts et d'archéologie. Photograph by C. Choffet. (top right) Pietà by Christoph Schwarz, c. 1550 / Château de Gruyères / photograph by J. Mülhauser. (bottom left) The Bishop by Eustache Le Sueur, c. 1640 / courtesy of Musées de Belfort. (bottom right) The Apothecary by Willem van Mieris, c. 1720 / © Pharmaziemuseum Universität Basel, Schweiz.
- (top) Village Entrance by Pieter Gijsels, c. 1650 / @ Musée Page 5 de Valence / photograph by Eric Caillet. (middle) Scene from the life of Christ, c. 1620 / courtesy of the Art and History Museum of Fribourg. (bottom) Landscape with a Cannon by Albrecht Dürer, 1518 / Fletcher Fund, 1919 / The Metropolitan Museum of Art.
- (left) Chalice by I. D. Clootwijck, 1588 / ImageStudio / Page 6 © Royal Museums of Art & History, Brussels. (right) Chalice, 1602 / ImageStudio / © Royal Museums of Art & History, Brussels.
- (top) Warship, c. 1700 / ImageStudio / Royal Museums Page 7 of Art & History, Brussels. (bottom left) Albarello, c. 1700 / courtesy of Museum Aargau / photograph by Romeo Arquint. (bottom right) Commemorative medallion, c. 1845 / courtesy of the History Museum of Lucerne, Switzerland. Page 8
- (top) Lion and lamb, c. 1650 / courtesy of the Abbey of Moyenmoutier, France.

(middle left) Chalice, c. 1590 / ImageStudio /C Royal Museums of Art & History, Brussels.

(middle right) Three Graces by Gérard van Opstal, c. 1650 / Royal Museums of Art & History, Brussels / photograph C History and Art Collection / Alamy. (bottom) Musicians and Walkers in a Park by Louis de Caullery, c. 1600 / bequest of the Musée Benoît-De-Puydt.

"Mesmerizing.... Finkel tells an enthralling story. From start to finish, this book is hard to put down." — The Wall Street Journal

Stéphane Breitwieser is the most prolific art thief of all time.

He pulled off more than 200 heists, often in crowded museums in broad daylight.

His girlfriend served as his accomplice.

His collection was worth an estimated \$2 billion.

He never sold a piece, displaying his stolen art in his attic bedroom.

He felt like a king.

Until everything came to a shocking end.

In this spellbinding portrait of obsession and flawed genius, Michael Finkel gives us one of the most remarkable true-crime narratives of our times, a riveting story of art, theft, love, and an insatiable hunger to possess beauty at any cost.

"In animated and colorful prose, Finkel summons the emotional intensity of a murder mystery. But old masters, not bodies, are missing.... The Art Thief is about heists, yes, but it also speaks to much more." — The Washington Post

"Exhilarating.... Finkel's narrative thrills and electrifies, until it all barrels toward inevitable capture, two shocking betrayals, and an astonishing conclusion." —Esquire

U.S. \$18.00

ISBN 978-1-9848-9845-6

Cover design by Joe Montgomery Cover images: (front) The Sleeping Shepherd (detail) by François Boucher © RMN-Grand Palais/Art Resource, NY; (back and spine) Still Life of Flowers (details) by Jan van Kessel the Elder. Photograph © Christie's Images/ Bridgemon Images

vintagebooks.com